A FUTURE FOR RELIGION?

New Paradigms for Social Analysis

editor
William H. Swatos, Jr.

SAGE PUBLICATIONS
International Educational and Professional Publisher
Newbury Park London New Delhi

Copyright © 1993 by Sage Publications, Inc.

For information address:

SAGE Publications, Inc.
2455 Teller Road
Newbury Park, California 9132

SAGE Publications Ltd.
6 Bonhill Street
London EC2A 4PU
United Kingdom

SAGE Publications India Pvt. I
M-32 Market
Greater Kailash I
New Delhi 110 048 India

Printed in the United States of America

Library of Congress Cataloging-in-Publication Data

A future for religion? : New paradigms for social analysis / edited by
 William H. Swatos, Jr.
 p. cm. —(Sage focus editions ; 151)
 Includes bibliographical references and index.
 ISBN 0-8039-4675-9 (cl). —ISBN 0-8039-4676-7 (pb)
 1. Religion and sociology. I. Swatos, William H., Jr.
BL60.F88 1993
306.6—dc20
 92-32146
 CIP

93 94 95 96 10 9 8 7 6 5 4 3 2 1

Sage Production Editor: Judith L. Hunter

A FUTURE FOR RELIGION?

OTHER RECENT VOLUMES IN THE
SAGE FOCUS EDITIONS

Contents

Acknowledgments

This book owes its greatest debt to the authors of the individual chapters. While each author is an expert in the field upon which he or she has written and each has previously written in his or her area extensively, the chapters as they stand here were written for this book with the specific intention of providing in each a survey, substantive contribution, and concrete agenda for future research.

The book also owes a debt to Mitch Allen of Sage Publications, who saw the need for it and encouraged me to take it on. I am happy he did, and I hope the product serves well the purpose for which it was intended within the sociology of religion.

We all owe at least two debts to the Association for the Sociology of Religion: first, because it brought us together; second, because it has provided me with the institutional resources to pursue the project comfortably. In this regard, I especially want to thank Jason Stevenson, who has been my mentor in computerization; Giles and Eric Swatos, who have responded to cries for help when Jason was not around to get me out of technological jams; Priscilla Swatos, who makes library searches relatively painless; and Melinda Rosales, who has a marvelous sense of humor and perspective while she moves papers from one stage of the production process to another.

Introduction

The sociology of religion is facing a double-barreled identity crisis. The first and more long-standing concern centers on the relationship of the subdiscipline to general or mainstream sociological theory and research —what Jim Beckford (1985) has termed "the insulation and isolation of the sociology of religion." This topic recurs in symposia and addresses with considerable regularity when sociologists of religion gather; and indeed, that it occurs at all is probably the best evidence that there is some truth to the perception. But a second challenge looms increasingly prominently; namely, that mainstream sociology itself is experiencing a considerable assault within the hallowed halls of the academy, as several major universities eliminate departments or reduce their strength (see, e.g., Kantrowitz, 1992). The result could well be that in seeking greater prominence in the networks of general sociology, the sociology of religion might be further excluding itself from a wider public.

This book is an attempt to reorient the sociology of religion to *new* paradigms in social scientific inquiry, reconsidering as we go timeworn assumptions about the sociological quiddity of religion—that which we are about in the sociology of religion. How did we come to this point? In his recent historical analysis of the sociology of religion from its inception in the heyday of industrial society to the present, *Religion and Advanced Industrial Society,* Beckford observes that although it is true that "religion" constituted an important category for practically all of the sociological forebears—Marx, Weber, Durkheim, Tocqueville, Comte,

Simmel, Spencer, Martineau, the American founders, and on and on—religion was also mainly conceived negatively: The *decline* of religion was, for these sociologists, to be certainly observed, possibly lamented, possibly celebrated. Only in the work of someone like Talcott Parsons was the transvaluation of religion to be seen as a religiously creative venture, but one that also lacked a distinctive or "strong" claim for religion (see Beckford 1989, chaps. 1-3).

Thus, a rather consistent theme was introduced into sociological lore, one that Jeffrey Hadden in his presidential address to the Southern Sociological Society in the late 1980s would rightly term a "*doctrine* more than a theory," based on "presuppositions that . . . represent a taken-for-granted *ideology* in social science"—a belief system accepted, ironically, "on faith," viz., the decline of religion or, at its mildest, the decline of what would generally be termed "traditional" religion (Hadden 1987, 588). This sociological dogma took different forms depending upon the specific theoretical perspective out of which it arose, but its ubiquity led to a "certainty" within sociology that the sociology of religion was studying a form of life in its death throes. Some sociologists of religion so accepted this funereal task that, when empirical data were proffered at variance from this position, these data were dismissed as peripheral residuals or even reinterpreted to argue that success actually proved failure.

New religious movements, evangelical and charismatic Christians, Jewish and Islamic revivals, data from some of the American mainline churches, and rethought historical analyses have now, as Hadden, Beckford, and others have demonstrated, swamped simple secularization and privatization theories. "Modernity arouses expectations that it cannot satisfy without stimulating the religious imagination," Danièle Hervieu-Léger notes (Hervieu-Léger 1990, S15); and one must either radically redefine "secularization," as she does, to be "the process whereby religion organizes itself to meet the challenges left by modernity" or, as I have argued (Swatos 1989, 153), understand the concept as signaling "a paradigm shift of major proportions in ways of knowing how the world works, in which heretofore widely accepted epistemological assumptions are directly challenged by new experiences"—that is, "secularization" is primarily a concept for the sociology of knowledge, and only secondarily for the sociology of religion. Even Thomas Luckmann, who once popularized the phrase "*invisible* religion" (Luckmann 1967), now is willing to talk instead of "shrinking transcendence and *expanding* religion" (Luckmann 1990), which is not only more accurate but

also exposes the underlying theological premises upon which the received sociological dogma has been based—namely, the intellectualized, rational high god of many generations of Western, Judeo-Christian academics, whose worldview was at considerable remove from the lived experience of the wider society of their own times, let alone that of ours.

Crucial to continued sociological misunderstanding of religion is a focus on content abstracted from experience (i.e., on "beliefs" understood propositionally rather than existentially). Attempts to manipulate the content of religion miss the sociological point that form precedes content and that religion must be *culturally relevant* in form before its content will be heard. In the move from premodern, to modern, to postmodern cultures, the relevant cultural forms of religion have necessarily shifted. Religions that address the culture of the emotions within the complexity of postmodernity draw comparably more converts from the populace at large, while those that engage in theological revisionism draw a smaller and smaller, largely intellectualized, sector of the population. For this reason "new" theologies hardly do better than the old at addressing contemporary spiritual needs and may even exacerbate existing difficulties (e.g., feminist theologies). Mainline liberal denominations spend more and more time talking to themselves as they grow fewer and fewer in numbers, while pentecostal and "nondenominational" congregations flourish. In this respect there is a covariance between the assumptions of historic sociology of religion and the historic denominations that in many ways makes each the accomplice of the other in the cycle of defeat, to which mainstream sociology itself may also be a party (see Swatos 1981).

The first professional meeting in the scientific study of religion that I attended as a new Ph.D. in sociology heralded the publication of the essay collection *Beyond the Classics?* (Glock and Hammond 1973). The book attempted to assay the degree to which the discipline had extended itself over at least a half-century from the core texts in the field. My reading of the essays led me to conclude "not much." I see us involved in explications of a handful of works, which may be of genuine significance in themselves, but with only limited evaluation of whether they are advancing the field today or into the future. Though I value both historical sociology and the history of sociology, neither is necessarily adequately positioned to address current developments. Social science is not the application of timeless truths but the development of explanatory and predictive constructs that tell us how to go on in varying forms

of human life. To that end theory and experience must enjoy relative "goodness of fit." This in turn demands attentiveness to the life world—to the problematics that constitute existence in our time and their implications for the future. It is this viewpoint that underlies not only the question that this collection seeks to address but also the ways in which we try to answer it.

Presences

Because it is our intention to explore a variety of trends in social analysis that may contribute to renewal in the sociology of religion, the several chapters in the book make unique contributions. Thus there is not a single theoretical perspective or research methodology that underlies our work. Each chapter is a discrete unit that surveys existing literature, offers a substantive contribution, and yields concrete research agendas. The latter are particularly important as they move the book from critical reflection upon the state of the discipline to practical activities that will advance it. As editor, I have made a decision about the layout of chapters that seems to make good sense to me in considering the book as a whole; yet it should be the case that the chapters can be read valuably in almost any order and that any contribution can stand on its own. My guiding principles in arrangement were to move from relatively more structural topics to more cultural ones and from more theoretical to more applied pieces. In fact, however, all the essays have structural and cultural components and offer both theoretical and applied aspects.

The opening chapter, by John Hannigan, looks at the possibilities for interfacing New Social Movement (NSM) theory and the sociology of religion. Historically, as Hannigan has shown in a previous article (1991), the subdisciplines of social movements and the sociology of religion have operated largely independently of each other, in spite of the similarities in their topics as sociological life forms. (As Roger O'Toole noted in a review article [1976], for example, there is a literature on political sects that has run largely parallel to, but apart from, church-sect theory in the sociology of religion.) With a substantive focus on movements surrounding environmentalism, Hannigan shows a variety of ways that NSM theory and concerns can interface with the sociology of religion to the enrichment of both. NSM approaches have the particular advantage of combining structural and cultural elements

in social experience in new ways that transcend the either-or dichotomies of traditional functionalist-conflict debates in sociological theory and thus really do take us beyond the classics.

It would be difficult to think of a phenomenon that caught Western students of religion more by surprise than the worldwide resurgence of religion—*political religion,* no less—that occurred with increasing visibility from the late 1970s onward. One major aspect of this apparent change was the movements that the media dubbed "fundamentalist." While this term technically is applied accurately only within the history of Protestant Christianity, it has taken on a wider general usage to encompass a variety of movements on a global scale. Frank Lechner, in the second chapter, reflects on the significance of this occurrence and the kinds of research needed to assess its importance. He notes the important ways in which these fundamentalisms are *distinctly modern* and raises questions about their long-run impact upon belief and action patterns that are disinterestedly religious. In terms of world political stability and world peace in the coming decade, there may be no more salient area of concern than this, however, as a fulcrum for articulating conflicts.

In the third chapter, then, Gene Schoenfeld uses a post-Marxist class analysis to interpret the varying significances given to religion among conflicting status groups. Developing upon his own prior work on religious militancy—a term that is often to be analytically preferred to "fundamentalism"—Schoenfeld shows how and why different aspects of religious worldviews can be adopted by ascending or retrenching status groups in expressing their demands vis-à-vis the dominant class in society. This gives rise, for example, to the inclusive militancy that most recently might be associated with something like the "Rainbow Coalition" of Jesse Jackson (ascending classes) versus the exclusive militancy of the Moral Majority (retrenching classes). The virtue of Schoenfeld's approach is to highlight the dimension of *change* in class analysis, a view that harks back in the sociology of religion to Max Weber's important observation in *The Protestant Ethic and the Spirit of Capitalism* (1930) that it was the "rising classes" or *parvenus* that constituted the carriers of this new worldview. Static class analyses of both Marxian and functionalist types have failed to grasp adequately the change dimension in class relations.

East Asia is certainly an important region for change in the modern world, and it presents largely untrod soil for the sociology of religion, most of whose concepts are derived from the European experience.

Inasmuch as commentators on world affairs suggest that the focus, especially of the United States's interest, will shift in the coming decades from the Atlantic to the Pacific, this sector of the global political economy presents a challenge to analysts of culture. Joe Tamney has had extensive experience in this part of the world as a researcher and teacher in Singapore, Indonesia, and Australia. From this work and an extensive literature review, he explores religious developments in Japan, South Korea, Singapore, Taiwan, and Hong Kong, giving particular attention to the status of Buddhism and Christianity. Elsewhere Joe has also written about the popularity of Islam in Indonesia (Tamney 1987), the largest Muslim country in the world. These insights could be usefully compared to media portraits of "fundamentalist" Islam in the Middle East.

For many students of religion, the phrases *Latin America* and *liberation theology* have become synonymous. In his chapter, however, Ted Hewitt extends sociological assessment of the Roman Catholic social justice agenda beyond the well-known South American example of Brazil to include Canada and the United States. In so doing, he indicates how different national priorities have influenced the ways in which the hierarchies in these countries have responded to human need and structural inequality. The Roman Catholic case is instructive in this instance because it represents the only truly universal religious organization in Christendom. As such, it is uniquely placed to be the carrier of Christian priorities for social justice onto the global stage. Thus, studying Catholic justice agendas is not parochial; quite to the contrary, it is essentially world open. Put differently, if the Roman Catholic Church cannot "pull off" a justice agenda, there is not going to be an operative Christian social justice ministry in world society. The research priorities that Ted suggests, then, are important not merely for students of Catholicism narrowly conceived; rather, they are *conditia sine qua non* for the possibility of a religious program of global proportions.

With the changes of focus from Eurocentrism to Latin America and the Pacific that inform the two prior chapters, Peter Kivisto's contribution reminds us that patterns of immigration to the United States and of immigrants among the United States population have changed dramatically over the past 25 years and in all likelihood will continue to be reflected in this population for the foreseeable future. Specifically, Asian immigrants are the United States's fastest growing ethnic peoples, and Hispanics are soon to become its largest ethnic segment. These peoples bring differences in religious orientations that will have impor-

tant impacts on the way American pluralism shapes itself. There will be both an increasing variety of religious practices and patterns, and differences in organizational compositions. The once "solid" German-Irish Catholic Church that was the "American" Church will soon become a Hispanic Church, or else will lose a significant element of its market share in American demographics. Peter zeros in on a significant lacuna in sociology of religion research and suggests some ways to fill this void. Like social movements, ethnic studies has operated along parallel tracts with the sociology of religion in spite of the clear overlap in the actual lives of their subject groups.

With Jim Spickard's chapter on religious experience we move farther toward the cultural pole in our reading. It is nothing short of shocking, if one thinks about it, that the sociology of religion has virtually ignored religious experience as a venue for research and theory. There is no question that the roots for this lie in the specific historical circumstances of the discipline's "founding fathers," but for a field that is inherently caught up in what Peter Berger (1961) has termed "debunking," one might expect that sociology could have been more quickly self-critical in this respect than it has been. Jim looks at the several ways religious experience has been treated in the social sciences (principally psychology) and then offers additional perspectives. He draws particularly upon his own research in several different religious traditions, including the ritual life underlying Native American sand painting, in an attempt to flesh out illustratively the frameworks he develops. His ideas for further research extend to more mainline traditions as well.

The work of Danièle Hervieu-Léger remains largely unknown outside the French-speaking world. Fortunately, this is becoming increasingly less true, and there is much hope that the present chapter will give her work on religious emotion, one of the most salient aspects of religious experience, a far wider readership. Danièle's chapter is relatively as close as this book is going to get in considering the "secularization thesis" at any length. As she explores the interplay of religion and emotion, she demonstrates the complexity of determining what both religion and secularization are as they exist in the lives of acting subjects. Drawing particularly from her research on the charismatic movement, she indicates how religion organizes itself to meet the challenges of (post)modernity and why these are different from those of prior epochs. Religion may thus be said to be neither "in decline" nor "resurgent" as much as *changing*; and to comprehend these new forms, sociology must change

its analytical paradigms. Old definitions do not help us understand new realities.

The themes of experience and emotion, change and self-criticism are further enhanced by John Simpson's chapter assaying the absence of consideration of *the body* in sociology. Drawing particularly upon theoretical suggestions of Meredith McGuire and Brian Turner, Simpson explores the ways in which sociology has treated people as *disembodied* actors and how the category of the body may be employed to help us understand sociopolitical and socioreligious developments under postmodern or late capitalist conditions. He gives particular attention to strategies of healing (tying back to the two prior chapters) and to sexualities (tying forward to the next chapter). Inasmuch as virtually all religious rituals involve body performance and there is ever-increasing concern in contemporary culture with body issues, failure to pursue these themes in sociological approaches to religion can only result in caricatures of reality. A particularly helpful concept introduced in John's chapter is the label *patric body,* to denote the construction of the body within those contemporary religious traditions sometimes termed *patriarchal* by feminists. Building upon Bryan Turner's work (1984), John notes that in our era the term *patriarchal* is anachronistic, in that it refers to a mode of production that has long since disappeared, and thus is flawed as an analytical tool when applied in the contemporary setting.

In an assessment of the status of the field of sociology of religion, Robbins and Robertson (1991) have indicated feminism as one of the significant dynamics that has had an impact on our work in the last decade. In her chapter, Mary Jo Neitz reviews many of the lines of inquiry that this larger sociopolitical development has generated in the field. I have placed her chapter toward the end of the book because her research agenda surveys from the feminist perspective many of the topics already introduced by the other authors. In a sense, then, she offers not only a set of feminist concerns but a feminist elaboration of other subject areas as well. This synthetic treatment should help readers see how the various topical threads can be woven together to develop a genuinely renewed sociology of religion. These issues can play into and out of one another in multiple directions. Were it not for the complexity such a format would have created in producing a single volume, each of the chapters could be an elaboration in this way in the face of the others.

In my concluding chapter, I look particularly at sociology of religion as an applied discipline. This is not to say that the other chapters are

not fruitful in this respect as well, but there is no question that application within sociology has achieved a new respectability after years of abuse at the hands of both abstract empiricists and grand theorists. At this stage in the discipline's history, it is important to recall some aspects of our origins too easily forgotten and to reassert the applied religious interests that were at the heart of much early sociological research. Religion was in many ways drummed out of sociology by apostles of "modernity"—a worldview that thought "science" could answer all human questions and meet all our desires. Nothing more than the current concerns of the environmental movement—to tie the end of the book to its beginning—need be brought to bear as evidence to indicate how myopic this view was. Of course, hindsight always has an advantage, and criticism of our forebears makes only a limited contribution. The purpose of my chapter, then, is to indicate how the sociology of religion might reasonably be employed in the service of applied concerns to advance both human well-being and the stature of the discipline.

Absences

There are two major areas that are not covered in this book that some might expect should be: developments in Eastern Europe, and what have been termed New Religious Movements (NRMs) or cults. A word on each:

Eastern Europe is not covered primarily because change there is occurring so rapidly that it is impossible to write with any accuracy about that situation. Surely it is potentially an important area for research, and I am aware of colleagues who are struggling to keep up with developments there (see, e.g., Nielsen 1992). Nevertheless, a chapter at this time would be purely speculative; indeed, its conclusions might be ludicrous even across the time elapsed from writing to publication.

The issue with NRMs is a more philosophical one. It has two aspects: First, in spite of all the debate a small number of New Religious Movements have created, the fact is that worldwide five new religious groups appear every week (Marty 1991, 16). Thus, like "fundamentalism," the issue of NRMs as it is portrayed in the media and a certain branch of "pop sociology" may well have an importance on paper far beyond any kind of representativeness in daily human experience. It is, furthermore, quite difficult to see how NRMs as a whole differ from

Old Religious Movements (see Bromley and Shupe 1979; Shinn 1987). Second, the term *cult* has taken on a clearly pejorative labeling function that preeminently reflects the antireligious bias of the "old sociology" from which we hope to depart in this volume. In my view most studies of cults, as that term is used in popular literature, reflect either prurient interest or prejudice that we now need to move beyond. That there is a cultic dimension to all religion, I have no doubt, but we would probably do better at this point to look, with Jim Spickard, at religious experience(s) and stop labeling groups on the basis of pseudoscientific modes of evaluation that have outlasted their utility.

References

Beckford, J. A. 1985. The insulation and isolation of the sociology of religion. *Sociological Analysis* 46: 347-54.

———. 1989. *Religion and advanced industrial society*. London: Unwin Hyman.

Berger, P. L. 1961. *Invitation to sociology*. Garden City, NY: Doubleday.

Bromley, D. G., and A. D. Shupe. 1979. The tnevnoc cult. *Sociological Analysis* 40: 361-66.

Glock, C. Y., and P. E. Hammond, eds. 1973. *Beyond the classics?* New York: Harper & Row.

Hadden, J. K. 1987. Toward desacralizing secularization theory. *Social Forces* 65: 587-611.

Hannigan, J. 1991. Social movement theory and the sociology of religion. *Sociological Analysis* 52: 311-31.

Hervieu-Léger, D. 1990. Religion and modernity in the French context. *Sociological Analysis* 51: S15-25.

Kantrowitz, B. 1992. Sociology's lonely crowd. *Newsweek*, 3 Feb., 55.

Luckmann, T. 1967. *The invisible religion*. New York: Macmillan.

——— 1990. Shrinking transcendence, expanding religion? *Sociological Analysis* 51: 127-38.

Marty, M. E. 1991. Never the same again. *Sociological Analysis* 52: 13-26.

Nielsen, D. A. 1992. Sects, churches, and economic transformation in Russia. In *Twentieth-century world religious movements in neo-Weberian perspective*, edited by W. H. Swatos, Jr., 125-41. Lewiston, NY: Mellen.

O'Toole, R. 1976. Underground traditions in the study of sectarianism. *Journal for the Scientific Study of Religion* 15: 145-56.

Robbins, T., and R. Robertson. 1991. Studying religion today. *Religion* 21: 319-37.

Shinn, L. D. 1987. *The dark lord*. Philadelphia: Westminster.

Swatos, W. H., Jr. 1981. Beyond denominationalism? *Journal for the Scientific Study of Religion* 20: 217-27.

———. 1989. *Religious politics in global and comparative perspective*. New York: Greenwood.

Tamney, J. B. 1987. Islam's popularity. *Southeast Asian Journal of Social Science* 15: 53-65.

Turner, B. 1984. *The body and society*. Oxford: Blackwell.

Weber, M. 1930. *The Protestant ethic and the spirit of capitalism*. New York: Scribner.

1

New Social Movement Theory and the Sociology of Religion

Synergies and Syntheses

JOHN A. HANNIGAN

After a long period of disciplinary isolation (see Beckford 1985; Robertson 1985; Turner 1983), the sociology of religion has increasingly been opening its doors to new interests and approaches. Robbins (1988a, 17) accords particular significance to the development of emergent linkages with other subareas of sociology, notably medical sociology, the sociology of deviance and social control, the sociology of organizations, social psychology, and social movements. In the latter case, one of the most promising leads for future theoretical development has been the synergy that has been observed between the sociology of religion and what has come to be known as the paradigm of the New Social Movements (NSMs).

By most accounts, the genesis of the New Social Movement concept can be traced to the German and French student and workers' movements of the 1960s and the impact that these had on academic observers. Up until then, students of social movements had assumed that a working-class constituency was a necessary basis for radical social action and that the incentives for such action were purely material (Klandermans and Tarrow 1988, 2). European social movement scholars observed that these new protest groups pursued interests that went

1

"beyond traditional and class issues to a range of new social, cultural and quality of life issues that emerged from the modernizing process occurring in these societies" (Dalton and Kuechler 1990, 3-4). This became even more evident in the actions and ideologies of an extensive network of citizen action groups that arose throughout Europe over the next decade.

The distinctiveness of NSM theory has been very much dependent on the ability of its proponents to distinguish successfully what is novel about these new movements, especially with relation to traditional leftist movements and to their own historical predecessors (i.e., the conservation movement, suffragettes). In this regard, NSMs can be typified on the basis of four categories of shared characteristics: goal orientations or aspirations, action forms, participants or support base, and values and ideology (Dalton and Kuechler 1990; D'Anieri, Ernst, and Kier 1990; Klandermans and Tarrow 1988). While most NSM scholars generally accept these criteria for distinctiveness, they vary considerably as to interpretation. As Tarrow (1990, 252) has observed, NSM models differ fundamentally over the question of whether the new movements are best conceived in structural or cultural terms. In Germany, the macrostructural approach is evident in the work of Eder (1985), Habermas (1984, 1987), Offe (1985), and others. One of the most explicit examples of this is Brand's (1990) continuing effort to construct a "mobilization cycle" for the development of NSMs. By contrast, French and Italian interpreters (Alberoni 1984; Melucci 1985, 1988, 1989; Touraine 1981, 1983, 1985) are more inclined to treat the new movements as "action systems" in which the construction of new identities is a central task of social movement actors.

Until recently, sociologists of religion have been somewhat tardy in embracing NSM theory. There are several possible reasons for this:

First, the rise of the New Religious Movements (NRMs) coincided temporally with the growth of NSMs. Rather than look beyond their own specialty area, sociologists of religion have tended to develop *their own* paradigms to account for the sudden burst of spiritual activity in the 1970s and 1980s. Robbins (1988b, 60-61) characterizes these as tending to be *crisis theories* or *modernization theories* (or combinations of the two) that "pinpoint some acute and distinctively modern dislocation which is said to be producing some mode of alienation, anomie or deprivation to which Americans are responding by searching for new structures of meaning and community." Most, Robbins argues, are also "parochial" in that they deal primarily with *intrasocietal* sources of

sociocultural transformation and ignore contemporary "globalist" or "world system" ones, while at the same time treating NRM sources in isolation from the sources of other contemporary movements.

Second, the sociology of religion has long been structurally and ideologically cut off from the leading edge of European left-wing social thought. Founded on a series of functionalist postulates, the sociology of religion has, for the most part, "been intellectually insulated against, and socially isolated from, many of the theoretical debates which have invigorated other fields of modern sociology" (Beckford 1989, 12-13). In America, where the sociology of religion has been organizationally centered, those scholars who have looked to contemporary social movement literature for guidance have chosen to embrace the homegrown "resource mobilization" paradigm (Bromley and Shupe 1979, 1980; Davidson 1985; Kent 1987; Khalsa 1986), rather than the more European macrosociological approaches. Where the field has ventured onto the Continent, it has found the neofunctionalism of the German social theorist Niklas Luhmann or the Catholic sociology of the Belgian researcher Karel Dobbelaere more appealing than various neo- or quasi-Marxist frameworks.

Conversely, ideological opposition to the inclusion of religion in the study of social change has long predominated in European perspectives on social movements (Hannigan 1991, 317). In this view, religion is seen as epiphenomenal, and religious movements are regarded as withdrawals from rather than encounters with social change. While the recent revival of interest in the writing of the Italian Marxist Antonio Gramsci has generated a growing body of work that deals with the interrelationship of religion, ideology, and social class (Billings 1990; Fulton 1987; Thompson 1986), this has been the exception rather than the rule. More typically, contemporary European social theorists have continued to depict religious movements as irrelevant, describing them variously as "nostalgic" (Touraine 1981, 97-99) and "retreatist" (Offe 1985, 827).

Fortunately, there are signs that these barriers and prejudices are starting to erode. As the NSMs of the 1970s increasingly fragment into two camps—those organizations and individuals who wish to work in an entrepreneurial fashion within mainstream society versus those who prefer to explore alternative cosmologies—NSM theorists have found it necessary to pay more attention to the cultural (and often the spiritual) dimensions of movement beliefs and actions. For example, Eder's (1990) claim that "environmentalism as a belief system can transform religious

traditions and become the basis for a new religious underpinning of modern societies" is an explicit recognition of the spiritual dimension of contemporary NSMs.

At the same time, some leading sociology of religion scholars have come to recognize the importance of these new currents. The most concerted attempt to link NSM theory and religion has come from Jim Beckford in his book *Religion and Advanced Industrial Society,* where he examines the contributions of Habermas, Offe, and Touraine. While he acknowledges that these writers overtly "categorize religion as one of the traditional, communitarian and regressive forces" (1989, 162), Beckford discerns a profoundly religious quality both in some NSMs and in the work of their interpreters. Another sociologist who implicitly recognized the importance of NSM theory for the study of religion is Barbara Hargrove. She wrote that "we may be in the midst of a cultural transition as significant as the one that moved the Western world from feudalism into the commercial/industrial culture of modernity." Hargrove discovered "new maze-ways" that could lead to a "larger vision of global responsibility and economic rethinking" (1988, S33). A third linkage between NSM theory and religion can be found in the work of Roland Robertson (1985, 1989) and his colleagues. As with the proponents of NSM theory, Robertson divines something "novel" about the sociocultural changes sweeping the modern world. One important aspect of this novelty is that contemporary upsurges in religious interest and activity are occurring on an intersocietal or global scale rather than within societies. Robertson and Chirico (1985, 231-32) cite Habermas's claim that "master *moral* issues" are increasingly becoming universalized, thus superseding or transcending "societally structured and culturally interpreted roles and needs and societally prescribed and culturally stipulated duties."

New Social Movement Theory and Contemporary Religion: Interpreting the Relationships

In interpreting the interrelationships between NSM theory and contemporary religion, the analyst has two options. The first, as suggested in Beckford's discussion, is to document the religious or spiritual dimensions of NSMs. By doing so, it is possible to identify a new, parallel form of religious consciousness hovering visibly in the "networks, campaigns and movements" of advanced industrial society (Beckford

1990, 9). The second path, which I have sketched out in an article in *Sociological Analysis* (1991) and which I will develop further here, is to apply the framework of NSM theory deliberately to the sociology of religion in order to develop a new, more synthetic approach to religious movements and change.

Religious Dimensions of NSMs

As we have seen, one of the major arguments for the relevance of NSM studies to the area of religion is that NSMs clearly possess a "religious quality" (Beckford 1989, 162). This is especially evident in the cases of feminist spirituality (Finley 1991; Jacobs 1990; Neitz 1990; Robbins and Robertson 1991) and the ecology movement. Since Mary Jo Neitz discusses the growth of feminist religion elsewhere in this volume, I will concentrate my attention on the religious dimensions of the ecology movement.

In a paper given at the World Congress of Sociology in Madrid, Klaus Eder (1990), a German thinker closely associated with NSM theory, argued that modern environmentalism has the capacity to "replace socialism as the first genuinely modern form of religion."

This association between ecological movements and religion may have reached its zenith in the form of contemporary Green awareness, but it has a long prior history, especially in the United States. Albanese (1990) has identified a strain of "nature religion," which she portrays as an alternative to both institutionalized "church religion" and the more secular "republican" or "civil" religion that have dominated American life and culture. In the nineteenth century, this found expression in the writings of such New England Transcendentalists as Emerson and Thoreau, in the movements for natural health and healing (Christian physiology, medical sectarianism), and in the "personalized religion of nature" espoused by the conservationist John Muir. In this century, nature religion has found form in the Green movement, in the spirituality of North American native peoples, and in various New Age incarnations.

One of the reasons that this "countercovenant" has been overlooked by sociologists of religion is that it has lacked an identifiable organization or structure. Instead, nature religion is a "social construct" that Albanese (1990, 7-8) uses to describe a "symbolic center and the cluster of beliefs, behaviors and values that encircle it." Nonetheless, as Martin Marty points out in his prefatory remarks to her work (p. xiii), Albanese's

book is not simply about "privatized religion"; rather, nature religion also involves *patterns of collective action*. From wilderness preservation and mind cures in the nineteenth century to present-day attempts to "heal" the earth, nature religion reveals a "passionate concern for place and mastery in society" (p. 8).

The current environmental movement has increasingly fragmented into two factions, described by Eyerman and Jamison (1989, 103) as "success-orientated environmentalism," whose main concern is stopping environmentally deleterious activities, and "value-orientated environmentalism," whose main concern is effecting a change in values and ways of thinking. For the latter, the environmental movement represents a holistic revolution in both thought and action in which environmental problems require "deep" solutions. Value-orientated environmentalism takes several philosophical forms, each of which can be seen as having distinctly religious underpinnings.

Deep ecology is an ecophilosophy that stresses the fundamental interrelatedness and value of all living things. It encourages a renewed sense of harmony with Nature, even if this means that humans have to scale back their material demands and live a simpler life. The basic principle of "biocentric equality" states that all things in the biosphere have an equal right to live, blossom, and reach their individual forms of self-realization.

Bill Devall and George Sessions, two of the founding figures of the deep ecology movement, credit such medieval thinkers in the Christian tradition as St. Francis of Assisi (1181-1226) and Giordano Bruno (1548-1600) as the "source for the deep ecology perspective of organic wholeness and biocentric equality" (1985, 90). St. Francis implicitly accorded to all creatures and natural processes a value entirely separate from human interest, a conceptualization that parallels the "rights of nature" idea that is central to deep ecology. In 1980 he was named by the Vatican as the "patron saint of ecologists" (Nash 1989, 93-94).

Ecofeminism equates the suppression and domination of nature with the domination of women and encourages a more spiritual approach to the natural world. Ecofeminists refuse to accept the male relationship with creation as normative for the whole of humanity, emphasizing instead the "essential and neglected role of women and nature within the human world view" (Primavesi 1990, 355). Ecofeminism, Oates notes, is more than a political alliance between two groups promoting a com-

mon cause; rather, it is based on a mutual recognition that the "reacquisition of what have traditionally been designated feminine styles of thinking and being are the very means by which environmental sanity can be restored" (1989, 27).

Both deep ecology and ecofeminism draw sustenance from elements of what Albanese terms "nature religion." For example, the beliefs and traditions of North American indigenous peoples are important ingredients in the ideologies of radical environmentalists. Nature, Albanese tells us, "provides a language to express cosmology and belief " for native peoples (1990, 155-56). Deep ecologists and other environmental fundamentalists have not hesitated to learn this language in their quest for a new ecological consciousness.

Nature religion has thrived not only on the margins (or perhaps the cutting edge) of secular environmentalism but also as part of the "religious environmentalism" that is growing within mainstream Christian denominations. Of particular note is the formulation of "creation-centered spirituality," especially in the Catholic theologians Matthew Fox and Thomas Berry.

Many of the principles of this creation-centered spirituality are coterminous with those of deep ecology. For example, the role of humans is diminished and put in its "proper perspective." Berry (1988) teaches that each of God's creatures does a single thing best; for birds it is flying, for fish it is swimming, for humans it is conscious self-reflection. Humans must use their unique talents to restore the earth to its natural balance. Central to this effort is the establishment of a new kind of economy situated in natural "bio-regions," where technologies must harmonize with nature (Hope and Young 1989, 752). Charlene Spretnak, a founding member of the Green movement in the United States, has assigned a crucial role to these creation-centered ideas; they are, she claims, the core of a postmodern religious theology that can anchor a collective attempt to restore rootedness in the cosmos and meaning in contemporary life (1988, 36-37).

One can see that the breadth and strength of the linkages between value-oriented environmentalism and nature religion are quite impressive. This common ground is both the site for Hargrove's (1988) "new mazeways" and for Beckford's (1990, 9) new spirituality that "favors synoptic, holistic and global perspectives on issues transcending the privatized self and the individual state."

NSM Theory as an Interpretive Paradigm
for Religious Movements and Change

NSM theory is important not only for alerting researchers to the existence of a new sacred-secular form of global religion; it also represents an innovative tool for the analysis of religious movements, present and future.

In applying NSM theory to contemporary religion, I have chosen to adapt the "cultural" or "constructivist" version, specifically the model of collective action as a social construction proposed by the Italian theorist Alberto Melucci. This approach in many ways resembles more recent versions of the "emergence" theory of collective behavior and social movements, as outlined by Turner and Killian, although each was developed independently from the other.

Melucci thinks that the NSM paradigm has been misconstrued by both advocates and critics. Both make historical uniqueness the acid test of the theory. And both suffer from a "myopia of the visible" that focuses attention on the measurable aspects of collective action, notably confrontation with the political system and effects on policies, while ignoring the more submerged but equally important production of new "cultural codes" (1988, 337). To Melucci, the core of a theory of the new movements is in understanding the process of constructing an action system that he terms "collective identity." As a process collective identity involves three interwoven dimensions: (1) formulating cognitive frameworks concerning the ends, means, and field of action (e.g., environment); (2) activating relationships among the actors, who interact, communicate, influence each other, negotiate, and make decisions; and (3) making emotional investments that enable individuals to recognize themselves. Melucci's conceptualization of collective identity is an attempt to synthesize action theory with the insights of the resource mobilization approach. Leadership and organizational structure are depicted as "attempts to give a more durable and predictable order" to emergent attempts at collective definition and redefinition; these attempts, in turn, are constrained by environmental factors that create differential access to identity resources (1988, 343).

Melucci's interpretation is particularly well suited for application to the sociology of religion. Unlike some versions of NSM theory, it does not presuppose that the movements under analysis are necessarily left-leaning and secular. Nor does Melucci insist on the presence of visible political protest; to the contrary, he decries "political reduction-

ism," while he emphasizes the importance of the social and cultural aspects of contemporary collective action.

Throughout most of human history, two systems of theology have confronted one another. With the "theology of authority," religion claims external authority as an extrahuman truth, a tutelage that humans must receive with docility. By contrast, the "theology of experience" conceives religion as "an inner inspiration upspringing in human consciences that have been tilled and sown by the divine Spirit" (Sabbatier 1904, vii). While radically different in outlook, neither form has been particularly open to the type of negotiation of identity by collective actors that Melucci emphasizes. Both systems are closed to this interactive process by virtue of the domination of a "normative style of interaction."

While sharing elements of the two traditional systems of theology, the "new religious consciousness" (Glock and Bellah 1976) of the past quarter-century has generally been more compatible with the emergent, interactive style described by Melucci. Rose (1987), for example, has noted how even within the confines of the traditional, male-dominated, hierarchical relationships of a charismatic community, the women of the Covenant fellowship actively negotiated certain aspects of their gender relationships. Similarly, Thumma (1991) has examined the process by which members of Good News, an Atlanta gay evangelical group, have reconstructed their religious identities to include a positive valuation of homosexuality.

Rochford (1989) has described the efforts of Kirton Hall, a small group of defectors from ISKCON, to work out in democratic fashion a new form of fellowship and worship within the Hare Krishna movement. Rochford observed these discussions to be "wide ranging and accepting in tone rather than dogmatic." Frequently members sought collectively to gauge the appropriate limits of "dovetailing," a form of ideological work that attempted to reconcile everyday activity and religious belief.

Finally, although it possessed a clear and universally recognized hierarchy, Gelber and Cook (1990) found that Creative Initiative, a middle-class "proto-sect" that was active in California in the 1960s and 1970s, had a collective dynamic that allowed a fairly high degree of introspection. The movement prided itself on its flexibility and willingness to change form and structure. Creative Initiative, which actually began as a Bible study group, evolved from a tightly controlled quasi-sect, called the Sequoia Seminar, into an open-structured New Age-style

movement and ultimately dissolved into a secularized peace movement called Beyond War. Despite certain dogmatic tendencies, the group (or at least its leadership cadre) engaged in a variety of exercises in collective identity building, from brainstorming sessions to generate new projects, to "econolusion" discussions to work out the role of economics in the movement.

According to Melucci, this collective negotiation of identity takes place in a system of constraints and opportunities that emanate from the field of action or environment of the movement. *Constraints* indicate the amount of resistance faced by the movement. The notion of *opportunities* comprises more than the absence of resistance; it also refers to the positive possibilities for action inherent in the societal structure and culture conditioning the social movement (d'Anjou 1990, 18-19).

In the case of Kirton Hall, what Melucci (1988, 333) terms a "failure or break in the constructive process" occurred because the group was unable to resolve the tension among the three vectors of the multipolar action system of the collective actors (i.e., ends, means, environment). The group functioned in an environment with limited opportunity structures. It was difficult to recruit externally because the reputation of the Hare Krishnas as a cult carried over to the Kirton Hall group. Ex-ISKCON members expressed resistance to joining another religious organization. Potential defectors opted to wait and see, and hope for internal reform. The democratic structure of the group helped ensure that a central charismatic figure would not emerge. Collective action eventually stalled because members of the group did not have the capacity to define both themselves and their relationships with the movement. What was lacking, then, was high "mobilization potential" (Klandermans 1986), which Melucci conceives as "an interactive and negotiated perception of action opportunities and constraints" (1988, 339).

By contrast, the Creative Initiative movement was more successful at resolving the continual tension that can exist in an action field between and among ends, means, and external relationships. For example, the movement managed to align its inclusive, egalitarian rhetoric with its elitist membership criteria by celebrating the special qualities of a creative minority while at the same time providing them with an opportunity to remake the world for everybody (Gelber and Cook 1990, 228). In the 1980s the collectivity was able to renew itself and attract large numbers of new recruits by shifting from a tightly controlled, religiously oriented quasi-sect to an open-structured, secularized group working for peace. It achieved this without provoking schismogenesis by retain-

ing many of the ideological principles first established in its days as a Bible study group but refashioning these in a secular format.

These relationships between and among ends, means, and environmental fields can, of course, be analytically described using other paradigms, notably resource mobilization theory. The advantage of adopting Melucci's social constructivist paradigm is its emphasis on collective action as a purposive orientation. In each of these examples—Covenant Fellowship, Good News, Kirton Hall, and Creative Initiative—movement members have not blindly followed a fixed set of rules and rituals; rather, they have collectively negotiated aspects of both their own identity and their relationship to the environment (other actors, available resources, opportunities, and obstacles).

Although it is more politically circumscribed, the same emergent quality of social action can be seen in Alain Touraine's (1981, 1983) theoretical schema in which he depicts a social movement as engaged in a constant quest to define fully its identity, totality (scope of its challenge), and opposition. Similarly, Eyerman and Jamison (1990) argue that social movements are the result of an interactional process that centers around the articulation of a collective identity and occurs within the boundaries of a particular society. In their characterization, the core of the collective action process in a movement involves the joint production of knowledge. (They use the rather idiosyncratic phrase "cognitive praxis" to identify this.)

New Social Movements are at the center of this "sociology of action" approach because they are especially open to collective negotiation and renegotiation by virtue of their flexible structures and innovative action repertoires. However, as we have seen, this constructivist paradigm can also be applied fruitfully to selected religious movements and organizations whose structure and ideology allow for a measure of creative participation, especially at the grass-roots level.

Research Agenda

In this chapter, I have argued that New Social Movement theory can play a significant role in the impending renewal in the sociology of religion. As the "new" movements of the past 20 years rapidly fragment, one part has increasingly become preoccupied with spiritual matters. As a result, the traditional lines between religious and sociopolitical movements have begun to blur. The global conjunction of sacred and

secular concerns requires the formulation of new theoretical perspectives that are capable of capturing the meaning and dynamics of these new parallel forms of religious consciousness. One possibility worth further exploration is the development of a "social construction" model of new movements that stresses the collective articulation of new grievances, identities, and forms of association.

In considering the contribution of NSM theory to a theoretical renewal in the sociology of religion, three specific research tasks can be isolated: (1) identifying and conceptualizing, (2) typologizing, and (3) operationalizing.

Identifying and Conceptualizing

With this first task, it is necessary to identify both the sources of the "new" movements and their distinguishing characteristics.

As we have seen, past discussions have typified NSMs according to four categories of shared characteristics: goals, action forms, support bases, and values. However, Tarrow (1988, 282-85) has argued that the confrontational tactics, new themes, and decentralized organizations that characterize the new movements are more likely to be a property of the environment in which they arise than of their themes, logics, or actors. To support this contention, he demonstrates that collective mobilizations among Italian Catholics in the 1960s and 1970s had much in common with the NSMs of the same period. In the course of their confrontations with church hierarchies, they were "renewed, radicalized and de-institutionalized" in ways that resembled the new movements. If this is correct, then we need to know what types of environments provide an optimal climate for collective action of the type found in both NSMs and in the episodes of Catholic protest and dissent that Tarrow describes. Tarrow's theory holds that collective actors will generate a social movement only where political opportunity is linked to both solidarity and confrontation with unjust authority. Are these the only salient conditions? What about the construction of collective identity that is central to Melucci's paradigm? Can this be subsumed under "solidarity," or is it an important missing component?

Elsewhere (Hannigan 1991), I have identified three processes—contestation, globalization, and empowerment—as being characteristic of contemporary movements: *Contestation* refers to a collective attempt to control those fields of experience where private life is becoming public. *Globalization* is a process whereby the field for new ideologies,

conflicts, and movements is transnational in nature. *Empowerment* describes the perception by movement participants that they have the power to influence their futures through collective action. One advantage of this approach is that it extends the analysis of new movements to groups that would otherwise be excluded from an application of NSM theory. While it is linked to structural trends such as those described by Robertson and Chirico, it does not depend on the proclamation of a new revolution in values or the identification of a "new class," as is the case with existing definitions.

Reworking the criteria for new movements also opens the possibility of applying the theory retroactively to movements of the past. For example, one could argue that, despite its experiential theology, the "evangelical movement" of the nineteenth century shares many characteristics with the "new" movements of the present era. Although they were more reformist than transformationalist, still the evangelicals did attempt to "reconstruct social and economic relations upon a Christian pattern" (White and Hopkins 1976, 6). With their emphasis on international missionary work, their challenge was global, even if their organizational structure followed national lines. One has only to read the evangelical literature of the day to sense the collective experience of power that evangelicals felt in their "frontal assault on virtually every prevailing assumption and habit of their time and their replacement by the principles and practices of vital Christianity" (Bradley 1976, 32).

As D'Anieri et al. (1990) have demonstrated, analyzing cases such as this, which vary both in historical setting and internal dynamics, can help to sharpen our understanding of what constitutes a "new" movement and under what conditions such movements emerge. A comparative historical analysis is of particular interest where movements recur from century to century with similar value themes and societal critiques. Is there any correspondence, one wonders, between Brand's (1990) model of "mobilization cycles" and the four "great awakenings" in American religious history?

Typologizing

In the past, most attempts to classify social movements have sloughed off sects, cults, and messianic-millennial movements into the category of "expressive" movements where "tension" is directed, managed, or drained off internally (Blumer 1951; Park 1967; Smelser 1962). In doing so, mainstream sociology has tended to marginalize religious

movements and to delegitimate them as a topic for serious study (Hannigan 1991).

By shifting the central thrust of analysis to the process of collective reformulation, the way is opened to the generation of fresh typologies of social and religious movements. These should arise from a consistent body of theory (Wilson 1973, 15), fully clarifying the theoretical background of the typology, its criteria of classification, and its consequences for movement organizations and activities (Rucht 1988, 319). New social and religious movements could, for example, be typified on the basis of the *source* of the emergent collective identities (indigenous or ascriptive identities, such as gender, race, and ethnicity, versus identities that may result from the production of collective knowledge by movement actors). Movements could also be distinguished on the basis of the *scope* of collective identity formulation—those whose identity is pegged to a specific geographical region or nation versus those whose identities have been articulated on a transsocietal or global scale. Furthermore, the collective collaborations of movement actors could be broken down into three types of activities—the collective articulation of grievances, the construction of new identities, and the innovation of new forms of association. These are only a few suggestions, but I hope they will convey the possibilities available when the sociological analyst is willing to move away from traditional dichotomies (institutional versus noninstitutional, expressive versus political, inward directed versus outward directed) and formulate instead typologies that derive from the process of collective reformulation within the social or religious movement.

Operationalizing

One barrier to further advances in NSM theory has been the failure to operationalize many of its hallmark concepts and processes (i.e., civil society, reflexivity, communicative action, historicity, and so on). In particular, there are very few linkages between the macrostructural NSM approaches and the more cultural or action-oriented versions. This, in fact, reflects the larger failure of social movement scholars to build intermediate theoretical bridges that would join macro-level observations to micro-level variables (McAdam, McCarthy, and Zald 1988).

Sociologists of religion are well placed to help address this problem. One by-product of the surging interest in NRMs since the 1960s has been the "anthropologizing" of the sociology of religion (Robbins 1988a,

14). While this has sometimes led to controversies (e.g., claims about the brainwashing of cult devotees) of more interest to religious researchers and their subjects than to social movement research in general, it has also provided a wealth of field data on the social psychology of collective action in emergent groups.

Future researchers can build on this approach in two ways. First, it should be possible to go back and reanalyze existing NRM data from the vantage point of a social construction model of new movements, such as that suggested by Melucci. This material is undoubtedly rich in firsthand accounts of identity building, culture creation, and empowerment. Second, the methodological expertise developed in the NRM field studies of the 1970s and 1980s might be fruitfully applied to the spiritually charged NSMs of the 1990s. Already, there is evidence that researchers are turning to movements (neopagans, New Agers) on the edge of NSM concerns. This interest could be extended to ecofeminists, spiritual ecologists, and others who have learned the language of "nature religion" as part of their challenge to existing institutions and values. This is not to say that every exotic group professing some form of "eco-religion" needs to be as fully (some might say excessively) documented as sometimes has seemed to be the case with NRMs. Nevertheless, insofar as this trend toward the "spiritualization" of NSMs is judged to be endemic, if not epidemic, it would seem to be important to link empirical details about them with existing theoretical insights and models.

References

Albanese, C. L. 1990. *Nature religion in America*. Chicago: University of Chicago Press.

Alberoni, F. 1984. *Movement and institution*. New York: Columbia University Press.

Beckford, J. A. 1985. The insulation and isolation of the sociology of religion. *Sociological Analysis* 46: 347-54.

———. 1989. *Religion and advanced industrial society*. London: Unwin Hyman.

———. 1990. The sociology of religion and social problems. *Sociological Analysis* 51: 1-14.

Berry, T. 1988. *The dream of the earth*. San Francisco: Sierra Club.

Billings, D. 1990. Religion as opposition. *American Journal of Sociology* 96: 1-31.

Blumer, H. 1951. Social movements. In *New outlines of the principles of sociology*, edited by A. M. Lee, 199-220. New York: Barnes & Noble.

Bradley, I. 1976. *The call to seriousness*. London: Jonathan Cape.

Brand, K. 1990. Cyclical aspects of new social movements. In *Challenging the political order*, edited by R. Dalton and M. Kuechler, 24-42. Cambridge: Polity Press.

Bromley, D., and A. Shupe, Jr. 1979. *The Moonies in America*. Beverly Hills, CA: Sage.

————. 1980. Financing the new religions. *Journal for the Scientific Study of Religion* 19: 227-39.

Dalton, R., and M. Kuechler, eds. 1990. *Challenging the political order.* Cambridge: Polity Press.

D'Anieri, P., C. Ernst, and E. Kier. 1990. New social movements in historical perspective. *Comparative Politics* 22: 445-58.

d'Anjou, L. 1990. *Social movements and collective definitions of the situation.* Paper presented at the XIIth World Congress of Sociology, Madrid.

Davidson, J. 1985. *Mobilizing social movement organizations.* Storrs, CT: Society for the Scientific Study of Religion.

Devall, B., and G. Sessions. 1985. *Deep ecology.* Salt Lake City: Peregrine Smith.

Eder, K. 1985. The "new social movements." *Social Research* 52: 869-90.

————. 1990. Environmentalism. Paper presented at the XIIth World Congress of Sociology, Madrid.

Eyerman, R., and A. Jamison. 1989. Environmental knowledge as an organizational weapon. *Social Science Information* 28: 99-119.

————. 1990. *Social movements.* University Park: Pennsylvania State University Press.

Finley, N. 1991. Political activism and feminist spirituality. *Sociological Analysis* 52: 349-62.

Fulton, J. 1987. Religion and politics in Gramsci. *Sociological Analysis* 48: 197-216.

Gelber S., and M. Cook. 1990. *Saving the earth.* Berkeley: University of California Press.

Glock, C., and R. Bellah, eds. 1976. *The new religious consciousness.* Berkeley: University of California Press.

Habermas, J. 1984. *The theory of communicative action,* vol. 1. Boston: Beacon.

————. 1987. *The theory of communicative action,* vol. 2. Boston: Beacon.

Hannigan, J. A. 1990. Apples and oranges or varieties of the same fruit? *Review of Religious Research* 31: 246-58.

————. 1991. Social movement theory and the sociology of religion. *Sociological Analysis* 52: 311-31.

Hargrove, B. 1988. Religion, development, and changing paradigms. *Sociological Analysis* 49: S33-48.

Hope, M., and J. Young. 1989. Thomas Berry and a new creation story. *Christian Century* 106: 750-53.

Jacobs, J. 1990. Women centered healing rites. In *In gods we trust,* 2nd ed., edited by T. Robbins and D. Anthony, 373-84. New Brunswick, NJ: Transaction.

Kent, S. 1987. Puritan radicalism and the "new" religious organization. *Comparative Social Research* 10: 3-46.

Khalsa, K. 1986. New religious movements turn to worldly success. *Journal for the Scientific Study of Religion* 25: 233-47.

Klandermans, B. 1984. Mobilization and participation. *American Sociological Review* 49: 583-600.

————. 1986. New social movements and resource mobilization. *International Journal of Mass Emergencies and Disasters* 4: 13-37.

Klandermans, B., and S. Tarrow. 1988. Mobilization into social movements. In *From structure to action,* edited by B. Klandermans, H. Kriesi, and S. Tarrow, 1-38. Greenwich, CT: JAI Press.

McAdam, D., J. McCarthy, and M. Zald. 1988. Social movements. In *Handbook of sociology,* edited by N. J. Smelser, 695-737. Newbury Park, CA: Sage.

Melucci, A. 1985. The symbolic challenge of contemporary movements. *Social Research* 52: 789-816.

———. 1988. Getting involved. In *From structure to action,* edited by B. Klandermans, H. Kriesi, and S. Tarrow, 329-48. Greenwich, CT: JAI Press.

———. 1989. *Nomads of the present.* Philadelphia: Temple University Press.

Nash, R. 1989. *The rights of nature.* Madison: University of Wisconsin Press.

Neitz, M. J. 1990. In goddess we trust. In *In gods we trust,* 2nd ed., edited by T. Robbins and D. Anthony, 353-72. New Brunswick, NJ: Transaction.

Oates, D. 1989. *Earth rising.* Corvallis: Oregon State University Press.

Offe, C. 1985. New social movements. *Social Research* 52: 817-68.

Park, R. 1967. *On social control and collective behavior.* Chicago: University of Chicago Press.

Primavesi, A. 1990. The part or the whole? *Theology* 43: 355-62.

Robbins, T. 1988a. The transformative impact of the study of new religions on the sociology of religion. *Journal for the Scientific Study of Religion* 27: 12-31.

———. 1988b. *Cults, converts and charisma.* London: Sage.

Robbins, T., and R. Robertson. 1991. Studying religion today. *Religion* 21: 319-37.

Robertson, R. 1985. The sacred and the world system. In *The sacred in a secular age,* edited by P. Hammond, 347-58. Berkeley: University of California Press.

———. 1989. Globalization, politics and religion. In *The changing face of religion,* edited by J. Beckford and T. Luckmann, 10-23. London: Sage.

Robertson, R., and J. A. Chirico. 1985. Humanity, globalization and worldwide religious resurgence. *Sociological Analysis* 46: 219-42.

Rochford, E. B., Jr. 1989. Factionalism, group defection and schism in the Hare Krishna movement. *Journal for the Scientific Study of Religion* 28: 162-79.

Rose, S. 1987. Women warriors. *Sociological Analysis* 48: 245-58.

Rucht, D. 1988. Themes, logics and arenas of social movements. In *From structure to action,* edited by B. Klandermans, H. Kriesi, and S. Tarrow, 305-28. Greenwich, CT: JAI Press.

Sabbatier, A. 1904. *Religions of authority and the religion of the spirit.* New York: Hodder & Stoughton.

Smelser, N. 1962. *Theory of collective behavior.* New York: Free Press.

Spretnak, C. 1988. Postmodern directions. In *Spirituality and society,* edited by D. R. Griffin, 33-40. Albany: State University of New York Press.

Tarrow, S. 1988. Old movements in new cycles of protest. In *From structure to action,* edited by B. Klandermans, H. Kriesi, and S. Tarrow, 281-304. Greenwich, CT: JAI Press.

———. 1990. The phantom at the opera. In *Challenging the political order,* edited by R. Dalton and M. Kuechler, 251-73. Cambridge: Polity Press.

Thompson, K. 1986. *Beliefs and ideology.* Chichester, UK: Ellis Horwood.

Thumma, S. 1991. Negotiating a religious identity. *Sociological Analysis* 52: 333-47.

Touraine, A. 1981. *The voice and the eye.* Cambridge, UK: Cambridge University Press.

———. 1983. *Anti-nuclear protest.* Cambridge, UK: Cambridge University Press.

———. 1985. An introduction to the study of social movements. *Social Research* 52: 749-87.

Turner, B. 1983. *Religion and social theory.* London: Heinemann.

White, R. C., Jr., and C. H. Hopkins. 1976. *The social gospel.* Philadelphia: Temple University Press.

Wilson, J. 1973. *Introduction to social movements.* New York: Basic Books.

2

Global Fundamentalism

FRANK J. LECHNER

Fundamentalism is fashionable—as a problem for social analysis more than as a form of religious faith and activism. To be sure, the reemergence of a certain kind of religious traditionalism in the public arenas of some countries was sufficiently surprising to justify a major scholarly effort to account for it. For Western scholars, the puzzle to be solved went beyond the apparent influence and success of some seemingly archaic cultural movements. The very way in which those labeled "fundamentalist" tried to bring a sacred tradition to bear on the public affairs of their societies compelled scholars to reexamine their assumptions about the "normal" role of religion in modern societies and about the continued viability of religious traditions themselves. By virtue of its public character, fundamentalism seemed to point to a different future for religion from what many scholars had assumed.

Since that is a matter of concern to more than just religion experts, the fashion is understandable. But as my opening sentence hinted, the great attention given to fundamentalism in social analysis should not mislead us into thinking that fundamentalism itself constitutes a long-lasting, worldwide wave of religious activism that will significantly reshape the societies in which it occurs as well as world culture at large. Indeed, careful perusal of recent scholarship on fundamentalism suggests that the life chances and likely influence of fundamentalist movements are determined by a number of limiting circumstances. In specific circumstances, neotraditionalist religiosity can flourish and become

publicly influential, but the experience of fundamentalist movements does not portend a brighter future for religion in general.

Lest I represent the research on fundamentalism as a closed program that provides answers to all questions, I hasten to add that social analysis in this area is very much an open and evolving enterprise that has as yet produced relatively few firm conclusions. In part, the openness stems from the fact that fundamentalism can be defined and approached in different ways. In addition, while scholars have made strides in debunking various misconceptions about fundamentalism, the picture is by no means complete. The comparative work on fundamentalism in different contexts has just begun; efforts to interpret fundamentalism as a global phenomenon with global ramifications are also in their infancy. Rather than as a source of intellectual frustration, this incompleteness should be taken as an incentive to extend the study of fundamentalism beyond the stage of fashion. Ideally the following selective overview of relevant aspects of social analyses of fundamentalism will convey both lessons learned and things to be done.

Problems of Definition

Modern, secular scholars often learn to practice a kind of methodological atheism, bracketing the very question of the "truth" of the beliefs and traditions they investigate. Religion in its various forms can then be studied like anything else, regardless of the actual values of the observer. At the same time, these scholars also often feel duty-bound to understand the other in his or her particularity, to engage in *Verstehen,* to do justice to the point of view of the actors under study. In the case of fundamentalism, these impulses have given rise to at least three types of definitions.

The simplest of these is the attempt to limit the meaning of fundamentalism to whatever the "people themselves" mean by it. This subjective definition of course has the virtue of concreteness. In the American context, for example, it enables us to identify as fundamentalist either, narrowly speaking, those who identify themselves as such or, more broadly, those who profess adherence to certain fundamentals of Protestant Christianity. Fundamentalists are theologically conservative "Bible believers" (Ammerman 1987), who among other things, consider Scripture inerrant and literally true (see Marsden 1980). The subjective definition enables us as well to make distinctions—in the American

case, again, most notably between "fundamentalists" and "evangelicals"—that presumably have real consequences, if only because the actors define their situation in these terms (see Ammerman 1982).

This approach suffers from limitations, however. First, in some societies the very category of "fundamentalism" is or was not available, which would make its scholarly use appear to be an imposition. Such impositions, though perhaps inevitable, are troubling to subjectivists and of course may arouse the resistance of the subjects themselves. Second, only some of "the people" under study would claim the label for themselves, so that strict use of the subjective definition tends to make "true" fundamentalism a fringe phenomenon from the start. This sacrifices scope for depth. Third, at least in principle, subjectivism also limits the kinds of questions to be asked about fundamentalism to those that fit with the actors' point of view, rather than making that very view (e.g., inerrancy and literalism) problematic in the first place. Finally, adopting a subjective definition presupposes that there is such a thing as *the* actors' point of view. In fact, however, that point of view has become widely and deeply contaminated by the public discourse on fundamentalism; many of those who vigorously support either Protestant or Islamic "fundamentals" have learned that fundamentalism is a dangerous label, a global stigma applied by the very groups they oppose —and so they shun at least the term, if not its conventional connotations. Not only that, but the involvement of subjectively identified fundamentalists with the forces they oppose (see below) means that there is no such thing as a clean version of fundamentalism "out there" that is both subjectively meaningful and open to objective interpretation.

A second type of definition is specifically interested in the renewed use of religious symbols for what actors claim to be "conservative" political purposes. This is the sociohistorical view of fundamentalism, proposed by Arjomand (1984) and adopted by others such as Riesebrodt (1990) as radical neotraditionalism. Here the point of view of historical actors is not taken for granted; rather, the imposition implied by "neo" is deliberate. The focus is also on public action rather than private belief, on the consequences rather than the substance of religion. As a basis for comparative study, this view serves well indeed. Yet it pays a price by distancing itself somewhat from the lived experience of groups to be studied. With little more guidance than a general appeal to "history," it leaves answers about the rise of neotraditionalism to be found inductively. And it provides few resources to decide how radical or revolutionary and how new traditionalist activism is.

A third type of definition derives from a more theoretical stance. In previous publications I have suggested that we can regard fundamentalism as one type of antimodernism, one form of value-oriented dedifferentiation (Lechner 1985, 1989, 1990, 1991). Fundamentalists, in this view, are those engaged in reintegrating a social order under the canopy of one all-encompassing sacred tradition. The benefit of this analytical or generic approach to fundamentalism is that it enables us to ask many questions the subjective approach might preclude. Relying on a bit of sociological theory borrowed mainly from Talcott Parsons (1971), it suggests how social action of this kind would typically proceed. It helps to open fundamentalism to general sociological inquiry focused on the fate and future of modernity, and it provides a framework for the systematic analysis of different kinds of dedifferentiation. The main drawback is that actors might not recognize themselves in their analytical portraits. While generic fundamentalism is meant to be inclusive, it tends to limit use of the term to cases of dramatic public action. And like the subjective definition, the analytical one does not address the way in which the term has become part of the syndrome under study. It can help to illuminate aspects of collective action; it cannot account for the variable uses of fundamentalism.

These definitions are not mutually exclusive, in the sense that arguments based on one need not be unacceptable to proponents of another definition. Each has different purposes—to foster detailed ethnography, systematic comparison, and theoretical interpretation, respectively. In practice, all three styles are evident in the literature, and many scholars combine elements of all three approaches. While the problems addressed by different approaches vary, there is sufficient overlap in actual groups and movements studied to allow us to treat fundamentalism as if everyone really were talking about the same thing.

Trends in Social Analysis.

The main substantive trend in social analyses of fundamentalism, Christian and Islamic above all, is the emergence of an account of the rise and public role of fundamentalism that effectively debunks conventional misconceptions on the subject. Let me first sketch the latter, running the risk of stereotyping the stereotypers. Fundamentalism, convention has it, is an archaic form of religiosity. It is the unshaken faith of the culturally backward who, though largely unaffected by the mod-

ern world, nevertheless seek to bring about a moral cleansing of societies that, in their view, have lost their traditional bearings. Where a sense of crisis and uncertainty prevails, fundamentalists are the ones offering certainty and all-encompassing solutions. In periods of rapid social change, such movements become widespread and influential. However modern the means they use, their purpose is fundamentally antimodern. For liberal modernists, they represent a real threat.

But is fundamentalism archaic? It may look that way to those who think cultural certainty is something not to be achieved in this world. Yet many of the themes in fundamentalist thought derive from recent intellectual developments, as Marsden (1980) has shown for American fundamentalists, who shared both individualist premises and a post-Newtonian common-sense philosophy with other religious groups. Adhering to tradition is different from traditionalism, a deliberate effort to regenerate tradition and make it socially significant again. The latter is a form of engagement with the modern world. In fact, the activist thrust of fundamentalists involves important changes in the tradition they claim to represent; their traditionalism is in some ways bound to be "revolutionary" (Arjomand 1984, 1988), as the actions taken by the Ayatollah Khomeini in merging political and religious leadership demonstrate (see Kimmel 1992).

But is fundamentalism nevertheless religious activism of the culturally backward? Few present-day fundamentalists can claim economic, political, or cultural elite status; their still noticeable class disadvantage has even inspired explanations of fundamentalism in terms of status anxiety or class warfare against a new "knowledge class" (see Hunter 1983). Yet current impressions can easily mislead. For example, it is now well known that early American fundamentalist leaders were by and large highly educated urbanites, several from elite institutions. In Iran, students and merchants played a crucial role in the Islamic Revolution (Arjomand 1988; Parsa 1989; Riesebrodt 1990). In Egypt, disaffected university-trained people are a core constituency of fundamentalist groups (Kepel 1985). In fact, as Ammerman (1991) has indicated, those experiencing a kind of social transition from one setting to another, moving into closer contact with "modernity," are more likely to respond to this in a fundamentalist fashion. Backwardness is to fundamentalism as poverty is to class consciousness: neither a necessary nor a sufficient condition.

Turning to substance: Are fundamentalists antimodern in their worldview? If one adopts the theoretical stance alluded to above, this is simply

a matter of definition: Fundamentalists are antimodern insofar as they engage in value-oriented dedifferentiation. Does this fit with what "ordinary" fundamentalists are trying to accomplish? To some extent it does: The opposition to the evils of modernity is real; a plural and inclusive world is to be replaced by a highly integrated and closed one. The sacred canopy must be restored. Yet the antimodernism of fundamentalists is deeply problematic. In part this stems from the ways in which even self-styled fundamentalists are implicated in the culture of modernity. American fundamentalists, for example, come from a tradition that used to value religious pluralism and separation of church and state; the differentiating rationality of modern times is by no means alien to them.

Obviously the fundamentalist predicament stems from the pressures to which any kind of antimodernism is exposed in minimally liberal modern societies—and even in those that are less than liberal but have to function in a liberalizing world system. Modernity is a corrosive force, in part by making religious traditions less and less significant in social affairs, in part by making the very idea of a return to certainty and homogeneity implausible. With few exceptions, fundamentalists wanting to make a case for change must appeal to modern principles for legitimation; in the process the radical implications of the fundamentalist stance are moderated. This means that the certainty offered by fundamentalist leaders is at best a temporary solution. Not only does fundamentalism have its origins in a sense of uncertainty, of a tradition under siege, but also the envisioned center cannot hold. Applying a presumably old tradition to a host of profoundly new problems invariably rekindles dilemmas the fundamentalist project intended to resolve.

As a result, the influence of fundamentalism is also easily overstated. In fact, in any recognizably full-fledged form it is a rare phenomenon. Even where conditions seem fertile, often only small minorities of potential activists become deeply involved in public action. The influence of fundamentalism is limited, at the very least, by the "cognitive bargaining" with modernity (Hunter 1983) in which fundamentalists must engage. Beyond this general limitation, there are many local conditions that determine the fortunes of fundamentalist efforts. Sometimes, of course, these conditions help to make fundamentalists flourish and gain great influence; the Islamic Republic of Iran in the 1980s is the prototypical (but still exceptional) case. The main research question thus becomes how to account for variations in those fortunes—in the strength and relative influence of fundamentalist movements in differ-

ent contexts. Recent comparative work has begun to address that problem.

Comparisons

Although some scholars have tried to identify fundamentalist strains in traditions other than Christianity, Islam, and Judaism, most of the scholarly attention in the field has focused on these traditions, and for good reason. After all, they take a distinctive interest in shaping the world according to a religious vision and can rely on *textual* fundamentals in doing so. However, even in these traditions fundamentalist "eruptions" are relatively rare. The question becomes under what conditions they occur. The answers provided thus far depend in part on the particular view of fundamentalism researchers adopt.

Probably the most ambitious work to date is that of Bruce Lawrence (1989). He views fundamentalism, as I do, in the context of a struggle with modernism and modernity (which he treats in a slightly more truncated fashion than I). In accounting for fundamentalism, the impact of the Great Western Transformation always must come first. Though the variant force of this impact explains the emergence of fundamentalism in the form of self-conscious groups, it is a necessary, not a sufficient condition. To clarify the active "defense of God" from the inside, Lawrence further examines how actors bring the resources of their tradition, symbolic and otherwise, to bear on problems they encounter. When those resources include precedent for sectarian action and a scripture that can serve as script, fundamentalist modes of dealing with social crisis become more likely. In particular instances, fundamentalism is also fueled by doctrinal debates (such as those in America over millennialism and evolutionism) that may have little societal relevance. When this symbolic "fuel" mixes with the structural inequities prevalent in countries that experience modernization as a relatively alien imposition, fundamentalism becomes a plausible vehicle for resistance.

Riesebrodt (1990) follows Lawrence in part, but takes his comparative analysis in a slightly different direction. He conceptualizes fundamentalism as one kind of radically traditionalist movement, which typically has its origin not so much in a grand ideological struggle between modernity and tradition, but rather in the increasing inability of traditional cultural milieux to reproduce themselves under modern, and specifically urban, conditions. Central to this reproduction, he

claims, is an overriding concern with maintaining or restoring a solid patriarchal structure. Finding variations on this general theme becomes a matter of identifying the factors aiding in the mobilization of protest movements that hark back to an original community, albeit for highly contemporary purposes. In the case of turn-of-the-century American fundamentalism, he emphasizes both internal stimuli, such as the resistance against church bureaucratization, and external conditions, such as the sociocultural differentiation of major cities. In the case of Iran, he highlights not only the impact of modernizing structural change in society at large, but also such factors as the actual threat from state action experienced by traditional milieux and the pervasive influence of new, Western cultural conceptions.

In my own work, I have tried to incorporate variables similar to those employed by Lawrence and Riesebrodt, but focusing comparisons more clearly on an analytically derived question. My approach is like that of Lawrence insofar as I treat fundamentalism, by definitional choice, as a form of antimodernism, characterized by value-oriented dedifferentiation aimed at restoring meaningful order on the basis of a sacred tradition. In line with a long tradition of sociological reflection, I treat modernity more broadly than Lawrence as a specific, relatively young form of social order, characterized by structural differentiation, cultural pluralism, social inclusion, and world mastery. For Lawrence and for me, the point of starting from a notion of antimodernism is to show precisely the many ways in which fundamentalism is implicated in and coopted by the culture it opposes. Like Riesebrodt, I am interested in systematic sociological analysis of variations. While agreeing with many of the "mobilization factors" he adduces, I treat the relevant variables in a slightly more abstract form and regard the patriarchal thrust of some fundamentalist movements as, at most, part of a larger pattern. Relying on the now extensive literature, I have elsewhere (1991, 110) suggested the following pattern: Religious movements are more likely to become a significant fundamentalist force in a society if they have at their disposal a tradition that can be easily interpreted as legitimation for dedifferentiation, if modernizing change represents a special problem for religiously constituted groups, if a fundamentalist program is the most effective and most plausible way to define and resolve multiple discontents, if there are historic precedents in the society for religious attempts at significant social change, if the society in question is not culturally pluralistic or socially differentiated to begin with, and if the main concerns of an emerging fundamentalist movement cannot be

channeled or deflected by existing institutions (a factor particularly lacking in Riesebrodt's scheme). Tracing this pattern in different times and places shows not only how fundamentalist movements can emerge, but also why in most cases their influence is severely circumscribed (see Lechner 1990). What such an exercise cannot accomplish, however, is to place fundamentalism in the context that has come to matter most, namely the global one; yet scholars have begun to analyze fundamentalism from a distinctively global point of view.

Global Perspectives

The "global turn" in sociology consists of sustained efforts by a number of researchers over the past few decades to treat the world as a social system in its own right. These efforts were obviously inspired by the simple realization that societies were becoming highly interdependent. Moreover, it became clear that the very processes in which sociologists were interested had an inherently global dimension. Nettl and Robertson (1968) argued, for example, that modernization consisted not of processes that simply occurred in similar fashion across the globe but rather of deliberate attempts by societal elites to place their society in a global hierarchy. Wallerstein (1974) saw this hierarchy as the product of long-term changes in the capitalist world economy, which had brought about not only a global division of labor but also a dominant world culture. This world culture became the primary concern of Meyer (1980) and his associates, who argued that modern institutions function according to global standards that are part of a "world polity." Robertson (1991; Robertson and Chirico 1985; see Featherstone 1990) described such phenomena as aspects of "globalization" and specifically called attention to the importance of religious reactions against this process, brought forth by the tensions it has produced. An early attempt to link sociocultural movements to world-level changes was made by Wuthnow (1980).

Given these scholarly precedents, what does it mean to speak of "global fundamentalism"? It means first of all that the predicament addressed by fundamentalist movements is a global one. Modernity is no longer a societal phenomenon, if it ever was. A reaction *against* modernity therefore necessarily has global implications: It entails a worldview in the literal sense of advocating a distinct view of "the world." For Islamic militants this includes an obligation to spread the Islamic

revolution and defeat the dominant Western satan. A global culture, not simply local circumstances, becomes the target of fundamentalist movements. The defenders of God aspire to bringing the kingdom of God to the earth as a whole, and in this sense they become important actors on the global scene. As global antisystemic movements, they attempt to resolve literally worldwide problems in global fashion—changing both the actual balance of power in the world and the cultural terms on which global actors operate. The struggle in which they are engaged is not, or not only, against modernity abstractly defined, but also for a particular shape of the globe. The extent to which they pursue this ambition depends in large part on variations in global change, on the extent to which particular societies or regions are socially or culturally unsettled by forces beyond their control.

The changing global condition not only becomes a context and target of fundamentalism, but also serves as its primary precipitating factor. Yet apart from globally induced variations in the strength of fundamentalism, the very attempt to restore a sacred tradition as a basis for a meaningful social order is globally significant, as one effort among others to preserve or achieve a certain cultural authenticity in the face of a greedy, universalizing global culture. It is, in other words, a particular, albeit radical and problematic, form of striving for communal and societal identity under circumstances that make such deliberate identification a global expectation—a point Robertson has repeatedly emphasized. Indeed, fundamentalism itself has become a global category, part of the global repertoire of collective action available to discontented groups, but also a symbol in a global discourse about the shape of the world. For liberal Westerners concerned about further "progressive" change, fundamentalism is the global Other, that which "we" are not; for those taking issue with the meaning and structure of current, Western-inspired global culture, fundamentalism becomes a most radical form of resistance, a symbolic vehicle. Interpreting fundamentalism in this global fashion is to subsume, not to discard, the treatment of fundamentalism as a form of antimodernism. Indeed, of all the conventional approaches to fundamentalism, this may well have the most lasting value; global culture, after all, is still (though not only) the culture of modernity. Standard criticisms of this approach as ethnocentric appear increasingly misplaced, for it is one that touches on crucial features of the global condition and represents a form of sociological realism rather than Western wishful thinking. To see fundamentalists locked in a struggle about the shape of the world is to recognize part of

their actual predicament, not to deny their particularity in imperialist fashion. In fact, those advocating a less analytical, more subjective approach to fundamentalism as well as other manifestations of religiosity or cultural difference (see Boele van Hensbroek, Koenis, and Westerman 1991) now face the difficulty that doing justice to the other in his or her particularity forces one to take into account the other's relation to universal structures, the other's reaction to alien penetration, the other's distinctly modern assertions of particularity (see Abaza and Stauth 1990).

In other words, the otherness of the other is increasingly problematic as a consequence of globalization; fundamentalism, to put it most simply, is inevitably contaminated by the culture it opposes. Just as in any pluralistic culture, the other is always already within us, we are also already in the other, even when she or he puts forth a grand display of antipluralist authenticity. In the modern world system, no fundamentalist can simply reappropriate the sacred and live by its divine lights. The very reappropriation is a modern, global phenomenon, part of the shared experience of "creolization" (Hannerz 1991). To see it as such is to include the other as full participant in a common discourse, a common society, rather than to relegate him or her to the iron cage of otherness.

The global perspective on fundamentalism also makes comparisons in the conventional sense problematic. Such comparisons, after all, presuppose that one can isolate the units to be compared, in order to examine the differential effects of similar but independently occurring processes. Often carried out for the sake of historical sensitivity, such an exercise increasingly comes to seem artificially abstract. Societies are now inherently oriented toward each other; they are involved in processes that encompass all; even the object of the comparison, namely the propensity to engage in fundamentalism, is no longer an indigenously arising phenomenon. Of course, careful comparisons can still help to determine the causal weight of particular factors in social movements. But, beyond that, the new global condition has changed the terms of scholarly analysis as much as it has the terms of actual social action.

A Future for Fundamentalism?

The global turn in the study of fundamentalism was partly inspired by the concern about the possible public influence of fundamentalism mentioned at the outset. In the end, the scholarly and the public interest

in fundamentalism converge on the question about the likely extent of this influence. Without repeating too much of what I have said in other contexts, I will briefly offer grounds for judging this influence relatively minor and for skepticism about the overall future of fundamentalism as we know it.

Of course, assessing the future of fundamentalism, a hazardous undertaking in any case, by no means exhausts the question of the future of religion addressed by this volume as a whole. Indeed, from the point of view of nonfundamentalist believers, it may well be the case that the demise of fundamentalism is a condition for the revitalization of serious religiosity. Expressing skepticism about the future of fundamentalism also does not imply that there is no future for research about fundamentalism. There is work to be done, if only because the trends in social analysis sketched above have improved our understanding but not answered all questions. And precisely because its future is problematic and conflicted, fundamentalism will remain a fruitful subject for research.

Turning to substance: As I and others have argued over the years, fundamentalism is a quintessentially modern phenomenon. It actively strives to reorder society; it reasserts the validity of a tradition and uses it in new ways; it operates in a context that sets nontraditional standards; where it does not take decisive control, it reproduces the dilemmas it sets out to resolve; as one active force among others, it affirms the depth of modern pluralism; it takes on the tensions produced by the clash between a universalizing global culture and particular local conditions; it expresses fundamental uncertainty in a crisis setting, not traditional confidence about taken-for-granted truths; by defending God, who formerly needed no defense, it creates and recreates difference as part of a global cultural struggle. So compromised, fundamentalism becomes part of the fabric of modernity.

Being compromised in this way portends a problematic future for fundamentalism—problematic, that is, from a fundamentalist point of view. It indicates one of the ways in which fundamentalism, like any other cultural movement, engages and must engage in creolization, juxtaposing the seemingly alien and the seemingly indigenous into a worldview and identity that combine both in new seamless wholes. Of course, upon inspection traditions often display a hybrid character. But if Robertson is right, such hybridization now becomes a normal feature of globalization, robbing cultures of easy authenticity while making the search for the authentic a virtual obligation. If the point of fundamen-

talism is to restore an authentic sacred tradition, this means that fundamentalism must fail.

This failure is exacerbated by the modern circumstances fundamentalism must confront. In some respects, modernity does act as a solvent, undermining the thrust of fundamentalist movements. Insofar as a society becomes structurally differentiated, religion loses social significance; once that happens, restoration is difficult if not impossible. In differentiated, specialized institutions engaged in technical control of the world, religious distinctions have little role in any case; the very conception of infusing a perceived iron cage with religious meaning necessarily remains nebulous. If a culture becomes pluralistic and tears down its sacred canopy, those who would restore it are themselves only one group among others. Making claims for a fundamentalist project requires wider legitimation, except where there is overwhelming popular support; such wider legitimation entails watering down the message. Trying to act globally with some effectiveness presupposes the use of global means, technological and institutional; but satellite dishes and fighter planes and nation-states draw the would-be opposition farther into the culture it claims to disdain. Although its relative success varies according to the conditions sketched above, fundamentalism is inevitably coopted.

But being modern and becoming coopted presuppose that there is a viable modern order to be coopted into. The future of fundamentalism is thus closely linked to the future of modernity. One advantage of the analytical view of fundamentalism, starting by conceptualizing it as one form of antimodernism among others in order to expose its modern character, is that it draws research on the subject into the larger discourse about modernity, central not only to the social sciences but in the public arena as well. If modernity in anything like the liberal version I adopt here can be sustained, albeit transformed through globalization, then the life chances of large-scale public fundamentalism are correspondingly diminished. How strong, then, is the fabric of modernity? Contrary to conventional assertions of the imperialism inherent in modernization or the emptiness of liberal culture or the loss of meaning in advanced societies, liberal modernity offers a wide variety of cultural meanings. The usual jeremiads about the ills and weaknesses of imperially secular modernity notwithstanding, the latter offers considerable room for free religious expression and experience. In the actual struggles about the future direction of world society, it appears to this biased observer, the liberal-modern view of social order thus far has prevailed against challenges issued by various kinds of antimodern movements

and regimes. Even after two world wars, the crises and conflicts of modern societies have not brought about the demise of the liberal modern project.

And yet, fundamentalism has its origins in real discontents experienced by real people; the mobilization factors that account for its relative strength in particular places have not disappeared everywhere; the tensions inherent in the globalization process cannot be resolved in any permanent fashion; in modern global culture, fundamentalism has found a place as part of a movement repertoire, to be activated when conditions are right. This does not enable us to make any clear-cut predictions about the reemergence of fundamentalism in the twenty-first century. It does enable us to say, more modestly if less informatively, that fundamentalism has a future—albeit one less bright than that of liberal modernity.

A Research Agenda

As I indicated at the outset, current research on fundamentalism is by no means a closed project. Each of the previous sections of this chapter in fact suggests things to be done. Some of these have been taken up by the Fundamentalism Project of the American Association for the Advancement of Science, led by Martin Marty; the results of its work have begun to appear (e.g., Marty and Appleby 1991) and will help to shape the field in the years to come. Nevertheless, this project should by no means have a monopoly on the field.

Consider first the problems of definition. In dealing with these problems, students of fundamentalism have been forced to reconsider dilemmas inherent in the sociological enterprise. As they tried to balance causal explanation and subjective *Verstehen*, thick description and formal analysis, particularizing ethnography and generalizing comparison, they rediscovered the limits and benefits of different scholarly approaches to cultural phenomena. But the reflexiveness scholars are slowly gaining also points to something new. Increasingly, they find the objective and the subjective blurred, the actors under study influenced by the very categories "objectively" applied to them. The term *fundamentalism* itself, for example, is contested in the real world, carries different meanings for different groups, and has helped to shape the efforts of various movements. The same goes for the seemingly abstract and academic concept of modernity. With religious activists often well-attuned to the discourse about them, it becomes less clear who is observer, who observed. Moreover, since fundamentalists of whatever stripe adopt a socio-

logical model of and for the world in which they operate, sociological research more and more involves confronting that model and offering a critique (Robertson 1985; Robbins and Robertson 1991). In this new setting for social analysis—where not just genres (Geertz 1983) but also categories and roles become blurred—researchers can further enhance their reflexiveness by turning to a study of the discourse of fundamentalism. Such a study would focus on the way in which the term itself and related categories take on various meanings in a worldwide debate. Who says what, against whom, on what grounds, for what purpose? By thus treating fundamentalism as a "site" of cultural contention, social scientists would turn a scholarly predicament into a research opportunity.

Recent research on the path *into* fundamentalism suggests that those who take it tend to have one thing in common: They are in transition from a less to a more modern setting; they try to defend and reproduce a traditional milieu against a perceived modern threat. This notion, defended by Ammerman and Riesebrodt among others, raises the question of whether more secure incorporation of previously transitional actors (or their offspring) into the framework of modernity typically leads to the dilution of fundamentalist allegiance and activism. Is there a common path *out of* fundamentalism? That is one issue for fresh empirical research. Even if there is such a path, it is likely to branch off in many directions. Further research is also needed to chart this branching process more precisely. Which activists become liberalized in belief and action, which withdraw into small communities of faith, which prepare for a public reassertion? How do different kinds of believers deal with the disappointments of religiously motivated public action in liberal societies?

Systematic comparative analysis of fundamentalist movements is shedding light on variations in their development and relative success. Yet we lack a study of the scope and ambition of Wuthnow's *Communities of Discourse* (1989). Though this work offers few theoretical recipes and at times slights the very discourse it claims to study, it does offer a framework for the analysis of oppositional movements that is particularly sensitive to social context and institutional response. Especially fascinating in Wuthnow's approach is the role played by parts of a divided political establishment in fostering a social movement that advocates an overturning of the established order. Elite divisions and support, lenient treatment by an uncertain state apparatus, and manipulation of a movement by various powerful groups to advance

their own interests may serve to strengthen a movement's thrust. Determining the relative weight of intended and unintended elite support is one of the tasks for further comparative research on fundamentalism.

The global turn in sociology has made uncontaminated comparisons increasingly difficult. Through the work of Robertson, in particular, it also is beginning to direct the attention of scholars to previously unstudied aspects of fundamentalism, as I explained above. From a global point of view fundamentalism offers one important instance of creolization—made more important by virtue of being wholly unintended. If even fundamentalists end up mixing and matching universal-global notions and particular-cultural ones, then this tells us something about the force and direction of globalization. Equally needed is deeper insight into the actual pattern of creolization: How does it happen? What cultural elements are selected from a wider global culture? What parts of a "local" identity are best preserved? What happens when local (e.g., Islamic) and global (e.g., United Nations) universalism clash? How do self-proclaimed adherents of an unchanging sacred tradition achieve a sense of wholeness in spite of creolization? Studying fundamentalism, then, becomes a matter of examining how globalization takes place. Minjung theology in Korea, mentioned by Tamney in Chapter 4, would be one fruitful venue for this type of project.

But fundamentalism is more than a site worthy of further study in its own right. As I suggested above, fundamentalists also participate in a global debate about the desirable future shape of the world. In this debate, fundamentalists offer a particular image of world order. In outline, we know what it looks like. But we need further study of fundamentalist models of and for the world: Whom and what do they demonize? What is the role of different cultures in their scheme? How will they use global resources to transform the world? How far do they wish to push dedifferentiation on a global scale? The answers will help to clarify not only where fundamentalists stand but also how the world is likely to change. In this way, focusing on distinctly global issues, the study of fundamentalism ultimately becomes a vehicle for inquiring into the future of liberal modernity on a global scale.

References

Abaza, M., and G. Stauth. 1990. Occidental reason, orientalism, Islamic fundamentalism. In *Globalization, knowledge and society,* edited by M. Albrow and E. King, 209-30. London: Sage.

Ammerman, N. 1982. Operationalizing evangelicalism. *Sociological Analysis* 43: 170-72.
————. 1987. *Bible believers*. New Brunswick, NJ: Rutgers University Press.
————. 1991. Southern Baptists and the new Christian right. *Review of Religious Research* 32: 213-36.
Arjomand, S. A., ed. 1984. *From nationalism to revolutionary Islam*. Albany: State University of New York Press.
————. 1988. *The turban for the crown*. Oxford: Oxford University Press.
Bannerman, P. 1988. *Islam in perspective*. London: Routledge & Kegan Paul.
Boele van Hensbroek, P., S. Koenis, and P. Westerman, eds. 1991. *Naar de letter*. Utrecht: Stichting Grafiet.
Featherstone, M., ed. 1990. *Global culture*. London: Sage.
Geertz, C. 1983. *Local knowledge*. New York: Basic Books.
Hannerz, U. 1991. Scenarios for peripheral cultures. In *Culture, globalization, and the world-system*, edited by A. D. King, 107-28. Binghamton: State University of New York at Binghamton.
Hunter, J. D. 1983. *American evangelicalism*. New Brunswick, NJ: Rutgers University Press.
Kepel, G. 1985. *Muslim extremism in Egypt*. Berkeley: University of California Press.
Kimmel, M. S. 1992. Satan and submission. In *Twentieth-century world religious movements in neo-Weberian perspective*, edited by W. H. Swatos, Jr., 105-23. Lewiston, NY: Mellen.
Lawrence, B. B. 1989. *Defenders of God*. San Francisco: Harper & Row.
Lechner, F. J. 1985. Fundamentalism and sociocultural revitalization. *Sociological Analysis* 46: 243-60.
————. 1990. Fundamentalism revisited. In *In gods we trust*, 2nd ed., edited by T. Robbins and D. Anthony, 77-97. New Brunswick, NJ: Transaction.
————. 1991. Fundamentalism and modernity. In *Naar de letter*, edited by P. Boele van Hensbroek, S. Koenis, and P. Westerman, 103-25. Utrecht: Stichting Grafiet.
Marsden, G. M. 1980. *Fundamentalism and American culture*. New York: Oxford University Press.
Marty, M. E., and R. S. Appleby, eds. 1991. *Fundamentalisms observed*. Chicago: University of Chicago Press.
Meyer, J. W. 1980. The world polity and the authority of the nation-state. In *Studies of the modern world-system*, edited by A. J. Bergesen, 109-37. New York: Academic Press.
Nettl, J. P., and R. Robertson. 1968. *International systems and the modernization of societies*. New York: Basic Books.
Parsa, M. 1989. *Social origins of the Iranian revolution*. New Brunswick, NJ: Rutgers University Press.
Parsons, T. 1971. *The system of modern societies*. Englewood Cliffs, NJ: Prentice-Hall.
Riesebrodt, M. 1990. *Fundamentalismus as patriarchalische protestbewegung*. Tuebingen: Mohr.
Robbins, T., and R. Robertson. 1991. Studying religion today. *Religion* 21: 319-37.
Robertson, R. 1985. Scholarship, partisanship, sponsorship, and "the Moonie problem." *Sociological Analysis* 46: 171-78.
————. 1991. Globality, global culture and images of world order. In *Social change and modernity*, edited by H. Haferkamp and N. J. Smelser, 395-411. Berkeley: University of California Press.
Robertson, R., and J. A. Chirico. 1985. Humanity, globalization, and worldwide religious resurgence. *Sociological Analysis* 46: 219-42.

Wallerstein, I. 1974. *The modern world-system,* vol. 1. New York: Academic Press.
Wuthnow, R. 1980. World order and religious movements. In *Studies of the modern world-system,* edited by A. J. Bergesen, 57-75. New York: Academic Press.
———. 1989. *Communities of Discourse.* Cambridge, MA: Harvard University Press.

3

Religion, Class Conflict, and Social Justice

EUGEN SCHOENFELD

Sociologists and the public take it as almost an axiom that religions provide eufunctions for both their adherents and societies as wholes. With respect to society, sociological theory proposes that religion provides for peace and harmony (Merton 1957), social integration (Durkheim 1965; Malinowski 1948), meaning and morality (Berger 1969). Theologies, especially of the Abrahamic traditions, teach that adhering to religious beliefs and principles, particularly when associated with religiously appropriate behavior, will bring God's blessing not only to the faithful person but also on the collectivity as a whole. For the individual, adherence to religion will result in peace of mind and salvation, while society similarly, as the Old Testament proposes, will enjoy the benefits of peace and economic prosperity (see, e.g., Deuteronomy, Proverbs). Functionalist sociology has historically attributed similar consequences to religion, virtually as a matter of definition.[1]

The functionalist view notwithstanding, however, religion is, as Lewy (1974) writes, "Janus faced." While on the one hand, it presumes to foster peace, it also encourages war and revolution. Whereas religion may enhance morality, its price is often the loss of personal freedom. Particularly when it enjoys a monopoly, religion will strengthen the collective consciousness (Durkheim 1965), but at the same time it also advocates and supports ethnocentrism and submissiveness to power and authority, and above all a rejection of, if not outright hostility to, all

those who do not adhere to its creed. In this chapter I will examine how religion contributes to social conflict. I will concentrate on how religion, by justifying and legitimating class ideology, sanctifies views of one class that stand in diametric opposition to the views of members of other classes.

Conflict

Conflict is the hostile condition that results when the interests of one unit in the social system stand in opposition to or are threatened by another unit. Coser's definition is somewhat more specific. He defines conflict as "a struggle over values and claims to scarce status, power and resources in which the aims of the opponents are to neutralize, injure or eliminate their rivals" (1956, 8). Generally, one can say that conflict and its associated hostility are the result of self and class interests associated with competition for scarce resources. Interests reflect a person's perception of those conditions that ensure personal or class benefits (or both).

In this chapter I will concentrate on the belief systems that provide religious justifications for class interests and thus enhance and support class conflict. I am not suggesting that class interests are the only form of conflict in religion. Of course, there are conflicts between various religions associated with matters of faith. These too, however, are part of a power struggle, namely a struggle between various religions who seek to control the definition of truth. Theologians who create and interpret religious belief systems also become a part of the intelligentsia, that is, a collectivity of persons who clarify or create ideologies by which classes and individuals justify their worldviews and the legitimacy or nonlegitimacy of the political system. The difference between the secular and the sacred intelligentsia, that is, between nonreligious and religious ideologists, is that the latter unite other-worldly and this-worldly ends. Thus, secular ideologists base their mode of legitimation primarily in the rational-legal system, whereas the sacred intelligentsia seek primarily traditional and charismatic legitimation. In the sacred system, soteriology and ideology are united, that is, the achievement of salvation is dependent not only on the acceptance of an appropriate theological belief but also on one's acceptance of class-based ideology. In this manner economic interests have become part of religious interests. To understand the relationship between class and religious beliefs,

we need at this juncture to examine the nature of social class and its relationship to religion.

Social Class and Social Status

Any discussion of the interrelationship between religion, economy, and conflict needs to be prefaced with a brief description of Marxian theory pertaining to the relationship between the system of production and the production of ideas that are the foundation of all forms of consciousness. This relationship is expressed in the preface to Marx's *Critique of Political Economy,* where he writes: "It is not the consciousness of men that determines their being, but, on the contrary, their social being that determines their consciousness" (1977, 182). In short, Marx proposes that awareness, that is, the meaning system through which each person interprets his or her existence, has its roots in the position the person occupies in the system of production. For Marx these positions were determined by either ownership or nonownership of *tools*— the means of production. What is most important to us is that the position one occupies in the productive process, namely one's social class, is the basis, or the infrastructure, on which a person builds his or her worldview (which for most people includes religion).

Marx, however, compounds the problem by suggesting that the ruling class controls not only the productive process but also the production of ideas. In *The German Ideology,* he proposes that "The ideas of the ruling class are in every epoch the ruling ideas, i.e., the class which is the ruling material force of society is at the same time its ruling intellectual force" (1976, 67). In this passage Marx seems to suggest that as a general rule, ideas, including religious ideas, reflect the interests of the ruling class. Thus, theology and its derived morality are part of and reflect the interests of the ruling class—namely, the class that controls and dominates the means of production. In short, those in power control those who generate ideas as well those who transmit ideas. For Marxists such as Althusser (1977), for example, religious institutions are part of the Ideological State Apparatus (ISA), the means by which the ruling classes disseminate their ideology and through which they attempt to maintain their hegemony.

The ruling class's dominance over the submissive classes is possible only as long as the latter do not develop their own class consciousness. As long as a social class is merely a social category (in Marxian terms,

eine Klasse an sich [a class by itself]), the submissive classes will most often reflect the interests of the ruling class. The ideas of the ruling class will be the ideas of the submissive class. However, when the latter develop class consciousness, there is also a concomitant development of their own class ideologies, which will reflect that class's self-interest. Marx's view thus proposes that the economic structure of society, as he states it in the preface, is "the real foundation, on which rises a legal and political superstructure and to which correspond definite forms of social consciousness. The mode of production of material life conditions the social, political, and intellectual life process in general" (1977, 389). Thus people's consciousness, which includes their worldview, their interpretation of the world and its meaning, all arise out of and correspond to the interest developed through the social class.

The concept of "class" in sociological theory and research has, nevertheless, not been without difficulties. These problems are associated with polemics between those committed to either the functionalist or conflict theoretical perspective. The first placed primacy on the Weberian model of stratification, the latter on Marx. The problem was that for the most part they ceased to perceive stratification from a holistic perspective. This is partly due to Weber's propensity for defining social realities as ideal types—isolated as abstract forms. Thus, class was defined as a social category, namely as a collectivity of individuals who share a common occupation, regardless of their social consciousness, while the common life-style and social prestige shared by individuals was termed social status. In reality, however, these two are but parts of one whole system. A person's occupation and his social prestige are indeed highly interrelated, so that occupational position, social prestige, and life-style are all bound together. Upward or downward mobility occurs simultaneously on all levels, that is, economically and socially. Hence, blue-collar workers who experience downward mobility experience a relative change of position both economically and socially vis-à-vis other groups who are part of their total reference construction.

In this chapter social class will not be equated with occupation or with occupational prestige scores. Rather, class is conceived here as collectivities who share a common view of their social position—that is, of their economic interests and social standing. In short, classes are those social groupings whose social position is expressed economically and who share a common worldview, including a theology.

From this perspective we can consider the existence of three different social classes: the ruling class, the ascending class, and the retrenching class. (There is a fourth class, the alienated class, which I will not discuss here; see Schoenfeld 1992.) The ruling class consists of those who control the means of production, and thus also have hegemony over the economic and political system. The ascending class consists of those who occupy the lower socioeconomic order, who were kept there by virtue of their social status as minorities but who are struggling to gain class mobility. Finally, there are those individuals who collectively constitute the retrenching class, that is, those who once enjoyed higher social status but, due to economic and social changes, have lost it and who now seek to regain their former social position.

Each of these groups shares a class-based collective consciousness, a worldview that reflects its interpretation of reality—in short, an ideology. The ascending class, who traditionally have been denied access to mobility and thus adequate life chances by virtue of their minority status, see the ruling class as their class enemy, and thus will seek to legitimate their opposition to that class. In contrast, the retrenching class see the loss of their status as the consequence of the ascending class's usurpation of their position, and will thus perceive that class as their threat and will develop an antagonism toward that class. The ruling class seek to justify their social position by defining the benefits the other classes accrue due to their relationship to them and, by virtue of their (self-defined) contribution to the social system, justify and demand the status quo. All ideologies, including class, as Weber has argued (1978, 212-307), need to be legitimated. Religion is one mechanism by which different classes seek to legitimate their point of view and the social order that they seek to maintain or change.

Religion as Ideology

Although Marx proposed that ideologies have their roots in the economic infrastructure, he did not elaborate on the process of its development. To him political consciousness was the consequence of interaction. To the extent that the modern factory system brought people in proximity to one another, it provided the necessary condition for interaction and thus for the development of political consciousness. In short, to Marx, ideology was a spontaneous consequence of the propinquity afforded by the new productive system; however, it was Karl Mannheim who, by combining Marx's and Weber's theories, isolated both the

process by which ideology is developed and its impact on interclass relationships. First, Mannheim proposes that the actual formation of ideology is the product of "free floating intellectuals," that is, of intellectuals who are not part of any class but who, for various reasons, become the spokespersons for a particular class. "In every society," Mannheim writes, "there are social groups whose special task it is to provide an interpretation of the world for that society." In contrast to Marx, for whom thought, and particularly ideological thought, was the product of class struggle, Mannheim proposes that it is in response to a need for order:

> This type of thought does not arise primarily from the struggle with concrete problems of life nor from trial and error, nor from experiences in mastering nature and society, but rather much more from its own need for systematization, which always refers the facts which emerge in the religious as well as in other spheres of life back to given traditional and intellectually uncontrolled premises. (1936, 10-11)

In this sense, Mannheim agrees with Durkheim, for whom the greatest social tragedy is anomie, the absence of meaning.

In a similar vein, Berger (1969) argues that the greatest danger to human existence is the absence of order—a state of anomie. In his view anomie is unbearable to the point where the individual may seek death in preference to it. Thus, to be able to exist people need nomos, order, rather than chaos, but they need an order and a meaning on which that order is based. It is the function of religion, in Berger's view, to provide such a meaningful order. It is not religion per se that provides meaning. Meaning, that is, a particular worldview that serves as ideology, is the product of the religious intelligentsia, the free-floating religious intellectuals who develop the meaning system. In this sense, we can say that religious intellectuals serve class interests, and theology, the product of their labor, is likewise in the service of these class interests.

For the meaning system to have an impact on the individual, it must be internalized and reinforced by society through what Berger terms a "plausibility structure," a group of people who support, reinforce, and legitimate one's worldview. From a conflict perspective, then, religious plausibility structure is synonymous with class. Thus, while religion urges us to serve but one master, the existential beliefs about the Master and the ideas regarding the way to serve Him are determined by Caesar.

Religious Ideology and Social Class

Mannheim proposes that a historical analysis of ideology indicates that all thought, including ideology and religious thought, are situationally determined. Thus, in analyzing religious ideology, as in any other form of ideology, we need to examine its situational source, its class infrastructure. From this perspective, we see that religions associated with the dominant classes seek to reinforce and justify their social position. The retrenching class, those who seek to reestablish their old social position, accept the values of the dominant class and through it seek to renounce the legitimacy of the ascending class's claims for their right to social mobility. The ascending class, composed primarily of the lower and exploited classes, attempt to give meaning to their social-situationally developed values, including religious ones that are both utopian and resentful, that is, systems of thought that transcend the objective realities of their situation and those that are antagonistic to the system that created the situation (Mannheim 1936, 45-46; 194-95). On the one hand, utopian thinking provides for false consciousness and submission to the ruling class through ressentiment and transvaluation. On the other hand, value systems that arise as a form of resentment to their social condition justify militancy (see Schoenfeld 1987, 1992). In this chapter I will examine briefly the religious ideologies that reflect primarily the ascending and retrenching classes, hence their diametric opposition to each other.

The ascending class constitutes those individuals whose lower socioeconomic status is the consequence of race, ethnicity, or religion, who have traditionally been relegated to the underclass. They become, however, an ascending class (or, in Marxian terms, a class for itself) when they acquire a unity through class consciousness. This consciousness consists of a variety of legitimating ideologies, some based on a rational-legal mode of legitimation; but quite frequently, also including a traditional or charismatic mode of legitimation based on religious or moral doctrine. These religious doctrinal values are antithetical to the dominant values. That is, these values support the claim that members of the underclass have a moral right to seek and be placed into such socioeconomic conditions as will ensure them better life chances and higher social prestige. The tone of the religious ideology resembles that of the Old Testament prophets' righteous indignation. An example of this tone is evident in the following excerpt of a Pastoral Letter written by 16 Roman Catholic bishops of Third World sees:

It is not true that God wishes there to be rich men enjoying the good things of this world by exploiting the poor: it is not true that God wishes there to be people always wretched. Religion is not the opium of the people. Religion is the force that exalts the humble and casts down the mighty from their seats, that gives bread to the hungry and reduces to hunger the overeaters. (in Lewy 1974, viii)

The moral principles that constitute the infrastructure of the ascending class are justice, equality, and the primacy of the collectivity. These values stand in opposition, at least in the United States, to the dominant values, which stress the primacy of the individual and his possessions. The tone of the speakers representing the retrenching class is also militant. They see a society that is sinful primarily because members of the society have abandoned the true ways of the past. In their messages to their adherents they urge a return to "old-time" religion and old-time ways. In essence, the religious values of the retrenching class oppose modernity, even as they are the creation of the specific sociocultural conditions of modernity (see Lechner 1985). Thus, Jerry Falwell, who can be considered one of the retrenching class's leading public spokespersons in the recent past, asserts that "for America to be free we must come back to the only principles that God can honor: the dignity of life, the traditional family, decency and morality and so on." He sees as his own mission to bring the United States "back to a moral standard so that we can stay free" (Chandler 1984, 41-42).[2]

Both the dominant and the retrenching classes hold, to a great extent, similar values. The dominant class is constituted by those persons who, by virtue of their economic position, control the means of production. Generally, this class is composed of the broad stratum of proprietors, both of businesses and service industries (including medical and legal services), and the managerial class. The retrenching class consists of those persons who once enjoyed, or believe they enjoyed, a higher social position than they do at present. Their reference group, thus, is not with the present proletariat; rather, they see themselves as a part of a respectable middle stratum. Religion and associated moral values serve this class as mechanisms by which they express their attachment to the dominant values; specifically, values that stand in opposition to the interests and values of the ascending class whom they perceive as a threat to their social status. The religious values of the retrenching class are love, freedom, and individualism.

Here I need to enter the following caveat: I do not argue that the retrenching class does not consider justice an important value or that the ascending class similarly rejects the Christian value of love. I am merely proposing that these two different sets of three values are the *dominant* moral views that reflect their class interests (see Schoenfeld 1989). Justice, as a religious value, is fundamentally an Old Testament concern. Justice, although not defined in the Old Testament, seems to be concerned with the principle of equity and the use of power. Specifically, we know that to the prophets it means abhorrence of the injustice that is exemplified by the various ways in which the powerful exploit the powerless. Like the prophets in the Old Testament, theologians of the ascending class (for instance, the proponents of liberation theology) seek accountability from those who wield power. Justice as a theological norm serves as a religiously legitimated mechanism by which the powerless (either politically or economically) demand in God's name that they have the moral right to examine and be critical of the conduct of those in power. This is quite similar to the ways the prophets in the Old Testament justified their criticism of the powerful.

Justice is a value that *justifies* class conflict. In the name of justice, a class demands its rights—rights that stand in diametric opposition to the privileges that have been usurped by the ruling classes. Thus we find that in liberation theology, a theology associated with the underclass in South American countries, the stress on economic and social justice assumes the tone associated with the Old Testament prophets. Justice addresses the idea of distributive equality; namely, it emphasizes the rights of all to have access to those conditions that determine people's life chances—to, for example, income and health care. In short, justice as a religious or political moral value has been used to justify changes and alterations in the social system, particularly in the system of stratification.

Whereas the ascending class stresses justice, the retrenching class stresses the Christian value of love. This value by its very nature can be used to support ideals of freedom, individualism, and self-determination, and as such it will reinforce conservative political tenets. Feuerbach (1957, 262) has already noted that Christian love is not "for the sake of goodness itself, not for the sake of man, but for the sake of God;—out of gratitude to God, who has done all for him." Love takes the form of payment or reward, and this form of love is transferred to interpersonal relationships. Namely, we love those who merit our love. We help those whom we select to help. In short, love leads us to make

judgments of individuals; it focuses our attention on the individual and not on the social system. We judge individual performance and not system performance, and such a perspective favors conservatism. It is clear, thus, that the value of justice and that of love serve different ideological masters (see Schoenfeld 1974).

Equality and freedom are two other moral perspectives that reflect ideological differences between the two class interests. The ascending class places primacy on equality, while the retrenching class emphasizes freedom. Equality as a religious ideology proposes, like justice, that God gave all people equal rights to life and therefore to those conditions that influence a person's chances to life. On the other hand, the idea of freedom, that is, liberty, particularly as enunciated in the political discourses of nineteenth-century liberal thinkers, stands for deregulation, that is, the absence of the collective control over the individual, and permits and justifies the social position of the powerful. Bendix, for instance (1963, 86-99), argues that the demand for freedom coincides with the rise of the bourgeoisie. For freedom and contract include the idea of personal choice, an important Protestant view, that can be and was used to legitimate economic exploitation in the factory system. Equality, in contrast to freedom, justifies and places primacy not on individual rights, but on collective rights. While freedom argues for each person's right to control goods and services, to maximize self(ish)-interest, equality calls for the sharing not only of power but also of goods and services. The moral ideology incorporated in the term *equality* opposes all forms of exploitation; but freedom, particularly as it is expressed in the laissez-faire theory, supports and legitimates exploitation. Both values, freedom and equality, have become part of religious moralities and have thus become legitimators of class interests.

The substitution of love for justice and equality, reflecting both the dominant class and the retrenching class, is evident in the teachings of Reinhold Niebuhr, perhaps the most eloquent exemplar of neo-orthodox Christian ethics. For him the problem of both politics and economics is a problem related to justice. But he defines justice as "love in action." Justice, in his perspective, is not the principle of equity as an inherent right of all individuals to equal life chances; rather, he perceives it as a principle rooted in the individual's emotion "love." For him, "the law of love is involved in all approximations of justice, not only as the source of the norm of justice, but as the ultimate perspective by which their limitations are discovered" (1935, 149). The rejection of the

principles of both justice and equality, at least as advocated by the
ascending class, is renounced by Niebuhr. He writes:

> The principles of equal justice are the approximations of the law of love in
> the kind of imperfect world which we know and not principles which belong
> to a world of transcendent perfection. Equality has no place in such a perfect
> world because this principle of equality presupposes competition of life and
> seeks to prevent this competition from resulting in exploitation, by advancing
> and defending the claims of one life with equal force against every other life.
> Since the law of love demands that all life be affirmed, the principle that all
> conflicting claims of life be equally affirmed is a logical approximation of the
> law of love in a world in which conflict is inevitable.

The religious roots of the ascending class's demand for equality, at least
equality for life chances, can also be found in the Old Testament. Like
the biblical concept of justice, equality denounces the unjust distribu-
tion of goods and services, particularly the accumulation of goods as a
consequence of exploitation.

The final two values that stand in a dialectical relationship and have
become part of theology are commitment either to individualism or to
the collectivity. Whereas the ascending class and the religions that serve
it place primacy on the collectivity, the retrenching class puts moral
ascendancy on individualism. As a central value of both the dominant
class and the retrenching class, individualism is the marriage of Protes-
tant virtues to capitalism. In essence, individualism proposes the right
of each person to maximize his or her own economic interests. Individ-
ualism is reflected in the legal concept of contract and is associated with
the principles of freedom, as the right of the individual to control his or
her own property. One way in which the moral values of individualism,
freedom, and love have influenced other religious ethics is evident in
the mainline religions' perspective on charity, which is perceived as a
free-will offering on the part of individuals who, out of their love, are
willing to share some of their God's gifts with others (see Schoenfeld
1989). Edmund Burke, the premier essayist of eighteenth-century con-
servatism, writes that charity is a "direct and obligatory duty upon all
Christians, next in order after the payment of debts." But, as Bendix
(1963, 74) notes, "It was a duty left to private direction."

In the following century this conception of individualism became
central to the Social Darwinist's view of society, which has been
criticized by Durkheim as a system that justifies unabashed self-interest
or "egoism." Individualism and self-dependency were central to the rise

of English industrialism as well as to Methodism. Thompson's (1966, 350-400) analysis of the rise of the English working class points out that an important teaching of Methodism, the new religion of the working class, was a self-reliance that reflected the same value that was central to the newly rising bourgeoisie in England. After all, as Burke commented, it is not the duty of the state or the more economically well-to-do members of society to "supply the poor those necessities which it has pleased the Divine Providence for a while to withhold from them" (Bendix 1963, 75). But if self-interest dominates, if the capitalist spirit with its religious vestiges justifies and encourages self-interest as the primary end, then what should motivate one to become his "brother's keeper"? The answer, of course, is love and Christian charity, the values espoused in the New, rather than the Old, Testament.

In contrast to the ascending class's demand for equality, the retrenching class as well as the dominant class emphasize the value of freedom. Freedom, as espoused by these classes, is related to these classes' perception of the economy, that is, the right of an individual to treat one's property in accordance with his or her wishes. Freedom, as Bendix elaborated, is the value in the bourgeois ideology by which the owners of the means of production—the factory owners—justified and legitimated a new mode of exploitation. Bendix proposes that by endowing each individual with economic freedom to seek and develop contractual relationships, the economically more powerful class can legitimate its right to exploit the weaker class. All economic relationships are in essence agreements between individuals; thus, one can create a dependency relationship in which the powerless individual is unable to achieve a contract that is essentially fair. The powerful control access to the means of production, which is absolutely essential for the powerless in his quest for wages. The powerless individual must thus succumb to the owner. Freedom, as the right of an individual to deviate from collective moral standards, is not part of this conception; that is, the retrenching class does not advocate the right to deviate in thought or in life-style (including, for example, sexual life-style, drinking, gambling, and the like). Their conception of freedom is to be free from those conditions that they perceive as having contributed to their loss of social status relative to those who gained. These different ideological views have been incorporated into and are a part of the corresponding religions' doctrines.

Research Agenda

Two essentially interconnected areas in the sociology of religion that either have been neglected or have had conceptual problems and are particularly pertinent to issues of religion and conflict, as I have outlined them in this chapter, are politics and morals. Since politics is based on ideologies that in themselves are a form of morals, it is no wonder that both areas have had a close tie with historical religions.

The problem with politics is that while there are theoretical expectations of its relationship with religion, studies have lacked consistent findings to this effect (Wuthnow 1973). The problem from the conflict point of view is the way class has been conceptualized: Class was perceived as a social category rather than a collectivity of individuals who have achieved a particular consciousness. In my conceptual scheme, I have proposed that the three classes differ in their consciousness, and that this consciousness is expressed in religious terms as justice, love, individualism, collectivity orientation, equality, and freedom. It is important that future research investigate the way in which religion and social class interact and use these different values to legitimate and justify either liberal or conservative political views and agendas.

Of particular interest are the schisms that developed within various denominations—schisms that on the surface seem to reflect theological differences, but which most likely are political in their nature. Thus, it would be important to determine the extent to which primacy is given to love (as a Christian value) as opposed to justice. Love, I propose, will be associated as a religious value with other-worldly concerns, while justice will reflect this-worldly concerns. Such a relationship is perhaps evident from Gary T. Marx's (1967) study of the civil rights movement. Thus, the issue: Can a religion that emphasizes personal relationships to be governed by love also become concerned with a critical view of the social system and its operation? Similarly, does an emphasis on love in contrast to justice also serve as justification for the ruling ideology? In short, we need to examine whether love in contrast to justice as a religious value is related to individualism and the view of poverty as individual responsibility.

Another important area of investigation related to the religious values of justice and love is their association with moral thought. Here the question that needs to be examined and studied is: To what extent do religious values reflect class interests through their advocacy of morals? We can take it as an axiom that morality, which essentially is a

guide for interpersonal behavior, consists of duties and privileges. Duties are conceptions that specify Ego's obligatory behavior toward the collectivity as a whole and toward individual others. Privileges, in contrast, are the reciprocals of duties, namely the collectivity's and other individual members' duties and obligations to Ego. Justice falls primarily in the first category in that it is the principle that stresses the obligations an individual has toward the collectivity and to other individuals. Freedom is associated with the second category, as the right (or the privilege) an individual enjoys to separate himself or herself from the collectivity and from other individuals. Justice, in this study, should be conceived as that aspect of morality that serves to ensure the "life chances" of others. Freedom, on the other hand, is each person's right to choose his or her own "life-style" and thus deviate from collective standards. In this regard, any condition that minimizes another's chances for a socially defined minimal level of a quality life, and especially to one's chances for life itself, is contrary to the principles of "justice" and hence immoral.

Justice as a moral principle prescribes both individual and collective commitment to ensure the life chances of others. Freedom, in contrast, stresses the sanctity of human uniqueness and the right of every person to differ from the collective in respect to thought and preference for a given way of life; by this I mean the right of an individual to join any religious organization, to profess nonpopular beliefs, and to participate in any life-style. Justice and freedom are not different ends of the same continuum. Rather, they represent two distinct aspects of moral principles. If justice consists of an individual's duties to others, in religious terms to be one's brother's keeper, then justice demands the sharing of one's wealth with others. In contrast, injustice is—in Durkheim's term—egoism, that is, an emphasis on the self and self ends. This is in distinct contrast to freedom, which in Durkheim's view is central to the new moral infrastructure of the "cult of individualism"—namely, the right of the individual to seek self-expression. (For an in-depth analysis of this problem, see Schoenfeld 1990.) The opposition to freedom is subjugation to the "collective conscience"—the infrastructure of archaic mechanical solidarity. Thus, the important questions to examine are: Do the religious values of justice and freedom reflect class interests, and does religion hence become the means by which moral teachings become the legitimator of class interests?

An alternative research problem in the relationship between social class and religious ethics relates to moral reasoning. Fowler (1981) has

examined moral reasoning from a developmental perspective. But, from a sociological perspective, it is equally important to examine how moral reasoning may be a function of class and reflect differences in class interests. All moral acts or contemplated acts need to be justified. Kohlberg suggests that the type of justification respondents give to the situational case called the "Heinz dilemma" provides a useful approach to the study of moral reasoning: The respondent is asked to evaluate the legitimacy of Heinz's theft of a drug to save his wife's life. The problem is that Heinz is unable to secure the necessary funds for the drug. The dilemma that the respondent must solve is: Is human life more important than property rights? The subject's response is an indication of his or her level of moral reasoning. Those in the lower stages of moral reasoning, Kohlberg proposes, emphasize "the 'principles' maintaining social order are obedience by the weak to the strong and punishment by the strong of those who deviate" (Kohlberg 1981, 148). This form of reasoning is similar to Durkheim's conception of preliterate societies dominated by the "collective conscience." Strong collective conscience today is characteristic of fundamentalist groups, where it still serves as an integrating force.

In contrast, other forms of moral reasoning and legitimation are based either on principles of empathy and care or on inherent "natural rights." Empathy and care are forms of reasoning that Gilligan (1982) argues are dominant among women and may be a natural human trait. Love and care are fundamentally expressive forms of moral reasoning and are characteristic among those who do not have power. It is reasonable to assume that if women's moral reasoning, because of their different social status and all that is implied therein, differs from those of men, then it should be equally true that moral reasoning should also differ among different social classes (see Schoenfeld and Mestrovic 1991). I wish to propose that the religious moral values of justice, love, and fear of God are the three modes of moral legitimation and that they reflect class differences. Justice, for instance, reflects the ideal of inherent rights or natural rights, is part of our national mythology, and is embedded in the language of the Constitution. Love is the *sine qua non* of the moral value of charity. Fear of God is explicitly theological.

Three corresponding forms of moral reasoning are those based on principles, care, and coercion; these should be treated in research as forms of moral reasoning and not as indices of moral stages. The first category consists of those who emphasize natural rights that may be based on the religious view of justice. The second group consists of

those who place primacy on the religious conception of love and give "caring" as a reason for moral behavior. "Moral-coercion" consists of those who legitimate and justify moral behaviors as religious duties ordained by God or as norms central to the collective conscience.

This reflects but a brief outline, an agenda, for research and studies of the relationship between religion, class, and political and moral values. Durkheim (1982) has attempted to define the path of sociology by arguing that sociology not only needs to become the science of morals, but it also needs to be practical.[3] The practical aim of sociology is to help society with its mission of improving people's quality of life. He writes: "Society has no justification if it does not bring a little peace to men—peace in their hearts and peace in their mutual intercourse" (Durkheim 1961, 16). Peace in Durkheim's sense is a function of a moral society, and it is rooted in the moral infrastructure of justice. Thus, the imperative task for sociology is to research the social nature of morality, particularly the nature of and the conditions that bring about justice. Justice, to him, was based in the moral distribution of rewards so that each person is compensated, not based on the market system but according to his or her contribution to the society's well-being. That is, all phases of human interaction in which goods and services are exchanged should be based upon moral principles. It is obvious that in most cases neither societies as a whole nor the individuals in them have any notion of moral equity. Perhaps what is even more important is that religions do not have a clear conception of moral equity. The problem that sociological research needs to address is: How can we establish and determine the idea of moral equity, that is, the principle of moral justice, and how can religion serve moral rather than class ends?

Notes

1. A good introductory text, for example, says quite matter-of-factly, "Religion reinforces shared values, thus giving meaning and purpose to life" (Bassis, Gelles, and Levine 1991, 142).

2. Although my analysis is written in the context of the political-economic situation in the United States, the class relations that I am discussing can be generalized globally. For example, in his analysis of what some would term the "fundamentalist" Jamaat-i-Islami, Ahmad (1991, 496) writes that "the backbone" of this movement "is not the lower classes" but instead "the lower sections of the new middle classes and traditional petty bourgeoisie." These groups, he says, are "psychologically alienated, socially declining, relatively well-off economically, but insecure and politically ineffective. They are reacting

against social deprivation at the hands of the upper social classes and government bureaucrats, on the one hand, and against the increasing militancy of the lower classes, on the other."

3. I need to distinguish between practical and pragmatic. Durkheim was opposed to the latter, particularly as a philosophy and worldview.

References

Ahmad, M. 1991. Islamic fundamentalism in south Asia. In *Fundamentalisms observed,* edited by M. E. Marty and R. S. Appleby, 457-530. Chicago: University of Chicago Press.

Althusser, L. 1977. *For Marx.* London: Verso.

Bassis, M. S., R. J. Gelles, and A. Levine. 1991. *Sociology,* 4th ed. New York: McGraw-Hill.

Bendix, R. 1963. *Work and authority in industry.* New York: Harper & Row.

Berger, P. L. 1969. *The sacred canopy.* Garden City, NY: Doubleday.

Chandler, R. C. 1984. "The wicked shall not bear rule." In *The new Christian politics,* edited by D. G. Bromley and A. D. Shupe, Jr., 41-62. Macon, GA: Mercer University Press.

Coser, L. 1956. *The functions of social conflict.* New York: Free Press.

Durkheim, E. 1961. *Moral Education.* Glencoe, IL: Free Press.

———. 1965. *The elementary forms of the religious life.* Glencoe, IL: Free Press.

———. 1982. *The rules of the sociological method.* New York: Free Press.

Feuerbach, L. 1957. *The essence of Christianity.* New York: Harper & Row.

Fowler, J. 1981. *Stages of faith.* San Francisco: Harper & Row.

Gilligan, C. 1982. *In a different voice.* Cambridge, MA: Harvard University Press.

Kohlberg, L. 1981. *The psychology of moral development.* San Francisco: Harper & Row.

Lechner, F. J. 1985. Modernity and its discontents. In *Neofunctionalism,* edited by J. Alexander, 157-76. Beverly Hills, CA: Sage.

Lewy, G. 1974. *Religion and revolution.* New York: Oxford University Press.

Malinowski, B. 1948. *Magic, science and religion.* New York: Free Press.

Mannheim, K. 1936. *Ideology and utopia.* New York: Harvest Books.

Marx, G. 1967. Religion, opiate or inspiration of civil rights militancy among negroes? *American Sociological Review* 32: 64-72.

Marx, K. 1976. *The German ideology.* Moscow: Progress Publishers.

———. 1977. Preface to *A critique of political economy.* In *Karl Marx,* edited by D. McLellan, 388-91. New York: Oxford University Press.

Merton, R. K. 1957. *Social theory and social structure.* Glencoe, IL: Free Press.

Niebuhr, R. 1935. *An introduction to Christian ethics.* New York: Harper.

Schoenfeld, E. 1974. Love and justice. *Review of Religious Research* 16: 41-46.

———. 1987. Militant religion. In *Religious sociology,* edited by W. H. Swatos, Jr., 125-37. New York: Greenwood Press.

———. 1989. Justice. *Review of Religious Research* 30: 236-45.

———. 1990. Privatization and globalization. *Archives de Sciences Sociales des Religions* 69: 27-40.

———. 1992. Militant and submissive religions. *British Journal of Sociology* 43: 111-40.

Schoenfeld, E., and S. G. Mestrovic. 1991. With justice and mercy. *Journal for the Scientific Study of Religion* 30: 363-80.

Thompson, E. P. 1966. *The making of the English working class.* New York: Vintage.

Weber, M. 1978. *Economy and society.* Berkeley: University of California Press.

Wuthnow, R. 1973. Religious commitment and conservatism. In *Religion in sociological perspective,* edited by C. Y. Glock, 117-32. Belmont, CA: Wadsworth.

4

Religion in Capitalist East Asia

JOSEPH B. TAMNEY

Religious pluralism within regions, within states, within families, and even within the individual is a defining characteristic of our time. While people continue to desire a set of beliefs and values that will give a sense of purpose and meaning to their lives, most of them have a choice among religious alternatives as well as between secular and religious ideologies. Modern people live in ideological markets, and this raises the question of what determines which ideology will be chosen in a certain context (Duke and Johnson 1989; Stark and Bainbridge 1985; Tamney 1987, 1992b).

This essay concerns East Asia—that is, that part of the world influenced by Confucianism. Because we know little about their populations, I will not consider the communist countries: mainland China, North Korea, and Vietnam. Thus, my focus is on religious developments in Hong Kong, Japan, South Korea, Singapore, and Taiwan. Specifically, I will consider the prevalence of religious nonaffiliation, the weaknesses of Buddhism, the so-called "new religions," the appeal of Christianity, and the significance of state ideologies.

Religious Nonaffiliation

Table 4.1 shows the religious composition of each country being considered. Noteworthy are the high percentages of people with no religious affiliation. Aside from Eastern Europe, the East and Southeast

Table 4.1 Religious Affiliation in East Asia (Year of Study
in Parentheses)

| Country | Folk Religion | Religious Affiliation | | | |
		Buddhism	Christianity	Other	None
Japan (1985)	4	39	1	2	53
South Korea		20	21	2	57
Singapore[a] (1990)		68	14		18
Taiwan[b] (1984)	65	15	4	1	15

[a] Chinese population only.
[b] Other research found that "nones" were 33% of the population in 1983 (Swanson 1986); Mitchell (1974) reported that 47% of the urban Hong Kong population was religiously nonaffiliated.
SOURCES: Hastings and Hastings 1986; Republic of China 1990; Singapore Department of Statistics 1991; United Nations 1991.

Asian region contains the highest percentage of nations with large num-
bers of religiously nonaffiliated people (Duke and Johnson 1989, 90).
The case of Singapore is especially instructive. This country contains
an East Asian people—the Chinese—and two South Asian peoples—the
Malays and people from the Indian subcontinent. The percentage of the
nonaffiliated is much higher for the Chinese (17.6%) than for the Malays
(0.1%) or South Asians (0.8%). How can we explain the tendency for
East Asian peoples to report no religious affiliation?

Folk religions have been the most popular ones in the region. These
religions have their own identities. As Viviene Wee (1977) has argued,
Chinese religion is a systematic religion, although noncanonical, with
its own worldview and ritual system. It is true that Chinese religion
has incorporated Buddhist elements: most notably the ideas of rebirth,
of self-cultivation, and of nirvana. But, such elements are redefined
to fit a religion that centers on gaining control of, or at least winning
this-worldly favors from a superhuman power that inhabits the world.
Similar arguments have been made for other folk religions in the region
(Hori 1968).

Because the folk religions have been so entwined with magic, they have
been especially vulnerable to the secularizing force of modernization.
Medicine, science, and technology compete with folk practices as means
of achieving health, agricultural success, and prosperity.

In the Chinese folk tradition, a funeral ceremony often involves the
preparation of elaborate paper models of cars, houses, and servants that
are to be burned so that the deceased may have these objects at their
disposal in the next life. "The 'servants' are advised [by a priest] to be

honest and hardworking, and the 'chauffeur' is warned to be sure to drive carefully. Finally the ceremonies are concluded with a bonfire of all the paper images" (Comber 1957, 22). In 1970 a student reported to me that he had asked his father, after such a ceremony, why paper money is burned. The reply was: "Whether dead people need money or food in the underworld, I don't know. Whether there is an underworld, nobody knows. What happens to a person after death, who can tell. But such things since your great-grandfather are always done." But modernization deprives tradition of its power to legitimate. Not surprisingly, religious nonaffiliation occurs more often among more educated people for whom the folk religions are superstitions (Basabe 1968; Dator 1969; Grichting 1971; Kuo and Quah 1988; Mitchell 1974; Tamney and Hassan 1987).

The folk religions of the Chinese, Japanese, and Korean peoples are less and less acceptable as worldviews to people in East Asia. These religions cannot eliminate modern technology, nor can they rely on tradition as the source of legitimacy. As folk systems dissolve in the process of modernization, many East Asians remain without religious affiliation.

This can happen because it has not been important in East Asia to have a particular religious identity. Attitudes reflecting this lack of concern about an individual's religious commitment can be found among East Asian peoples. Grichting (1971, 378) asked a sample of Taiwanese how their family would react if they wanted to marry someone who did not share the family's religion. Most (53%) said their family would remain neutral, and another 6% believed their family would be supportive. A finding with a similar significance was that 72% of the Japanese believed that all religions amounted to the same thing (Spae 1971, 218).

East Asians can be tolerant of religious pluralism because religious collectivities have not been functionally significant. In part, the lack of concern about religious identity results from the fact that in East Asia ethnic and national identities have not been defined in terms of a religion (Kitagawa 1965, 336; Tamney 1978; Welch 1968, 86). In part, the lack of concern about religious identity stems from the fact that organized religions in East Asia have not been important sources of a sense of community. It is the family cult that has provided identity in a community, although in the case of Japan it must be understood that the extended family has been equated with the nation (Bellah 1970). In East Asia, religions have not been essential parts of ethnic or national identities, nor have they provided needed feelings of social solidarity.

As a result, religious affiliation with an organized religion has been less functional than in other parts of the world. Thus, it is said that in Chinese and Japanese societies, religion other than the family cult is a personal affair (Davis 1983, 132; Hsu 1971, 57).

It may be the case that spirituality in East Asia is essentially multireligious. The Japanese case is especially interesting. While the Japanese are described as religious (e.g., Basabe 1968), an amazingly high percentage of the Japanese population does not claim a religious identity (see Table 4.1). Is one-half of the population without spirituality? As Basabe (1968, 117) put it, being religious for the Japanese means a person is composed (the external sign) and at peace (the internal sign). All paths to this twin goal are spiritual means, and each person is free to find the appropriate combination of religious tools. What is true of the Japanese in this regard may apply to the other East Asian peoples, many of whom do not feel a need to perceive themselves as affiliated with a religious group. Their tradition allows for individual searching and experimentation to find a personal spirituality.

Thus, in East Asia the relative frequency of religious nonaffiliation has resulted from the loss of faith in folk religions, the fact that religion beyond the family cult has not been socially significant, and the expectation that the spiritual quest is a personal affair for which each individual assembles her or his own gods, rituals, and beliefs.

Buddhism

In East Asia, Buddhism is a weak institution. Although it is described as the dominant religion in the region, actually relatively few people are committed to pure, nonsyncretic Buddhism (Tamney and Hassan 1987; see also Finney 1992). In Singapore, a much lower percentage of Buddhists claimed they were very devout compared to other religious groups (Kuo and Quah 1988). Basabe studied a random sample of Japanese men, ages 20 to 40 years, who lived in four large cities ($N = 1,303$). Five percent of his sample were traditional Buddhists, that is, Buddhists outside the new religions. Among this subsample, 47% felt no special attraction for any religion, including their own (Basabe 1968, 50). In contrast, 87% of those affiliated with Soka Gakkai, a new religion, reported feeling especially attracted to their religion. There are several reasons for the failure of Buddhism to be popular in East Asia.

Table 4.2 Authoritarianism in World Religions

Dimension	Religion			
	Catholicism	Islam	Hinduism	Buddhism
Dogmatic Authority	3	3	0	1
Directive Authority	3	3	3	0
Institutionalization	3	1	1	0
Total	9	7	4	1

SOURCE: From *Political Development: An Analytic Study* by Donald Eugene Smith, 1970, p. 176. Copyright 1970 by Little, Brown and Company. Used with permission.

First, Buddhism is weak structurally. Smith (1970, 175) developed an analytic framework for assessing the authoritarianism of a religious organization. He related authoritarianism to: (a) dogmatic authority, the degree of conviction that one's religion has the absolute truth; (b) directive authority, the extent to which a religion's regulations were comprehensive, covering all aspects of life; and (c) the institutionalization of authority, "the complexity and effectiveness of truth defining and rule enforcing structures." Smith compared several world religions on authoritarianism. In his evaluation 3 was the highest score, and 0 was the lowest. His findings appear in Table 4.2, and from these it can be seen that Buddhism is not likely to be highly successful in a social sense. Its meaning will not be clear. It will not seem relevant to many decisions, and it will not be able to use its resources efficiently to reach out to people.

To this day in South Asia, the organizational weakness of Buddhism is masked by its close affiliation with the state. Siriwardane (1965) has argued that Buddhism, more than other religions, is dependent on the state for success because it is a monastic religion and thus involves the laity only weakly. The secular nature of the East Asian states, therefore, is the second reason for the weakness of Buddhism.

A third reason is that the East Asian elites have not been committed to Buddhism. It is a notable feature of societies in which Buddhism is established that this ideology is never the sole religion. This is as true in South Asia as in East Asia. However, there is an important difference between the two regions. In South Asia, Buddhism has coexisted with animism; the latter belonged to the masses, while Buddhism was the religion of the elite. As a result, a relatively pure form of Buddhism was nurtured by South Asian elites, who ensured that Buddhist values were supreme in their lands (Sarachandra 1965). As a result, the Theravada

version of this religion retained a distinct identity and a privileged position in South Asian countries.

In East Asia, the dual model took a different form. After the T'ang dynasty, Buddhist monks felt the contumely of the Chinese literati, who until this century were confidently neo-Confucian (Wright 1959, 103). Similarly, during the Tokugawa period of Japanese history social classes were affected by different creeds and ideals, "the creed of the Samurai being Confucianism and that of the people Buddhism" (Anesaki 1963, 262). In Japan, Buddhism has probably exerted more influence on the elite than in China. Yet, in both countries the commitment of the elite to Confucianism has had the same weakening effects on the Buddhist institution. Buddhism was left to the masses, among whom it fused with folk religions, and especially with the family cult (Dore 1958, 315; Hackmann 1910, 257).

In East Asia, Buddhist monks have not been respected (Basabe 1967; Chan 1953; Tamney and Hassan 1987, 42-43). Buddhism was judged by Confucian criteria. Hackmann (1910, 245-48) suggested that the lack of respect for Buddhist monks in China resulted from their origin in the lower classes, the fact that monks did not study the literary classics, which was the most widely accepted route to social prestige, and because of such corrupt behavior by monks as opium smoking. Since its appearance in China, Buddhism has been criticized for emphasizing suffering, being unfilial, encouraging celibacy, and promoting begging (Smith 1968). Similar, albeit less intense, problems plagued Buddhism in other East Asian countries. Lack of elite support, little respect for the clergy, and corrupt practices reinforced one another and resulted in Buddhism's low prestige.

A fourth reason for the weakness of the Buddhist institution is modernization. Land reform has deprived Buddhist groups of their primary source of funds. Likewise, physical mobility has severed historic family ties with Buddhist temples (Ken 1972). At a more fundamental level, whereas Buddhism had become associated with death, especially in Japan, modernization offered hope of a new life, and people wanted a religion that told them how to live (Kitagawa 1965).

The fifth reason is the absence of a sense of urgency among Buddhist leaders. Generally, Buddhists accept that after death people are reborn and that the quality of the new life is determined by the law of karma. The karma-rebirth orientation means that everyone has endless time to reach nirvana and that, by and large, people can accept Buddhism only when their karma is good. Holding such a viewpoint, one may not expect

widespread acceptance of Buddhism nor experience any urgent need to change the situation. Hackmann (1910, 46) suggested that this belief in gradual progress toward enlightenment over lifetimes was the reason Buddhism made little effort to counter the inroads of other religions and was, in his view, fatal to Buddhism.

A sixth reason for the weakness of Buddhism is the secularization of one of its most appealing elements, meditation. In Japan, it is part of the popular culture that meditation can give spiritual strength to conquer personal obstacles (Dore 1958, 322). Before cramming for exams, students may spend a few weeks in a Zen temple to "enter the realm of not self." Japanese companies have required new employees to spend a few days as monks to learn mental concentration and discipline. One executive commented that workers return from the monastery better able to follow orders (Ushio 1969). In Singapore, meditation supposedly has become a fad being practiced for the "wrong" reasons: relaxation, mental power, or worldly success (Tan 1990). A person need not become a Buddhist to benefit from meditation.

Observers have suggested a Buddhist renaissance in East Asia (Korean Overseas Information Service 1989; Kuo, Quah, and Kiong 1988). Throughout the region, efforts are being made to purify Buddhism by disentangling it from folk religions. Generally, Buddhist groups in East Asia have been remodeling themselves along the lines of Christian churches; the laity are exercising more leadership, and the groups are engaging in more educational and charitable activities (Caldarola 1982; Norihisa 1972; Raguin 1976). Based on a Singapore study, the Buddhist renaissance seems to be more a matter of nominal Buddhists becoming more serious about their religion than of Buddhism winning converts from outside their faith (Kuo and Quah 1988).

But Buddhism also has strengths. It is an Asian religion, yet also a cosmopolitan one, making it appealing to those who want to break with tradition yet not identify with the West (Kuo et al. 1988; Tamney 1992a). Meditation, although often secularized, has gained worldwide prominence. Moreover, the Japanese Buddhist cultivation of an appreciation of nature and of aesthetic values appeals to modern people. In a *post-modern* world where people question valuing the individual, have raised beauty to be on a par with goodness, and have ceased to be lords of the jungle, Buddhism certainly has a future (see Finney 1992), but it is not clear that this is the dominant worldview of the East Asian.

Japanese New Religions

In Taiwan, "syncretistic sectarianism is a powerful new religious force" (Republic of China 1990, 573). About 5% of the South Koreans belong to new religions (Chung 1982). Such groups have been especially successful in Japan, where in 1980 reportedly 22% of the population belonged to the new religions (Ellwood 1987).

The Japanese groups are syncretic blendings of elements from folk religion, Buddhism, Confucianism, and Shintoism. The term *new religions* includes groups that have come into existence since the early part of the nineteenth century. What distinguishes them is that they focus on the individual rather than the household or community and they evangelize among the masses (Ken 1972). The new religions are reactions to the corruption of Buddhism and the failure of Buddhist and Taoist priests to reach out to people dislocated physically and culturally (Hardacre 1984; Morioka 1969).

Traditional elements are strong in the new religions. Each religion is identified with a historical, shamanesque figure toward whom loyalty is of fundamental importance. The organization is based on a parent-child model. Joining a new religion "locates all members in a vertical network of quasi-familial relations" (Ken 1972, 101). The well-developed organizations give counseling and fellowship to uprooted and lonely people, and within them women are allowed a greater role than in all other social institutions (Hardacre 1984, 193). The new religions are oriented to this world. Members are promised better health or material success (Blacker 1962). As Chung wrote about the Korean new religions: "They appeal largely to the lonely and troubled migrants, and in general to lower-class people suffering from illness, unemployment, poverty, or family problems" (1982, 623).

Hardacre (1986) has emphasized the neo-Confucian influence on new religions. The spiritual goal is self-cultivation—that is, the transformation of the self so that one's potential is fulfilled. The "self" is not an isolated entity; rather, it exists as parts of relationships to other people and things. Thus, self-cultivation means perfecting how one plays one's parts. A fulfilled self is evidenced in perfect (often equated with harmonious) relationships. The emphasis on cultivating the self leads to believing in the power of the individual to change her or his life. In the new religions, success or happiness depends on how well one cultivates the self, and failure is blamed on the individual's poor self-cultivation. The empowerment of the individual fits the modern context.

The new religions that have come into existence during the past 30 years are noticeably influenced not only by Asian traditions but also by Western spiritualism, theosophy, and other occult sources (Davis 1991, 800). Unlike their predecessors, the new religions attract many young people, whom it is suggested are overly restrained and bored by modern, rationalized society. In compensation, they seek spontaneous, exciting experiences in nondogmatic groups (Mullins 1989; Shigeru 1991).

The new religions are bridges between tradition and modernity. However, Davis (1991) has suggested that these religions are evolving into purely modern forms of religion. It should also be noted that Chinese new religions have not been as popular as those originating in Japan. In Singapore, a Japanese new religion, Nichiren Shoshu, is growing; Chinese new religions (e.g., the Red Swastika Society), however, are nearly invisible (Tan 1971).

Christianity

As can be seen in Table 4.1, Christians are a significant part of the population in South Korea, Singapore, and Taiwan. By contrast, in Japan Christians are 1% of the population, and they represent no more than 0.5% of the mainland Chinese (Neill 1987). In the countries where Christianity is relatively strong, it continues to grow. Among the Singapore Chinese, the percentage Christian increased from 10.7% in 1980 to 14.1% in 1990 (Singapore Department of Statistics 1991, 1). In 1987 Christianity became the largest religious group in South Korea.

Generally, Christianity has been able to grow in East Asia because of the declining popularity of folk religions and the weaknesses of Buddhism. Moreover, Christian groups have had the resources and evangelistic motivation to engage in missionary work. Because Christianity has been associated with the West, it has benefited from the overall achievement of European civilization. Missionaries often stood out and were respected because they founded schools, hospitals, and charitable organizations. Those attending Christian schools have tended to convert to Christianity (Kuo and Quah 1988; Tamney and Hassan 1987). Since World War II, Christians have established a number of transnational organizations, and as Digan (1984, 27) has noted, it is an advantage "to be the world's most conspicuously transnational religion when the world itself is entering a new transnational era."

Liberal Christianity, which emphasizes the struggle for social justice, has played a role in Asia and especially in Korea and Taiwan. A liberally activist church is most in evidence in South Korea. When Protestant missionaries first entered Korea, they worked among the common people, establishing schools and translating the Bible using the Korean alphabet (whereas the elite used the Chinese alphabet). Protestantism stood for equality, and joining this religion was a way of expressing rebellion against the establishment (Huang 1967). Moreover, during the Japanese occupation, Protestantism became associated with Korean nationalism (Digan 1984, 37). More recently, Koreans began developing Minjung theology, which is a style of liberation theology (Hyun 1985). Since the 1970s, international organizations such as the Christian Conference of Asia and the Federation of Asian Bishops' Conferences have issued statements aligning themselves with the causes of the poor (Digan 1984, 50). Liberal Christianity has gained support throughout the region because it has been involved in organizing on behalf of human rights, social justice, and women's rights.

Since World War II, American fundamentalist groups have become very active in the region and seem to be the segment of Christianity that is growing the fastest, at least in Singapore and Taiwan (Kuo and Quah 1988; Republic of China 1990). Such groups offer rewards similar to those associated with folk religions such as healing and exorcism (Chung 1982; Hinton 1985). The Full Gospel Central Church in Seoul is said to be the world's largest church, with a membership in 1983 of 250,000 people. Its success depends not only on effective organization but also on meeting the practical needs of its members for health, fertility, success, and protection from evil spirits. The church's founder functions as a shaman: "The only difference is that a shaman performs his wonders in the name of spirits while [the] Reverend Cho exorcises evil spirits and heals the sick in the name of Jesus" (Yoo 1986, 74). Because Buddhism lost its own identity and became confused with folk religions, the latter's disintegration harmed Buddhism. In contrast, Christianity, like the new religions, has been able to coopt elements of folk religions while retaining a modern image. As a result, the cooptation of folk elements has increased the popularity of Christianity.

In addition, charismatics, more than others, offer rewards formerly associated with family life, namely personal counseling and a sense of community. Singaporeans have been attracted to charismatic churches by the "community spirit which confers a sense of belonging and identity" (Kuo et al. 1988, 17). Youth for Christ has provided personal

counseling not only on spiritual matters but also regarding family and peer relationships. As one university student wrote: "Nobody at home seems to have time for me, so I turn to these counselors."

But church growth has been accompanied by significant leakage. Swanson (1986, 2) estimated that two-thirds of Taiwanese converts do not remain Christians. The figure for Singaporean Protestants was estimated to be one-third (Hinton 1985, 176). The Taiwanese problem to some extent is a result of Christian emigration, but the typical Chinese attitude toward religion must also be considered. Two images have been used to explain the relationship between the individual and a religious group. On the one hand, a church has been likened to a store: People would visit the establishment only as long as the church (store) provided goods they needed (Hsu 1968, 596). On the other hand, the Chinese word for "church" means "a teaching association." Many Taiwanese converts described their conversion as resulting from a teacher-student type of relationship (Swanson 1986, 93, 179). Ties to stores and schools do not convey permanency.

Whereas Buddhism and Confucianism have had to modernize, Christianity has had to engage in indiginization and contextualization. The former process has been largely completed, as the churches are now staffed by local people. But, contextualization is another matter. The foreignness of Christianity has been one reason for its avoidance. Cultural differences between Asian culture and Christianity are illustrated by this contrast between Japanese culture and Christianity: the Japanese emphasis on continuity between the divine and human versus the Christian division between the sacred and the profane, an optimistic view of human nature versus the Christian doctrine of sinful nature, and "a group-oriented ethic aiming at social integration as distinct from an interior ethic oriented to the individual who stands alone in the presence of God" (Norihisa 1972, 73).

Ironically, it is among the fastest growing segment of Christianity that a major cultural impediment exists. It is among the fundamentalist Christians that there coexists an intolerance of other faiths and a drive to convert all others to the evangelist's own church. This attitude clashes with the deep-seated Asian commitment to harmony. Aggressive evangelism was a reason used by the Singapore government to pass a law regulating interrelationships among religious groups in the name of religious harmony. When he was prime minister of Singapore, Lee Kuan Yew reportedly said that Singapore is too Asian to become a Christian society (Kuo et al. 1988, 11). Christian theology in East Asia

is "largely a reproduction of theological trends and traditions imported from the Euro-American world" (Song 1991, 2); however, some theologians are working to develop a theology rooted in the Bible *and* the history, symbols, and stories of Asia.

State Ideologies

In East Asia, Confucianism functions as a quasi-religion with schools replacing churches. Among Confucianists, immortality may be sought through public service or scholarship (Tamney 1988, 126). Moreover, morality in East Asia has been rooted less in religion than in Confucianism. It is the latter that has significantly influenced education in East Asia (Tu 1991, 743).

As a region, Asia stands out regarding the average percentage of total instructional time allocated to nonreligious moral education in the primary school curriculum (Benavot et al. 1991, 93). Moral education is a school subject throughout the region. In Japan, the content of this subject is a source of conflict between the government, which favors traditional values, and the teachers' union, which supports liberal ideals (Tomoda 1988). The Korean texts emphasize anti-communism and nationalism primarily; the subjects of economic development, militarism, and social stability are of secondary importance; other topics receiving little attention include democracy and the welfare state (Suh 1988, 99). Taiwanese texts emphasize filial piety and patriotism. Primacy is given to the group over the individual: "This is the leitmotif repeated again and again in the textbooks. It is a conscious rejection of what is considered the extreme individualism of the West" (Meyer 1988, 114). At the moment, Singapore is developing a new moral education program that will incorporate some Confucian values (Tamney 1988, 1992a).

Meyer analyzed the treatment of religion in Taiwanese school textbooks for the first nine years of compulsory education. Generally, while science was praised, superstitious religion was condemned. The world religions such as Buddhism, Christianity, and Islam were praised as sources of support for social order. Moon year festivals were treated as valuable *cultural markers*. Filial piety was positively portrayed, as was Confucianism, which was not treated as a religion. He writes:

In my judgment, the overall impression of religion which the textbooks give to the students would be something like this: religion is a part of the history of China and other great world cultures. Much of it is superstitious and ought to be discarded. But some religions do preserve important values, especially in upholding morality and public order. However, one who follows Confucius (though this view is never directly stated), has these values already and has no need for all the religious trappings which go with them. (Meyer 1987, 50)

Throughout the region, the Confucian approach is linked with nationalism. In Korea, elaborate events celebrate Tan-gun, the mythical progenitor of the Korean people. Some Christians have criticized this development as a violation of the separation of church and state, but the government sees Tan-gun as a symbol of cultural identity standing above religious differences (Buzo 1986). In Japan, Westernization is being blamed for supposed increases in selfishness and materialism; those espousing this definition of the situation promote a modern civil religion based on a sacred national identity (Davis 1991; Takayama 1988).

There is a Confucian revival going on East Asia (Rozman 1991; Tu 1991). In reaction to Western culture, scholars are modernizing Confucianism, but it is not yet clear whether this ideology can retain its identity and at the same time accommodate the social and cultural changes taking place in East Asia (Tamney forth.). Confucian scholars are receiving government support in several countries (Tu 1991). However, this is a mixed blessing, because opponents of those in power become opponents of Confucianism. Whether or not the Confucian revival succeeds will influence the popularity of all religions in East Asia.

Conclusion: For Further Research

East Asia is an ideological market dominated by folk religion, Buddhism, Christianity, Confucianism (or Confucianism-nationalism), the new religions, and communism. The strength of any one is partially dependent on the weaknesses of all the others. As a worldview, folk religions are losing their usefulness, legitimacy, and integrity. Folk rituals are being transformed into artistic ethnic markers. Folk beliefs and practices are being coopted by charismatic Christianity and the new religions. However, it is possible that Shintoism and Taoism will develop clearer, unique identities and more effective organizations.

In this competition, Christianity has advantages beyond financial resources. First, because Christianity has long existed in a differentiated

society in which alienation is endemic, it has learned to compensate for loss of community and to respond to the need for personal guidance in a modern society. Second, Christianity has already accommodated such humanistic values as individualism and self-realization that shape modernity. Third, pentecostal-charismatic Christianity has been able to coopt folk practices such as spiritual healing without losing its modern image. Yet, this religion remains foreign in East Asia.

While Christianity undergoes contextualization (i.e., tries to accommodate Asian cultures), the other regional ideologies are modernizing, that is, trying to accommodate values largely originating in the West. Are all these ideologies converging? Alternatively, diversification rather than convergence may be functional, because the former will more readily allow individuals to fashion personally satisfying religious styles. Ross played down the uniqueness of the Asian religious orientation, that is, of someone using diverse religious sources such as Confucianism, Buddhism, and Taoism; as he wrote: "It is not impossible to conceive a Christian who is a believer in Plato, who is also a religious devotee, and an ardent Spiritualist" (1900, 59). Indeed, in the present New Age such a depiction is quite easy to imagine. In East Asia, it may not be that ideological convergence occurs, but that each individual will fashion a personal spirituality that both satisfies individual needs and suits the person's context. Religious affiliation may become even less important in East Asia, as each individual creates a religious montage.

Future research should follow the two strategies of focusing on specific religions and considering the East Asian ideological market as a whole. Because Buddhism is being modernized and has traits appealing to modern people, it has potential for growth. The crucial question is whether it will mobilize the resources necessary to actualize its potential. Studies need to focus on the monks and their organizations: Is there a personnel crisis? Are monks working with and legitimating lay leaders? Do monks want to convert the masses? Do religious leaders have the skills and material resources to build effective organizations? The fate of Buddhism also depends on its relationship to folk practices and on its capacity to compensate for the declining significance of the family. At the present time, the new religions and Christianity have outperformed Buddhism regarding these two matters. Researchers need to search for any sign of the development of a Buddhist equivalent of the charismatic form of Christianity.

The new religions, bridges between the traditional and the modern, seem shifting more toward the modern side as their membership be-

comes more middle class. Does this mean they are losing their functional value and will decline in popularity? Or, will the syncretic nature of these religions make them increasingly attractive to cosmopolitan people? Given that a research tradition has developed for Japanese new religions, the need is for studies of new religions in Chinese contexts; after studies of specific groups, scientists can discuss the broad issue of why Chinese new religions have not been popular and whether this will change.

As East Asia modernizes and emulation of the West declines, the fate of Christianity in Asia may depend on the outcome of the contextualization project. Scientists need to understand what theologians are doing in East Asian schools of theology. For one thing, there is the question: Accommodate Christianity to which local context? At the present time, Christianity is the dominant religion among the aboriginal people of Taiwan (Republic of China 1990). To what extent should aboriginal culture be accommodated? How would the urban elite of Taiwan react to such contextualization? A Taiwanese survey found broad agreement on the following value priorities beginning with the most important: "family security, world at peace, inner harmony, comfortable life, friendship, prestige, faith, religion, happy afterlife" (Grichting 1971, 351). What would it mean for Christianity to adjust to such a context? Research concerning contextualization must simultaneously consider, however, whether East Asians are becoming more Westernized, thus making it less necessary for Christianity to adapt to Asian cultures. Scientists also need to study specific Christian congregations over at least a three-year period; the guiding questions would be: Why do people join? How many converts remain? Is contextualization relevant to the conversion process?

At the same time, global projects are necessary. It has been suggested that religious nonaffiliation is socially acceptable in East Asia. However, will the declining significance of traditional communities such as extended families result in more people permanently joining religious groups to satisfy a need for a sense of belonging? Or, will the religious pluralism in the region and the spread of cultural postmodernism to East Asia reinforce the acceptability of personal forms of spirituality? These questions can be answered by national surveys concerning religious affiliation.

Research is needed to determine the relative significance of secular and religious ideologies. Qualitative and quantitative studies should focus on what factors affect specific familial, economic, and political

decisions. Do spiritual values shape decisions made by East Asians not affiliated with religions? To what extent are decisions affected by Confucian values, and are these values consistent with or divergent from existing religious perspectives? Finally, some sociologists should work to integrate all such research as they assess the relative advantages of the various East Asian ideologies and attempt to predict the future of religion in East Asia.

References

Anesaki, M. 1963. *History of Japanese religion*. Rutland, VT: Tuttle.

Basabe, F. 1967. *Japanese youth confronts religion*. Tokyo: Tuttle.

———. 1968. *Religious attitudes of Japanese men*. Tokyo: Tuttle.

Bellah, R. 1970. Father and son in Christianity and Confucianism. In *Beyond belief*, edited by R. Bellah, 76-99. New York: Harper & Row.

Benavot, A., Y. Cha, D. Kamena, J. W. Meyer, and S. Wong. 1991. Knowledge for the masses. *American Sociological Review* 56: 85-100.

Blacker, C. 1962. New religious cults in Japan. *Hibbert Journal* 60: 305-15.

Buzo, A. 1986. Worship at the shrine of Korean nationalism. *Far Eastern Economic Review* 132 (24 April): 48-49.

Caldarola, C. 1982. Japan. In *Religions and Societies: Asia and the Middle East*, edited by C. Caldarola, 629-59. Berlin: Mouton.

Chan, W. 1953. *Religious trends in modern China*. New York: Columbia University Press.

Chung, C. 1982. Korea. In *Religions and Societies: Asia and the Middle East*, edited by C. Caldarola, 607-28. Berlin: Mouton.

Comber, L. 1957. *Chinese ancestor worship in Singapore*. Singapore: Moore.

Dator, J. A. 1969. *Soka Gakkai*. Seattle: University of Washington Press.

Davis, W. 1983. Japanese religious affiliations. *Sociological Analysis* 44: 131-46.

———. 1991. Fundamentalism in Japan. In *Fundamentalisms observed*, edited by M. E. Marty and R. S. Appleby, 814-42. Chicago: University of Chicago Press.

Digan, P. 1984. *Churches in contestation*. Maryknoll, NY: Orbis.

Dore, R. P. 1958. *City life in Japan*. London: Routledge & Kegan Paul.

Duke, J. T., and B. L. Johnson. 1989. Religious transformation and social conditions. In *Religious politics in global and comparative perspective*, edited by W. H. Swatos, Jr., 75-109. New York: Greenwood Press.

Ellwood, R. S. 1987. New religions in Japan. In *The encyclopedia of religion*, vol. 10, edited by M. Eliade, 410-14. New York: Macmillan.

Finney, H. C. 1992. Pilgrimage to Japan. In *Twentieth-century world religious movements in neo-Weberian perspective*, edited by W. H. Swatos, Jr., 75-91. Lewiston, NY: Mellen.

Grichting, W. L. 1971. *The value system in Taiwan 1970*. Taipei: privately printed.

Hackmann, H. 1910. *Buddhism as a religion*. London: Probsthain.

Hardacre, H. 1984. *Lay Buddhism in contemporary Japan*. Princeton, NJ: Princeton University Press.

———. 1986. *Kurozumikyo and the new religions of Japan*. Princeton, NJ: Princeton University Press.

Hastings, E. H., and P. K. Hastings. 1986. *Index to international public opinion, 1984-1985*. Westport, CT: Greenwood Press.

Hinton, K. 1985. *Growing churches Singapore style*. Singapore: Overseas Missionary Fellowship.

Hori, I. 1968. *Folk religion in Japan*. Chicago: University of Chicago Press.

Hsu, F.L.K. 1968. Chinese kinship and Chinese behavior. In *China's heritage and the Communist political system*, edited by P. Ho and T. Tsou, 579-608. Chicago: University of Chicago Press.

———. 1971. *The challenge of the American dream*. Belmont, CA: Wadsworth.

Huang, S. 1967. Protestant churches in Korea. In *Aspects of social change in Korea*, edited by C. I. E. Kim and C. Chee, 148-64. Kalamazoo, MI: Korea Research and Publications.

Hyun, Y. 1985. Minyung theology and the religion of Han. *East Asia Journal of Theology* 3: 354-59.

Ken, A. 1972. New religious movements. In *Japanese religion*, edited by Agency for Cultural Affairs, 89-104. Tokyo: Kodansha International.

Kitagawa, J. M. 1965. The Buddhist transformation in Japan. *History of Religions* 4: 319-36.

Korean Overseas Information Service. 1989. *Facts about Korea*. Seoul: Hollym.

Kuo, E. C. Y., and J. S. T. Quah. 1988. *Religion in Singapore*. Singapore: Ministry of Community Development.

———, J. S. T. Quah, and T. C. Kiong. 1988. *Religion and religious revivalism in Singapore*. Singapore: Ministry of Community Development.

Meyer, J. F. 1987. The image of religion in Taiwan textbooks. *Journal of Chinese Religions* 15: 44-50.

———. 1988. A subtle and silent transformation. In *The revival of values education in Asia and the west*, edited by W. K. Cummings, S. Gopinathan, and Y. Tomoda, 109-30. Oxford: Pergamon.

Mitchell, R. E. 1974. Religion among urban Chinese and non-Chinese in Southeast Asian countries. *Social Compass* 21: 25-44.

Morioka, K. 1969. Contemporary change in Japanese religion. In *Sociology and religion*, edited by N. Birnbaum and G. Lenzer, 382-86. Englewood Cliffs, NJ: Prentice-Hall.

Mullins, M. R. 1989. The situation of Christianity in contemporary Japanese society. *Japan Christian Quarterly* 55 (2): 78-90.

Neill, S. C. 1987. Christianity: Christianity in Asia. In *The encyclopedia of religion*, vol. 3, edited by M. Eliade, 418-23. New York: Macmillan.

Norihisa, S. 1972. Christianity. In *Japanese religion*, edited by Agency for Cultural Affairs, 71-88. Tokyo: Kodansha International.

Raguin, Y. 1976. Buddhism in Taiwan. In *Buddhism in the modern world*, edited by H. Dumoulin, 179-85. New York: Collier Books.

Republic of China. 1990. *Republic of China yearbook 1990-1991*. Taipei: Kwang Hwa.

Ross, J. 1900. The Chinese people and their religion. *Proceedings of the Philosophical Society of Glasgow* 32: 48-59.

Rozman, G., ed. 1991. *The East Asian region: Confucian heritage and its modern adaptation*. Princeton, NJ: Princeton University Press.

Sarachandra, E. R. 1965. Traditional values and the modernization of a Buddhist society. In *Religion and progress in modern Asia*, edited by R. Bellah, 500-530. Glencoe, IL: Free Press.

Shigeru, N. 1991. Youth, deprivation, and new religions. *Japan Christian Quarterly* 57 (1): 4-11.

Singapore Department of Statistics. 1991. *Census of population 1990.* Singapore: Department of Statistics.

Siriwardane, C.D.S. 1965. Buddhist reorganization in Ceylon. In *Religion and progress in modern Asia,* edited by R. Bellah, 531-46. Glencoe, IL: Free Press.

Smith, D. E. 1970. *Religion and political development.* Boston: Little, Brown.

Smith, D. H. 1968. *Chinese religions.* New York: Holt, Rinehart & Winston.

Song, C. 1991. *Third-eye theology.* Maryknoll, NY: Orbis.

Spae, J. J. 1971. *Japanese religiosity.* Tokyo: Oriens Institute for Religious Research.

Stark, R., and W. S. Bainbridge. 1985. *The future of religion.* Berkeley: University of California Press.

Suh, S. C. 1988. Ideologies in Korea's morals and social studies texts. In *The revival of values education in Asia and the west,* edited by W. K. Cummings, S. Gopinathan, and Y. Tomoda, 93-108. Oxford: Pergamon.

Swanson, A. J. 1986. *Mending the nets.* Pasadena, CA: Carey Library.

Takayama, K. P. 1988. The revitalization movement of modern Japanese civil religion. *Sociological Analysis* 48: 328-41.

Tamney, J. B. 1978. Chinese family structure and the continuation of Chinese religions. *Asian Profile* 6: 211-17.

————. 1987. Islam's popularity: the case of Indonesia. *Southeast Asian Journal of Social Science* 15: 53-65.

————. 1988. Religion and the state in Singapore. *Journal of Church and State* 30: 109-28.

————. 1992a. Conservative government and support for the religious institution in Singapore. *Sociological Analysis* 53: 201-17.

————. 1992b. *The resilience of Christianity in the modern world.* Albany: State University of New York Press.

————. forth. Confucianism and democracy. *Asian Profile.*

Tamney, J., and R. Hassan. 1987. *Religious switching in Singapore.* Singapore: Select Books.

Tan, H. 1971. The Singapore branch of the World Red Swastika Society. *Ching Feng* 14 (4):131-41.

Tan, K. K. 1990. Meditation for beginners (calm and tranquility). *Buddhist Library Newsletter* (Singapore).

Tomoda, Y. 1988. Politics and moral education in Japan. In *The revival of values education in Asia and the west,* edited by W. K. Cummings, S. Gopinathan, and Y. Tomoda, 75-92. Oxford: Pergamon.

Tu, W. 1991. The search for roots in industrial East Asia. In *Fundamentalisms observed,* edited by M. E. Marty and R. S. Appleby, 740-81. Chicago: University of Chicago Press.

United Nations. 1990. *1988 demographic yearbook.* New York: United Nations.

Ushio, S. 1969. Instant Zen. *Asia Magazine* (12 Oct.): 8-10.

Wee, V. 1977. *Religion and ritual among the Chinese of Singapore.* Master's thesis, National University of Singapore.

Welch, H. 1968. *The Buddhist revival in China.* Cambridge, MA: Harvard University Press.

Wright, A. 1959. *Buddhism in Chinese history.* New York: Athenaeum.

Yoo, B. W. 1986. Response to Korean shamanism by the pentecostal church. *International Review of Mission* 75 (Jan.): 70-74.

5

Liberation Theology
in Latin America and Beyond

W. E. HEWITT

Since its informal baptism at the historic 1968 Latin American bishops' meeting in Medellín, Colombia, liberation theology has emerged as a subject of considerable controversy among students of the Roman Catholic Church. Liberationists themselves and others on the Catholic left have equated this new theology with true Christian praxis, offering not only insight into the causes of poverty and injustice in the world, but presenting the faithful with a vehicle for overcoming the conditions that oppress them (see, for example, Ellis and Maduro 1989). Yet, with equal vehemence, others have criticized liberation theology for its lack of attention to empirical realities (Dodson 1979; Hewitt 1989a), its predominantly ideological character (McCann 1981), or its uncritical use of Marxism (see McGovern 1988, 51).

Such intellectual debates aside, however, there is little question that since its inception, liberation theology has developed a sympathetic audience within segments of the Church itself. Certainly its influence may be identified at the lowest levels of the institution, especially among the poor and oppressed, who are the focus of liberationist concern. To a considerable extent, liberationism has also been embraced by those lay Catholics and clergy who have chosen to work alongside the less privileged in their struggle for a better life.

At higher levels of the institutional Church, by contrast, overt support for liberation theology is less apparent. Nevertheless, Church leaders

in a number of countries have professed at least some measure of attachment to the liberationist cause. Where it is in evidence, moreover, such attachment is of considerable significance, since the willingness of the upper hierarchy to redirect the collective wealth of the Church to social justice ends may serve as a primary catalyst for the adoption of liberationist praxis within the larger institution.

Within the literature, much attention has already been focused on this relationship between liberationist thinking and institutional practice orchestrated at the level of the upper hierarchy. For the most part, though, this research has examined the attitudes and activities of Church leaders in underdeveloped countries—especially those of Latin America (Bruneau 1974, 1982; Levine 1980, 1986). Far less attention has been paid to related Church undertakings in more affluent settings, even though evidence exists that the social justice cause of liberationism has been adopted, to at least some extent, in many parts of the developed world.

In an attempt to broaden the geographical focus of research on liberationist influence, this chapter moves beyond the traditional venues of concern to consider the impact of the current social justice cause in this more affluent context. Following a brief overview of the origins and nature of liberationist influence, the investigation begins with an examination of the words and actions of the upper hierarchy of Brazil—a country currently undergoing the stresses and strains of development, and one where the Church has developed a reputation as one of the most progressive within world Catholicism in implementing the "preferential option for the poor." The study then moves to consider developments within the national bishops' conferences of the United States and Canada, two highly industrialized countries that represent examples of somewhat qualified and progressive attempts, respectively, to embrace the liberationist principles that have been effectively applied in the Brazilian case.

Overall, the comparison reveals both similarities and differences across national boundaries in terms of the depth and consequences of an institutional commitment to the liberationist cause. The study suggests, moreover, that such international variation is a function not only of development-related environmental factors, but also of important cultural variables. In its conclusion the chapter points to avenues for further research on the nature and origins of social justice concerns in these and other cases, as well as on the ability of individual churches—and indeed, liberation theology itself—to develop further in light of both

indigenous enviro-cultural factors and important shifts in perspective and priority on the part of the Vatican.

Liberationism and Institutional Practice

In spite of criticisms, there can be little question that the strong political language and abiding concern for the just social order voiced by liberation theology has found a home within the Church. Consonant with liberationist calls for the Church as an institution to take the side of the poor, this is true even at the highest levels of institutional governance—an important development, given that it is precisely here that the resources and the power of the Church can be most effectively marshaled to effect real change.

As regards the precise way in which liberationist concerns with social justice have achieved some measure of prominence among the upper hierarchy, a number of theories have emerged over the years, focusing mainly on Latin America. Some authors—especially liberationists themselves—have stressed the role of the poor and oppressed directly in convincing Church leaders to address injustice, while assigning only a secondary "reinforcement" function to the content of liberation theology (see Boff 1981; Gutiérrez 1983). Others have adopted a similar position but have assigned the primary transformative role to key intermediary strata (such as those involved with Catholic Action, or progressive elements within the clergy and lay orders), who they believe have enhanced the receptivity of the liberation cause among the episcopate (Adriance 1986; Mainwaring 1986). Finally, there are those who argue for a more direct role of liberation theology itself, as well as other progressive influences emerging from twentieth-century Catholic social teaching. According to this view, it is these ideological influences, combined with the bishops' recognition of widespread suffering and the need to preserve hegemony in the face of secularizing influences, that moved the bishops to act (see, for example, Bruneau 1974).

It is not the task of this chapter to examine and assess the direct or indirect role played by liberation theology, or the environmental and ideological factors cited above, in enhancing progressivism within the highest levels of the Church. In good measure, this has already been attempted elsewhere, especially involving the Latin American case (see Adriance 1991; Hewitt 1989b). Instead, here we will simply investigate

the extent to which liberationism's well-known call for the promotion of social justice has been heeded by the institutional Church in disparate social settings.

The Brazilian Case

The Roman Catholic Church in Brazil has long represented a very formidable organizational presence within society. Currently, it possesses more than 350 bishops, 12,000 priests, and nearly 40,000 men and women religious, who operate from an 8.5-million-square-kilometer territorial base that includes some 250 dioceses and 6,000 parishes. The Church counts as its members, moreover, nearly 90% of the Brazilian population, estimated in 1990 at 150 million (CNBB 1984, 95; IBGE 1986, 52).

In terms of its societal role, this important institution has historically been a conservatizing force in Brazilian society. Since the European discovery of Brazil in 1500, the Church had worked hand in glove with the State in an effort to secure the interests of each. In return for its support of the State, and thus for economic and political elites in Brazil, the Church was supported financially and given full dominion over matters of faith (Bruneau 1974).

By the late 1950s, however, the Church in Brazil had begun to change, addressing itself to the this-worldly needs of the great mass of Brazil's citizens—the poor. In the case of Brazil as elsewhere, there has certainly been much controversy about why such a change took place (see Hewitt 1989b). There is little question, however, that this transformation was strongly conditioned by changing realities both within the Church—in the form of progressive social teaching—and within Brazilian society—such as the massive dislocation caused by rapid industrialization in the postwar period, and the installation of the repressive bureaucratic-authoritarian state structure developed in the wake of Brazil's 1964 military coup. Out of these new realities, what evolved was a Church consciously and aggressively seeking to promote social change, in accordance with the program called for by liberation theology—the "preferential option for the poor."

This "option for the poor" has, for the most part, been coordinated by the highest level of the Church government in Brazil—the Conferencia Nacional dos Bispos do Brasil or CNBB (National Conference of Brazilian Bishops). In terms of rhetoric alone, the bishops conference

has, since its formation in 1952, engaged in strong social justice advocacy. Between 1970 and 1980 especially, during the height of the repression orchestrated by the military dictatorship, the frequency and ferocity of justice-related statements was particularly noteworthy. Though struck in general terms, and not mentioning the military specifically, the statements of this period were clearly critical of the political and economic status quo in Brazil. Some, including *Comunicação Pastoral ao Povo de Deus* (1976), denounced specific acts of injustice against the Church and other members of society. Others, such as *Exigências Cristãs de uma Ordem Política* (1977), and subsidiary documents like *Igreja e Política: Subsídios Teológicos* (1974), were designed to remind policymakers and ordinary Brazilians of their political and social duties as good Christians and citizens.

In the early 1980s, taking advantage of incipient moves to democratization on the part of the regime, CNBB documents became even more explicitly critical of the ruling military and, for the first time, sought to articulate and obtain support for specific social reform initiatives. Thus, in *Reflexão Cristã sobre a Conjuntura Política,* released in 1981, the CNBB sought to "sensitize public opinion to the extremely grave picture of mass worker lay-offs in Brazil," as well as other social problems, and to "reaffirm to the suffering classes that we are at their side and support their efforts at tackling their problems and seeking just solutions" (pp. 11-12). Subsequently produced documents and studies, such as *Solo Urbano e Ação Pastoral* (1982), *Diretrizes Gerais da Ação Pastoral da Igreja do Brasil* (1983), and *Por uma Nova Ordem Constitucional* (1986) helped to clarify further and strengthen the CNBB's social justice position, and to develop broad support for its program.

In addition to official documents and statements, the social justice concerns of the upper hierarchy have been institutionalized through a variety of practical means. Through its promotion of the yearly *Campanha da Fraternidade,* for example, the CNBB has worked to enhance discussion of key justice issues, such as racism or poverty, throughout the Church. Moreover, with the help of Church research agencies such as the Instituto Brasileiro de Desenvolvimento (IBRADES) and the Centro de Estatística Religiosa e Investigações Sociais (CERIS), it has frequently commissioned studies designed to inform Church members and all Brazilians as to the deteriorated state of Brazilian society, politics, and economics.

As early as the mid-1970s, the CNBB had also developed some focused action-oriented agencies and commissions that placed the institution

securely at the forefront of the battle against social injustice (see Mainwaring 1986; also Bruneau 1974, 1982). These include the Comissão Justiça e Paz (CJP), formed in 1971 as a watchdog group on the domestic civil rights situation; the Conselho Indiginísta Missionário (CIMI), formed in 1973 to protect the human and civil rights of Brazil's native population; the Comissão Pastoral Operária (CPO), which concerns itself with workers' rights and labor issues; the Comissão Pastoral da Terra (CPT), created in 1975 to protect the rights of small landholders; and the Movimento de Educaçao de Base (MEB), which is essentially the heir of a literacy campaign first organized by the Church in the late 1950s and early 1960s.

One last front on which the leadership of the Church has moved effectively to institutionalize the social justice thrust is through its promotion of the base Christian communities or CEBs. Currently, there are estimated to be some 3 to 4 million Brazilians involved in 60,000 to 80,000 of these groups, located for the most part among the poor in rural or urban working-class areas. Typically, each group counts about 20 to 50 members, although some claim to attract up to 200 (see, for example, Bruneau 1982; Hewitt 1991; Mainwaring 1989). As grass-roots organizations protected and legitimized by the Church, many of these groups have been on the front lines of confrontation with political authority, combining their more devotional undertakings with political consciousness raising and petitioning activities. During the years of the military dictatorship especially (1964-1985), the groups served as an important space for ordinary Brazilians to air popular grievances. Just as important, however, by their mere existence, the CEBs have served as an omnipresent reminder to successive governments of the Church's commitment to social justice.

The United States Case

With some 350 bishops, 58,000 priests, and 130,000 women religious (Mosqueda 1986, 140), the Roman Catholic Church in the United States, in terms of physical size, compares favorably with its sister institution in Brazil. As regards its presence in society, however, the United States Church is much less of a force. With a nominal membership of approximately 49 million, the United States Church accounts for only about 28% of the population (as compared to nearly 90% in Brazil) and competes with a myriad of Protestant and other religious groups in a very

lively religious marketplace. In socioeconomic terms, as well, the United States Church operates in an entirely different context from its Brazilian counterpart. Unlike Brazil, the United States is a developed country—a leading member of the Group of Seven major industrial powers.

This is not to say, however, that the United States Church operates within a society that is devoid of social problems. Without question, pockets of poverty and underprivilege exist, and of considerable size. Significantly, as well, such pockets have tended to thrive disproportionately among specific racial and ethnic groups—especially African-Americans and Hispanics.

In good measure, then, the United States possesses at least some of the forces that gave rise to the concern for social justice in Latin America, and indeed, to the extent that liberationism has found a foothold in the United States, it is precisely among those whose position resembles that of the poor and oppressed in that region (see Rosado 1992). As an example, during the first Theology in the Americas Conference, held in Detroit in 1975, liberationists in attendance found their views well received by "people linked with minority movements, such as the Blacks, Hispanics, Native Americans, and other . . . groups" (Stewart 1982, 19). Working committees for these groups, as well as for labor and Asian Americans were set up, and met once again at a subsequent Theology in the Americas Conference held in 1980.

By contrast, within the upper levels of the institutional Church in the United States, liberationist thinking has been offered a much cooler reception. Indeed, it would be difficult to envision the leadership of the United States Church as "liberationist" in any real sense.

This is not to say, however, that the United States bishops, as compared to their Brazilian counterparts, have completely rejected the social justice cause. In terms of rhetoric, the bishops have most certainly in recent years released important statements on global and domestic socioeconomic and political issues (see Benestad 1982). On the international front, both through their own National Conference of Catholic Bishops (NCCB) and the United States Catholic Conference (USCC)— in which they play the major role—the bishops have spoken out strongly on human rights issues. In their 1974 statement, titled *Development-Dependency: The Role of the Multinational Corporation,* for example, they addressed the deleterious effects of global-scale corporations on Third World development. The United States bishops also advocated pacifism during the Vietnam War in their *Human Life in Our Day* (1968), and

spoke out on the evils of nuclear proliferation in documents such as *The Challenge of Peace,* released in 1983. On the domestic front as well, the United States bishops have called attention to a number of problems. The bishops have commented forcefully, for example, on problems faced by farm labor, in documents such as *Farm Labor* (1968) and *Resolution on Farm Labor* (1975). Similarly, in their 1975 statement, *The Right to a Decent Home: A Pastoral Response to the Crisis in Housing,* the bishops reflected on housing problems. On the economy, the United States bishops have also released several important statements, among them *The Economy: Human Dimensions* (1976) and *Economic Justice for All* (1986).

Still, these and other episcopal documents have tended to operate within a rather narrow spectrum of concern. In their treatment of international issues, development-related or North-South concerns have largely been superseded by a focus on questions related to the same East-West issues that have dominated United States politics since the Second World War. Similarly, while the bishops' concern for the downtrodden is clearly evident in their statements on domestic affairs, calls for social and economic restructuring are either absent or muted—unlike the Brazilian case. For the most part, the bishops' statements are oriented more toward policy formation and alteration at the level of government than wholesale societal transformation.

The NCCB's pastoral on *Catholic Social Teaching and the U.S. Economy* (1984) provides an interesting case in point. Although the statement is somewhat critical of political leadership in the United States, it has been described as timid due to both its emphasis upon policy deficiencies and its lack of consideration of the structural causes of social ills (Harrison 1985). Baum (1985) has suggested as well that the statement is a mere reflection of the dominant liberal tradition in America insofar as it advocates a piecemeal or individualistic approach to the solution of social problems.

Where, moreover, the bishops have specifically invoked the "preferential option for the poor" in their 1984 statement, they appear to have adopted a circumscribed understanding of the notion. Although the concept ideally is meant to express solidarity with the poor in their struggle to transform inherently unjust social structures (as was shown in the case of Brazil), the United States bishops have used it more as a principle of social ethics, which must be merely taken into account when advocating or formulating public policy. Moreover, as Baum (1985) points out, the bishops have directed their pastoral on the economy to

those in authority in America, not to the grass roots in the first instance, as the "option for the poor" would seem to dictate.

In terms of concrete undertakings in support of liberationist aims, the United States bishops have adopted a similarly circumscribed approach. To be sure, the USCC does possess three justice-related committees and corresponding departments operating in the areas of Communications, Education, and Social Development and Peace (Benestad 1982, 143). This last department includes a Domestic Social Development Office and an Office for International Justice and Peace, which has been particularly active in providing curriculum material on social justice issues for Catholic schools, adult education programs, and in preparing articles for the Catholic press and journals. All in all, however, the function of these bodies is educational, with little or no emphasis on organizing active opposition to particular forms of injustice.

At lower institutional levels, Justice and Peace offices are also active on the social justice front (Murphy 1987, 61), but little is known of the quantity, distribution, or functions of these. As in Brazil, a base Christian community movement is known to exist as well, operating among concerned middle-class intellectuals, or within specific ethnic and other underprivileged sectors of the population (see Cason 1984; Cox 1984, 124; Mosqueda 1986, 158). Unlike Brazil, however, these American CEBs operate largely in isolation from each other and receive no coordinating direction at the level of the national institution.

The Canadian Case

While not overtly hostile to the theology of liberation and its ends, evidence of its influence in the United States case is, then, somewhat limited. Yet, the United States example is not necessarily typical of more affluent countries. A much better example of the adoption of the liberationist cause can in fact be found in another highly developed country immediately to the north—Canada.

Indeed, in many respects, the Canadian Catholic Church has more in common with its Brazilian counterpart than that of the United States. Like the Brazilian Church, for example, in terms of its size and role in society, the Canadian Church is a much larger institution than it is in the United States. While it operates from a base of just 64 ecclesiastical units (as compared to nearly 250 in Brazil) and has only 128 bishops (compared with Brazil's 350), it possesses roughly the same number of

priests and religious (12,000 and 40,000, respectively). Moreover, although the Canadian Church does not enjoy the monopolistic position of the Brazilian Church, Canadian Catholics account for nearly one-half of the total national population of 25 million (Bibby 1987, 47; Canadian Catholic Church Directory 1988).

In terms of its commitment to social justice, the Canadian Church also appears to fall in step with its sister Church to the south. Where rhetorical content is concerned, like the Brazilian Church, the Canadian Church has long spoken out against social injustice, much longer and more vociferously than has been the case in the United States (see Sheridan 1987). Even before Vatican II, in fact, in such statements as *Christian Citizenship in Practice* (1956), *Collaboration Between Management and Labour* (1959), and *The Social Teaching of the Church* (1961), the Canadian Conference of Catholic Bishops (CCCB) had initiated an attempt to educate Catholics about Church teaching with respect to social justice.

During the 1960s, after the close of the Council, statements began to address social and political issues even more directly, as well as taking on a clear North-South perspective. CCCB pronouncements, such as *Poverty in Canada* (1966) and *On Development and Peace* (1968), outlined the nature of social problems in some detail and affirmed the Church's role as a defender of the downtrodden. This tendency was further strengthened in important documents subsequently prepared by specific episcopal committees. Among the most significant of these were the Episcopal Commission for Social Affairs'(ECSA) *The Church's Solidarity With Workers and With Victims of Social Injustice* (1968) and *Liberation in a Christian Perspective* (1970).

As in Brazil, it was really after 1970 that the most strident and controversial episcopal declarations began to appear. In a string of documents produced by the CCCB or its Administrative Board, including *Sharing National Income* (1972), *From Words to Action: On Christian Political and Social Responsibility* (1976), and *A Society to Be Transformed* (1977), the Church launched a frontal attack on the Canadian social, economic, and political establishment. These and other statements also called, in no uncertain terms, for a fundamental restructuring of Canadian society, so as to make it more compatible with Christian ideals. As the bishops stated in *Unemployment: The Human Costs* (1980):

The Gospel calls us to prepare for God's Kingdom by participating in the building of a society that is truly based on justice and love. In Canada today,

this vision includes a more equitable distribution of wealth and power among the people, and the development of this country's resources to serve basic human needs.

Throughout the 1980s, these trends continued, with the release of some of the most focused and explicit episcopal statements yet witnessed—most of them prepared by the Social Affairs Commission. The Commission's *Ethical Reflections on the Economic Crisis* (1982), for example, offered a stinging attack on government inaction during the economic recession of the time, and even laid out a program for social and economic reform. Released in 1987, *Free Trade: At What Cost?* decried the Canadian government's intention to remove trade barriers with the United States, citing detrimental effects the plan would have on employment and social programs.

Compared with its American counterpart, the Canadian episcopal conference has also developed far more means for institutionalizing its social justice concerns. One important agency established by the CCCB to promote social justice in Canada is the Canadian Catholic Organization for Development and Peace. Mandated to promote international cooperation to fight underdevelopment, the CCODP has, since its inception in 1967, undertaken to educate Canadians about the reality, causes, and consequences of world poverty, and with a yearly budget of some $16 million, frequently sponsors small-scale development projects in underdeveloped countries. Currently, Development and Peace encompasses 278 local groups and some 2,500 volunteer members and maintains representative bodies in 50 of the 64 Canadian dioceses ("Development and Peace" 1988, 8).

Another vehicle supported by the Church for the operationalization of its social justice agenda has been the Social Affairs Commission of the CCCB. Operative in various forms since the 1950s, the Commission is currently formed of eight bishops (chosen from within the CCCB) who meet five times per year to set their agenda. In addition, the Commission maintains a permanent secretariat (the Social Affairs Office) to puts its directives into action.

The social justice concerns of the Commission fall into three program or target areas (see ECSA, 1984). The first priority area concerns questions of faith and justice, and the relationship in general between religion and secular practice in the social and political spheres. The second priority area is justice in Canada, and deals with issues of regional inequality, native people, urban poverty, and so forth. The third

area of concern is justice in the Third World, and involves issues such as human rights, world peace, and environmental protection.

In each of these areas, the Commission, through its national office, undertakes a variety of activities, following a methodology that roughly resembles the see-judge-act strategy developed by the Catholic Action movement and later propagated by Latin American liberation theology (see Cleary 1985, 63-65). The Commission maintains, first, a social research function, involving information gathering on issues of concern (for example, such as urban poverty). Second, there is an attempt to educate Catholics and other Canadians as to the extent to which problems exist. This is usually accomplished through the publication of statements and documents, such as *Ethical Reflections on the Economic Crisis*. Finally, the Commission stimulates concrete action through various social outreach strategies. For example, it seeks representation on relevant social policy bodies and interchurch committees; it networks with various organizations and agencies already active on projects related to the Commission's priority areas; and finally, it attempts to establish and maintain communication links with popular associations, such as labor unions, women's groups, ecumenical organizations, and Church groups (ECSA 1984; Interview with Tony Clarke, Director of Social Affairs Office, CCCB, 30 June 1989).

Mirroring the Brazilian experience to some extent, one last area where the institutionalization of social justice concerns has been attempted is through the phenomenon of the base Christian communities. Indeed, in the CCCB's *From Words to Action* (1976), parish and local community groups are seen as playing a vital role in the fight for social transformation by denouncing injustices, "speaking the truth to those in power," and directly participating in "actions to change the policies of governments, corporations, and other institutions that cause human suffering."

Sympathetic observers of the Canadian base community phenomenon have identified lay communities in Canada existing among all social classes and attuned to a variety of issues. According to Clarke (1981), for example, there exist, on the one hand, a number of "popular Christian communities"—composed of factory workers, native people, the poor, refugees, and immigrants—that focus on issues of immediate importance to their participants. On the other hand, Clarke has discovered a variety of "progressive Christian communities"—formed of more affluent Canadians—with an interest in more global issues, related to

such things as industrialization, food and energy production, development, regional disparities, and human rights.

Though strong similarities do exist, it would, however, be misleading to suggest that the Church in Canada is a replica of its Brazilian counterpart when action on these and other justice areas is concerned. While, for example, the statements of the Canadian bishops speak with all the ferocity of the Brazilian pronouncements, justice organizations have had mixed success. Although it has been a strong supporter of overseas development projects, Development and Peace has maintained only a skeletal presence where public education in Canada is concerned. In 1989-1990, public awareness programs accounted for 14% of organizational disbursements, an amount only slightly greater than that used for administrative purposes ("Development and Peace" 1991). Moreover, Development and Peace maintains educational coordinators or *animateurs* in only 19 of Canada's 64 Roman Catholic dioceses; and while it is true that these are spread out rather evenly, given the distribution of the Catholic population, the ratio of dioceses to *animateurs* in all regions is typically above 3 to 1.

The national Social Affairs Office similarly has had limited success in engaging ordinary Catholics in social justice activities. This is because, according to the terms of the Social Affairs Commission's mandate, it is prohibited from interfering directly or indirectly in local Church affairs. Thus, if a bishop decides not to involve himself or the laity in social justice matters within his own realm, the Social Affairs Office has no power to circumvent diocesan authorities to stimulate or assist social justice initiatives. As a result, the ratio of dioceses to social justice offices in Canada has remained at approximately 1 to 5, with more than 250,000 Catholics served by each.

Unlike Brazil, finally, the CEBs have remained largely unexploited by Church leaders as a means for furthering social justice ends. In fact, although accounts of grass-roots community activity have been provided in generic form by authors such as Clarke, and occasionally appear in Catholic media sources such as the *Catholic New Times,* as in the United States case, the dimensions and scope of the phenomenon have not even been definitively established by the Church.

An Agenda for Future Research

The examination to this point reveals both similarities and differences in terms of the way in which liberationist calls for action on social

justice issues have been answered by church leaders within a broad range of social settings. Clearly, however, much remains to be explored with regard to the fate of liberationist tendencies within world Catholicism.

One area for further research concerns those specific factors that affect international variation in institutional receptivity to liberationist ends. As the cases of Brazil, Canada, and the United States show, the propensity to pursue social justice is not merely a function of variables related to economic development. While underdeveloped Brazil is clearly the leader where the institutional commitment to social justice is concerned, Canada, with a much higher standard of living, has also moved significantly in this direction. Interestingly as well, Canada is more progressive in this regard than the United States, despite the fact that the two countries are nearly identical in terms of economic performance. Obviously, then, other factors, perhaps related to culture, geography, or national or church politics, are also at play in determining the institutional propensity to adopt the liberationist cause.

Using archival, census, and national sociopolitical data, these and other variables affecting institutional orientation at the international level might be more fully investigated. A potential sample for comparative analysis might include at least two nations—one more and one less progressive in terms of episcopal words and action on social justice —within three broad developmental strata: for example, underdeveloped, semideveloped, and developed. Comparisons could thus be made between the Philippines and Paraguay, Poland and Mexico, and Canada and the United States, and the different subgroupings. With the social, economic, and political characteristics of these nations exposed, the root causes of liberationist appeal (or nonappeal) in each might more definitively reveal themselves.

Another set of research questions arises from recent concerns about liberationist influence generally within the international Church, especially as the Vatican turns up the pressure to depoliticize the institution (see Della Cava 1989; Lernoux 1989). Certainly, in the three cases cited in this chapter, there is evidence of a growing pressure to replace the "option for the poor" with a concern for more pastoral issues. This has led to a growing rift in episcopal ranks between conservatives and progressives, and a general reduction in official support for the social justice cause in all three settings.

Evidence of this retrenchment, perhaps not surprisingly, is least obvious in the United States case—where social justice tendencies are least developed. In terms of potential research, it will be interesting to

see, nevertheless, whether developments on the international front—especially in Eastern Europe—and a retreat from the brink of nuclear war, will bring less emphasis within episcopal statements on East-West issues and an enhanced focus on growing domestic social problems (such as drug abuse and the homeless). In the United States case, future research might also focus on developments at the regional level. For example, given its largely underprivileged Latino constituency (now estimated at 27% of the United States Church; see Mosqueda 1986, 140), it is plausible that sectors of the United States Church with significant Latino populations may resist conservative tendencies and continue a move to the political left. To test this hypothesis (or others related to still other segments of the Church), an ethnic and class stratified sample of United States dioceses or even parishes might be constructed, and their leadership examined in terms of their support for justice-related statements and activities. This would be undertaken using a combination of archival research and self- or researcher-administered questionnaires and interview schedules. At the same time, examination of such a sample could serve to point out precisely where support for liberationism is likely to remain strongest. Are the Latino constituency and its leadership more progressive on this front than, say, the African-American? Is support for liberationism stronger among intellectuals and the Catholic left or among the working classes, who have had more direct exposure to social and economic oppression?

The Brazilian and Canadian Churches also provide fertile terrain for future research of this type, given the evidence of the ongoing retreat of support for liberationism. In Canada, first, the CCCB determined as recently as late 1989 that the social justice statements and documents released by the Social Affairs Commission in the name of the Church should be both fewer in number and subject to approval in principle by the general assembly. Previously, such releases needed only the approval of the CCCB's president. In a further development, a number of social justice offices in the dioceses have reportedly been slated for closure ("Canadian bishops 'renovate' " 1989). In Brazil, the move to conservatism since the mid-1980s has been even more obvious. Confronted not only by Vatican warnings about direct involvement in politics (Della Cava 1989) but also by growing competition from aggressive Protestant churches (Bruneau and Hewitt 1992), the Brazilian Catholic church is increasingly showing signs of a return to devotional offerings—offerings that it is hoped will be more "saleable" to its presently volatile constituency. Certainly already, in individual dioceses,

bishops have moved to dismantle agencies and commissions involved in popular causes, and to direct the base communities into more pastoral areas of concern. An even more salient indication of a move to conservatism has been evidenced by the CNBB's April 1991 meeting in Itaici, São Paulo, where there emerged strong support for an official realignment of the Church's this-worldly role with the more conservative directives on Church action outlined by Pope John Paul II.

In both Canada and Brazil, diocesan or parish-based comparative research of the type suggested for the United States case may serve a useful purpose in tracking the fate of liberationist influence early on, and at the ground level. In both settings, comparative contemporary and historical archival research on the words and actions of Church leaders in traditionally progressive dioceses or regions could be compared with data collected from a control group of more conservative areas, in order to discern trends before they appear within the larger national institution. In Canada, for example, developments within historically progressive dioceses such as Victoria might be compared with the situation in conservative Vancouver, or Hull compared with Toronto. In the Brazilian case, recent changes in historically progressive São Paulo or Recife might be compared with the more conservative Rio de Janeiro or Porto Alegre. Given concerns about the conservatizing influence of the growing evangelical Protestant movement, still another approach might involve developing a stratified sample of dioceses in which Protestant churches have been growing rapidly and where they have not. This would help determine whether or not the threat of Protestantism is assisting the Vatican in forcing a return to more pastoral concerns. Here again, São Paulo, long known as a hotbed of Protestant activity, might be contrasted with Fortaleza, where the percentage of nominal Catholics is still very high.

Another potential area for research concerns the possible resistance effect of the various Church agencies, commissions, and grass-roots movements developed by the progressive hierarchy in countries such as Chile, the Philippines, and even Canada. In Brazil, for example, there are those who argue that the national Church's broad social justice infrastructure may serve to counter conservatizing pressures. Adriance (1991), for instance, has argued that the base Christian community phenomenon in particular—especially in the more isolated rural areas where land conflicts are still much in evidence—will not only survive conservative pressures but may well lead the way to a continued emphasis on justice and liberation within the institution as a whole. This

argument, however, presumes the existence of a strong and vital rural CEB presence, which has yet to be empirically demonstrated and which, in any case, may be losing significance in a rapidly urbanizing, industrial milieu. As for urban CEBs, recent research shows that in the absence of institutional support, their ability to forge real social change has been circumscribed (Drogus 1992; Hewitt 1991).

The true effect of such movements may be revealed, however, only through further empirical research on their nature, scope, and effect. Again, following a diocesan comparative method—utilizing a combination of archival, interview, and participant-observation techniques undertaken in the field—one might examine a particular grass-roots phenomenon (or a limited range of these) in terms of its numerical strength, geographical distribution, and activity profile, in order to determine both likelihood of survival and impact upon the local Church. In Brazil, the CEBs would be an obvious target for such research. One might pick a sample of two dioceses with significant CEB populations—one perhaps predominantly rural and the other urban—and then draw samples of CEBs for further examination, using interview schedules and archival material on CEB strength and activities. In Canada (or the United States, for that matter), a similar study of parish-level social justice committees, refugee assistance centers, or peace and justice groups within specific geographic areas or dioceses might also be entertained, with an eye to assessing their basic organizational and orientational disposition, and more important, their ability to reach and inform Catholic opinion at the leadership level.

One last area for research that clearly suggests itself has to do with the changes in liberation theology itself within the increasingly conservative Vatican climate. Certainly, on the current's home turf, there are few signs that the cause of liberationism will be welcomed as warmly at the fourth Latin American Bishops meeting, to be held in Santo Domingo in 1992, as it was at previous CELAM encounters. Further, in the face of "instructions" emanating from the Vatican regarding the correct way to do liberation theology, the persecution of prominent liberationists such as Leonardo Boff, and the continual criticism of Marxist tendencies, questions remain as to whether liberationism can indeed survive.

Already, there are signs of accommodations to official criticism contained within more recent liberationist works. As historians and other observers of liberation theology have noted, liberationists such as Gutiérrez have taken much greater pains in their more recent writings

to emphasize the importance of the spiritual over secular political concerns (McGovern 1988, 99-101, 227-33). In an even more dramatic move, Leonardo Boff announced that he had "thrown in the towel" and will no longer contest Vatican-sponsored criticism of his work ("Boff submits" 1991). Do these developments spell the death knell of liberation theology as we have known it, or the birth of a new theologically "correct" and empirically grounded force for interpreting social reality and promoting social change? An answer to this question is possible, but only through historical content analysis of liberationist writings, undertaken with conservative developments within the international Church as a chronological guide.

References

Adriance, M. 1986. *Opting for the poor*. Kansas City, MO: Sheed and Ward.
———. 1991. Agents of change. *Journal for the Scientific Study of Religion* 30: 292-305.
Baum, G. 1985. A Canadian perspective on the U.S. pastoral. *Christianity and Crisis* 44: 516-18.
Benestad, J. B. 1982. *The pursuit of a just social order*. Washington, DC: Ethics and Public Policy Center.
Bibby, R. W. 1987. *Fragmented gods*. Toronto: Irwin.
Boff, L. 1981. Theological characteristics of a grassroots church. In *The challenge of basic Christian communities*, edited by S. Torres and J. Eagleson, 124-44. Maryknoll, NY: Orbis.
Boff submits to Vatican. 1991. *Catholic New Times*, 20 October, 2.
Bruneau, T. C. 1974. *The political transformation of the Brazilian Catholic church*. London: Cambridge University Press.
———. 1982. *The church in Brazil*. Austin: University of Texas Press.
Bruneau, T. C., and W. E. Hewitt. 1992. The church and politics in Brazil. In *Conflict and competition*, edited by E. Cleary and H. Stewart-Gambino. Boulder, CO: Lynne Rienner.
Canadian bishops "renovate" their corporate house. 1989. *Catholic New Times*, 17 December, 8-9.
Canadian Catholic Church Directory. 1988. Montréal: Publicité BM Advertizing.
Cason, J. W. 1984. *Basic Christian communities in the U.S. context*. Paper presented at the annual meeting of the Society for the Scientific Study of Religion, October, Chicago.
Clarke, T. 1981. Communities for justice. *Ecumenist* 19: 17-25.
Cleary, E. L. 1985. *Crisis and change*. Maryknoll, NY: Orbis.
CNBB (National Conference of Brazilian Bishops). 1984. *Igreja no Brasil-1984*. Brasília: CNBB.
Cox, H. 1984. *Religion in the secular city*. New York: Simon & Schuster.
Della Cava, R. 1989. The "people's church," the Vatican, and Abertura. In *Democratizing Brazil*, edited by A. Stepan, 143-67. New York: Oxford University Press.

Development and Peace in Canada. 1988. *Global Village Voice* 13 (Fall): 8.

Development and Peace worries about Share Lent '91. 1991. *Catholic New Times*, 3 March, 16.

Dodson, M. 1979. Liberation theology and Christian radicalism in contemporary Latin America. *Journal of Latin American Studies* 11: 203-22.

Drogus, C. 1992. Popular movements and the limits of political mobilization at the grassroots in Brazil. In *Conflict and competition*, edited by E. Cleary and H. Stewart-Gambino. Boulder, CO: Lynne Rienner.

Dussel, E. 1978. *Ethics and the theology of liberation*. Maryknoll, NY: Orbis.

————. 1981. *A history of the church in Latin America*. Grand Rapids, MI: Eerdmans.

ECSA. 1984. *Mandate*. Canada: mimeographed.

Ellis, M., and O. Maduro, eds. 1989. *The future of liberation theology*. Maryknoll, NY: Orbis.

Gutiérrez, G. 1983. *The power of the poor in history*. Maryknoll, NY: Orbis.

Harrison, B. 1985. Social justice and economic orthodoxy. *Christianity and Crisis* 44: 513-16.

Hewitt, W. E. 1989a. Liberation theology as social science. In *Sociological studies in Roman Catholicism*, edited by R. O'Toole, 143-66. Lewiston, NY: Mellen.

————. 1989b. Origins and prospects of the option for the poor in Brazilian Catholicism. *Journal for the Scientific Study of Religion* 28: 120-35.

————. 1991. *Base Christian communities and social change in Brazil*. Lincoln: University of Nebraska Press.

IBGE. 1986. *Anuário estatístico*. Rio de Janeiro: Fundação IBGE.

Lernoux, P. 1989. *People of God*. New York: Viking.

Levine, D. H., ed. 1980. *Churches and politics in Latin America*. Beverly Hills, CA: Sage.

————. 1986. *Religion and political conflict in Latin America*. Chapel Hill: University of North Carolina Press.

Mainwaring, S. 1986. *The Catholic church and politics in Brazil, 1916-1985*. Palo Alto, CA: Stanford University Press.

————. 1989. Grassroots Catholic groups and politics in Brazil. In *The progressive church in Latin America*, edited by S. Mainwaring and A. Wilde, 151-92. South Bend, IN: University of Notre Dame Press.

McCann, D. 1981. *Christian realism and liberation theology*. Maryknoll, NY: Orbis.

McGovern, A. F. 1988. *Liberation theology and its critics*. Maryknoll, NY: Orbis.

Mosqueda, L. J. 1986. *Chicanos, Catholicism, and political ideology*. Lanham, MD: University Press of America.

Murphy, M. 1987. *Betraying the bishops*. Washington, DC: Ethics and Public Policy Center.

Rosado, C. 1992. The role of liberation theology in the social identity of Latinos. In *Twentieth century world religious movements in neo-Weberian perspective*, edited by W. H. Swatos, Jr., 195-209. Lewiston, NY: Mellen.

Sheridan, E. F. 1987. *Do justice!* Toronto: Jesuit Centre for Social Faith and Justice.

Stewart, G. 1982. *Liberation theology in the Americas*. Unpublished paper.

6

Religion and the New Immigrants

PETER KIVISTO

In the modern world system, labor migrations from the periphery or less developed countries (LDCs) to the center or more developed countries (MDCs) have been an essential element for economic expansion and development; and in the process, the populations of the most advanced industrial societies have become increasingly heterogeneous (Reimers 1985; Zolberg 1989). Since World War II, both Western Europe and North America have experienced the creation of substantial immigrant communities. While this chapter will concentrate on the United States, at least passing comment on the European and Canadian scene is appropriate at the outset.

Immigration is selective, predicated on a complex set of factors that motivate individuals to exit their homelands in order to relocate in another society. Furthermore, as recent research has indicated, chain migration, which is predicated on a constant flow of information between sending and receiving countries, is a structured collective activity. In cases such as the British experience, residents of former and present Commonwealth nations left societies that had been profoundly shaped by British colonial rule, and thus entered a nation that was both familiar and foreign. Thus, the largest immigrant communities were formed by West Indians, especially Jamaicans; Asians, chiefly from India, Pakistan, and Hong Kong; and Africans from a variety of former British

AUTHOR'S NOTE: I wish to acknowledge the support services provided at the Center for Advanced Studies, the University of Iowa.

colonies. One consequence has been the emergence of a "race problem." Canada has also seen the rapid growth of these communities, and because of the relatively small size of that nation's population, has experienced a pronounced demographic impact. The French situation is similar in many respects to the British, as North Africans from such countries as Algeria, Morocco, and Tunisia—former colonies—have settled in the metropolis. While their political and cultural integration into French society is more problematic than that of their immigrant counterparts in Britain, their legal status is certainly more secure than that of the *Gastarbeiter,* or guest workers, from Yugoslavia and Turkey who have played an important role in the German economy. The status of guest worker leaves vulnerable many in Sweden, Norway, and Denmark as well, but none in these countries has experienced quite as virulent an expression of extremist right-wing nativist hostility as have those residing in Germany since the recent unification of the country (Rex 1991; Rex, Joly, and Wilpert 1987).

Throughout its history the United States has been an immigrant-receiving nation (Portes and Rumbaut 1990; Rumbaut 1991). Indeed, the mass migrations from Europe, Asia, and Latin America during the nineteenth and early twentieth centuries constituted the largest movement of peoples in history. The peak decades of immigration occurred after the Civil War, coinciding with rapid industrialization and urbanization. This great migratory wave ended in 1924, with the passage of legislation that restricted immigration. The Great Depression and World War II served as a further brake on immigration, so that by mid-century Oscar Handlin could write his classic work on immigration, *The Uprooted* (1952), about a major component of the American past that had no apparent bearing on contemporary events. At the same time, Will Herberg would formulate his understanding of the religious character of the nation. As the title of his book, *Protestant-Catholic-Jew* (1955) suggests, America was by that time no longer a Protestant empire but a Judeo-Christian land in which each of these three religious expressions was accorded a place in the nation's religious pantheon (Marty 1991). Furthermore, Herberg thought that the salience of ethnicity would progressively erode, to be replaced by a heightened affiliative salience of these three religious options. Such thinking, characteristic of the postwar period up to the late 1960s, was predicated on the assumption that no significant infusions of new people into the nation were likely to occur.

However, in 1965 a reformulation of existing immigration laws established the basis for a new wave of immigration, which has been taking place since the new law took effect in 1968. Three consequences of the Hart-Celler Act are of particular note: It made possible a sizable increase in the volume of immigration; by ending national quotas, it facilitated a dramatic increase in the number of immigrants from Asia and Latin America; and it encouraged professionals (an instance of Third World "brain drain") to migrate, thereby increasing the number of middle-class immigrants (Jasso and Rosenzweig 1990; Rumbaut, 1991).

The three major categories of immigrants reflect the challenge to the assumptions held by an earlier generation of scholars of both immigration and religion. First, Asians have accounted for 37% of the total immigration between 1960 and 1989. Various groups have grown significantly during the past quarter-century, the largest immigrant groups being the Filipinos, Chinese, Koreans, and Vietnamese. Second, Hispanics from various points in Latin America account for 39% of total immigration during the same period. They have come primarily from Mexico, Puerto Rico (though these are not strictly speaking immigrants, given the island's territorial status), and Cuba. Finally, though their numbers are considerably smaller than the above-noted groups, immigrants from the Middle East have had an impact on certain areas of the country, such as the Syrian and Lebanese population in Detroit. In addition, a number of groups that have arrived in smaller but still substantial numbers are also of interest to this discussion, including such diverse peoples as Russian Jews, Haitians, Dominicans, Jamaicans, Salvadorans, Colombians, and Cambodians.

Recent Research on Immigrants and Religion

A brief summary of recent work on religion and the new immigrants reveals some of the dilemmas that confront the sociologist of religion in undertaking work in this area. In the first place, it is necessary to determine precisely who are the new immigrants. Some groups have migrated to America in large numbers only since 1968, but in other cases, such as the Chinese and Mexican, recent migration constitutes a renewed wave in a longer history of movement to this country. Furthermore, categorizations of immigrants can be problematic if one is interested in religion. Muslims in America, for example, originate from a number of different parts of the globe, and thus if the interest is in the

varied ways in which Islam has been introduced into the United States, it is necessary to examine a variety of immigrant communities from the Middle East and East Asia.

Perhaps a reflection of the marginalization of the sociology of religion is the relative neglect that religion has received in research on the new immigrants. Compounding this lack of attention is the fact that the research devoted to different groups by immigration scholars is uneven.

A comparative example can be instructive. As noted above, two of the largest Asian immigrant groups are the Filipinos and the Koreans. In 1985 the Filipino immigrant population was reported to be 1,051,000, or about twice the size of the Korean group, which was at the same time approximately 542,000. Despite the fact that the Filipino group is larger, it has received remarkably little scholarly attention, reflected in Cordova's (1983) characterization of this group as the "forgotten Asian Americans." On the other hand, a solid body of research has been devoted to the Korean-American community (Choy 1979; Hurh 1977; Hurh and Kim 1984; Hurh, Kim, and Kim 1979; H. Kim 1977; I. Kim 1981; Shim 1977). While the reasons for these differences are many, part of the explanation has to do with the availability of scholars interested in studying a particular group and equipped with the skills to do so—including language skills. Archdeacon (1985) has shown that students of earlier arriving immigrant groups tend to come from those groups. This appears to be a general pattern today as well. For whatever reason, the Koreans have a cadre of sociologists committed to immigration research, while the Filipinos have not evidenced a similar level of interest.

These differences in scholarly interest are compounded when the topic of religion is introduced. Far more attention has been paid to issues related to the economics and politics of immigration than to the religious dimension in recent immigration research (Pedraza-Bailey 1990; Portes and Rumbaut 1990). While this is no doubt in part a reflection of the central concerns of the discipline at large, the differences in levels of attention across groups can also mirror the reality of religious life in different immigrant communities. Research on Koreans has highlighted the centrality of Protestant Christianity for these arrivals (H. Kim 1977; I. Kim 1981; Min 1991; Shin and Park 1988). In contrast, more of the Filipino community has been nominally Roman Catholic, and their lack of active involvement in American Catholicism can contribute to the concomitant lack of research into the religious dimension of the Filipino-American community (see Pido 1986). Parenthetically,

the body of work on new Chinese immigration, largely arrivals from Hong Kong and Taiwan, looks far more like that of the Filipinos than the Koreans. The religious dimension has not figured prominently in recent research on new Chinese immigrants (cf., Mangiafico 1988; Wong 1982; for an exception, see Palinkas 1984, for a study of Chinese Christians in the San Diego area).

It should be noted that the extent to which topic choice actually reflects or distorts the character of the immigrant community is a complicated matter. Some Korean sociologists, for example, are members of an organization that has no counterpart for these other Asian groups: The Association of Korean Christian Scholars in North America. The role of such a group in shaping research agendas could itself be a topic worthy of investigation.

The situation with Hispanic immigrants parallels that of Asians. Mexicans, the largest single group of immigrants during the past quarter-century, have been generally portrayed as having an ambiguous relationship with Roman Catholicism. The intensity of their religiosity is a matter of some debate. Less unclear is the fact that they have tended to resemble earlier Italian immigrants in their somewhat tenuous relationship with an American Catholic church whose hierarchy did not include Mexican Americans and which had few Mexican or Mexican-American priests to serve predominantly Mexican congregations. This may help to account for the relative neglect of research into the religious dimension of Mexican America's transplanted culture (for exceptions, see Levin and Markides 1988; Markides and Cole 1984). Despite the veritable explosion in Chicano studies, this situation has not changed appreciably in recent years. The same situation exists for the two other large Hispanic groups, the Puerto Ricans and the Cubans. In the case of the former, even the sociologist of religion Joseph Fitzpatrick (1987) pays scant attention to this topic in his book on Puerto Ricans on the mainland. Research on Cuban Americans in general has lagged behind that of the two larger Hispanic groups, no doubt due in part to the fact that Cubans do not have as long a history in the United States as their counterparts (Perez 1986).

Turning from Judeo-Christian immigrants, it is instructive to observe that the *Harvard Encyclopedia of American Ethnic Groups* (Thernstrom 1980) includes an entry on Muslims, but none on Hindus, Buddhists, Sikhs, or Jains. Perhaps this is not surprising, given the rate of growth of the Islamic population in America. The 2 to 3 million Muslims in America today may, according to some predictions, continue to grow,

with Muslims thus emerging as the second-largest religious group in the United States after Christians by the year 2000. From a single mosque build in Cedar Rapids, Iowa, in 1934, the number has grown to around 600. Muslim immigrants from Lebanon, Syria, Albania, and Bosnia arrived prior to the end of mass immigration in the 1920s and have been the object of a small number of instructive studies (Elkholy 1966; Kayal and Kayal 1975; Naff 1985).

The newly arrived have come both from the Middle East and East Asia. Useful studies of Arab Americans include works by Abraham and Abraham (1981, 1983), and Aswad (1974). While these works are couched more in ethnic than religious terms, they are complemented by others that give primacy to Islam. Several noteworthy examples are Richardson (1981); Waugh, Abu-Laban, and Qureshi (1983), and Waugh et al. (1991); comparative studies of Muslims in the United States and Canada; Kelly's (1984) inquiry into the relationship between religion and politics in the Muslim-American community; and Haddad's (1991) edited collection on the Muslim institutional presence in America. An invaluable work is Haddad and Lummis's *Islamic Values in the United States* (1987). Conducted under the auspices of the Hartford Seminary, this project involved the first systematic survey of Muslim Americans that was designed to address the ways and the extent to which Islamic values have been preserved, abandoned, or transformed. It explores the behavioral consequences of varied responses to traditional values on a range of issues, including modes of Islamic religious observance, economic matters, diet, alcohol consumption, and gender roles.

Immigrants from India and Pakistan have brought with them several different religions. A few works are devoted to general overviews of migrants from East Asia (Fisher 1980; Jenson 1988; Saran 1985; Saran and Eames 1980), or in the case of Melondy (1977) and Takaki (1989), to East Asians as a subset of the entire immigrant population that Takaki characterizes as "strangers from different shores." In each of these cases, some attention is given to religion. A small number of studies have been published on distinct religioethnic groups. Gibson's (1988) study of Sikhs in California is one such instance. While religion is not ignored in this conceptually sophisticated ethnographic account, her primary interest is with the ways in which Sikh children respond to assimilative pressures in high school. Kashima's (1977) study of Buddhism is a more panoramic analysis of Buddhism that is useful as a starting point for future work.

An interesting and careful investigation of Hindus, Jains, Sikhs, and Muslims from India has been conducted by Fenton (1988). This work moves from the national level to a community study of Indians in Atlanta. Part of the value of the book rests with Fenton's extensive use of quotations from his subjects. Related to this is the more comprehensive, finely textured, historically grounded, and empirically rich book by Raymond B.Williams, *Religions of Immigrants From India and Asia* (1988). Like Fenton's, this one also engages in community studies, in this case involving Chicago and Houston.

If, as this brief survey of the larger groups among the new immigrants suggests, the topic of religion has been addressed unevenly and in what amounts to a rather small corpus, this situation is even more pronounced for smaller groups or subgroups. For example, research on Caribbean immigrants is only now beginning. In this regard, Karen Brown's (1991) recent ethnography of a Haitian voodoo priestess in Brooklyn is a trailblazing work that could serve as a model for similar investigations.

Implications of Current Trends in Ethnic Theory

While the sociology of religion has its own conceptual tools to bring to bear on the study of immigrants and religion, this particular subject matter calls for an integration of these tools with those derived from ethnic studies. Elsewhere in this volume John Hannigan has indicated the significance of new social movement theory for the sociology of religion. In a similar fashion, the following pages are an effort to point to current trends in ethnic studies that can beneficially inform future research on new immigrants who are both ethnic groups and religious groups, or perhaps in some cases can best be seen as religioethnic groups.

Until recently, theoretical discourse about ethnicity has been limited chiefly to polemics that pitted assimilationists against pluralists. The sterility of these debates has become increasingly apparent, and efforts are under way to develop an alternative theoretical paradigm that would adequately account for both persistence—the focus of pluralists—and change—the central concern of assimilationists (Kivisto 1989, 11-23; see also Higham 1982; Kivisto 1990). As the long-time student of ethnicity and of the sociology of religion, J. Milton Yinger, has commented, "Neither the assimilationist thesis nor the persistence-of-ethnic-difference antithesis is adequate" (1986, 39).

Thus, we have arrived at a situation aptly described by Ewa Morawska (1990, 218) in the following way: "The assimilation paradigm in its classical version has been abandoned on account of its excessive simplicity, and the 'ethnicity-forever' approach that replaced it is also passing away." If both of these theoretical perspectives can be faulted for seeing only part of the larger picture, one might think that an alternative paradigm would operate at a higher level of abstraction, thereby incorporating both approaches into its overarching theoretical model. This has been attempted by a variety of reductionist theorists, intent on identifying a single analytical tool in the study of ethnicity and ethnic relations.

Ethnic identity can be predicated on rational considerations, but it is not necessarily so based. It can also be shaped by traditional modes of conduct, its habitual character incapable of being seen as rational. The task of ethnic studies is to consider both possibilities and to attempt to sort out their respective roles in particular instances. This approach demands that careful attention be paid to the ways in which people shape their own lives. It also requires that careful attention be given to the muddle of historical contingency and the complexities of concrete historical events. To the extent that such attention is given—to the extent that the social sciences intersect with history—grand theories cannot be sustained. Instead, more modest theories, akin to what Robert Merton referred to as "theories of the middle range," should guide empirical inquiry. As Herbert Gans (1985, 303) has suggested, paradigms that can profitably guide ethnic research must be "more situationally sensitive" than most of those employed in the past. Such a program would find theoretical "goodness of fit" with Swatos's situationalist approach (1990) to the sociological study of religion.

A new approach that builds on some of the most compelling insights of earlier theories has recently received the attention of social historians and historical sociologists. It begins with the rather simple sociological assumption that ethnicity is a social construction. After describing the contours of this approach, I will suggest the value of incorporating strands from other theories into this general orientation.

The social construction of ethnicity has been referred to by a number of terms. For example, anthropologist Eugene Roosens (1989) has defined this as "ethnogenesis." His position is essentially an instrumentalist one that is indebted to a perspective very much like that of rational choice, and with its inherent limitations. In his view, ethnicity emerges and is sustained over time when leaders make rational choices,

predicated on self-interest, that require efforts to mobilize ethnic identity and collective action. While not the whole picture, Roosens is instructive insofar as he indicates that the role of ethnic leadership must be considered, and more generally therefore, a careful examination of the inner workings of ethnic communities is also essential.

Jonathan Sarna (1978) describes a process that he calls "ethnicization." Referring specifically to immigrant groups in America, he argues that at their time of arrival, these groups were highly fragmented, and there was little indication of communal unity. This changed over time as a result of two factors: ascription and adversity. Ascription refers to the definition of group identities and the assigning of individuals to particular groups by outside agents, particularly by political and economic elites in the larger, host society. The connection between ascription and adversity is a dialectical one, insofar as those chiefly responsible for defining the ethnics also confront them from a position of power and are frequently a source of hostility and exploitation, out of which ethnic communities are in turn created. They are designed to meet the immediate social, political, and cultural needs of the ethnics. Sarna's characterization of this process may leave too much in the hands of powerful elements outside the ethnic group, thus overstating the powerlessness of the ethnics both in defining who they are and in confronting the dominant society. In other words, it may view the ethnic too simply as a victim, thereby downplaying the active role ethnics had in shaping their own lives. Nonetheless, the virtue of his perspective rests with its call to locate or contextualize the ethnic group in terms of the larger society.

This perspective is echoed in Yancey, Ericksen, and Juliani's "emergent ethnicity" thesis (1976, 391). The authors downplay the impact of cultural heritage and argue that rather than being an ascribed attribute, ethnicity is structurally conditional. Of central importance are the intersecting influences of occupational location, residential patterns, and institutional affiliations. The result is that "[a]s society changes, old forms of ethnic culture may die out but new forms may be generated." Douglass and Lyman (1976) concur with this position but concentrate on individual actors, rather than the ethnic group, exploring the strategies actors employ in accepting or rejecting aspects of ethnicity in the process of creating a self-identity.

A social constructionist term of recent development originated with Werner Sollors (1989): "the invention of ethnicity." His choice of words derives from a similar notion advanced by historian Eric Hobsbawm,

who has written about the "invention of tradition." He explains that what he means by invented tradition is the following: "a set of practices, normally governed by overtly or tacitly accepted rules and of a ritual or symbolic nature, which seeks to inculcate certain values and norms of behavior by repetition, which automatically implies continuity with the past" (1983, 1). Sollors uses his particular term to challenge the primordialist belief that ethnicity is at bedrock an irrational or preconscious form of cultural attachment, rooted either in blood or in a past lost in the fog of time. Ethnic identity necessarily appeals to tradition, and tradition is something created, sustained, and refashioned by people. However, Sollors also wants to steer clear of those who see ethnicity as merely a rational construct of those intent on manipulating it for political or economic ends (see Glazer and Moynihan 1975). While he does not dismiss this instrumentalist position out of hand, he does not want to reduce all of what counts as ethnic to such means-ends calculations.

Picking up on this idea of ethnicity as something that is invented, an interdisciplinary group of historians and social scientists has suggested that:

> [E]thnicity itself is to be understood as a cultural construction accomplished over historical time. Ethnic groups in modern settings are constantly recreating themselves, and ethnicity is constantly being reinvented in response to changing realities both within the group and the host society. Ethnic group boundaries, for example, must be renegotiated, while the expressive symbols of ethnicity (ethnic traditions) must be repeatedly reinterpreted. By historicizing the phenomenon, the concept of invention allows for the appearance, metamorphosis, disappearance, and reappearance of ethnicities. (Conzen et al. 1990, 38)

This process of invention must be seen in a dialectical or reciprocal way, for not only do immigrants and indigenous peoples shape ethnic definitions and boundaries, but so does the dominant group in the society and so do the other groups that make up the societal totality. Differences in political, economic, and cultural power must be considered in analyzing this ongoing process of constituting and reconstituting ethnicity. At times some groups have found themselves to be in an advantageous position, in relation to other groups, by having at their disposal greater resources that can be employed in their attempt to construct a favorable and pragmatically useful identity. Other groups have had fewer resources and less power, and as a result have had far less say in this

process. Their identities have, to a comparatively greater extent, been imposed from the outside.

Furthermore, both within and outside different groups, there are usually two or more competing versions of ethnic identity and group definition. The invention of ethnicity perspective calls attention to this situation and to the intragroup struggles for hegemony that generally result as a consequence of these differing versions of what it means to be a member of a particular ethnic group. Furthermore, given the assumption that this process of group definition is never accomplished once and for all, the invention of ethnicity calls for paying careful attention to changing circumstances.

Finally, the invention of ethnicity model questions the extent to which we can speak about a clear and singular cultural and societal core or center. The process of ethnicity is reciprocal. That is to say, just as this center plays a role in ascribing identities and a location in the social order to ethnic groups, so these groups have a part in shaping the form and content of the center.

Almost three-quarters of a century ago the historian Arthur Schlesinger, Sr. (1921), focusing on the United States, made a case for a research agenda that studied not only the impact of America on the ethnics, but also the impact of these diverse groups on America. To date, the latter part of this equation has too frequently gone unheeded by historians and social scientists. However, those arguing for this new paradigm have echoed Schlesinger by contending "that what is distinctively American has been itself a product of this synergistic encounter of multiple peoples and cultures" (Conzen et al. 1990, 54). Obviously, this also applies to other countries.

The invention of ethnicity paradigm is not intended to be an instance of grand theory. It does not seek to be predictive or to articulate propositions from which can be derived law-like patterns of behavior. Instead, it is conceived in a manner that fully accords with Blumer's (1954) "sensitizing concept" in that it orients us to an appreciation of the place of human agency in creating social worlds. Given this character, it is appropriate to attempt to complement this perspective with other conceptual tools.

One of particular relevance is that of "ethnic boundaries." Fredrik Barth is generally credited with establishing the singular importance of boundaries in the definition of ethnic groups. He rather bluntly contends that "[t]he critical focus of investigation from this point of view becomes the ethnic *boundary* that defines the group, not the cultural stuff

that it encloses." He is referring to social rather than territorial bound-aries. Boundaries can be rigid or flexible, expansive or constrictive, permeable or impenetrable. They are subject to change. The ethnic boundary "canalizes social life—it entails a frequently quite complex organization of behavior and social relations" (Barth 1969, 15). The boundary is seen as enabling certain kinds of relationships to exist while constraining or limiting others. It is the principal device that distinguishes the respective nature of intragroup and intergroup relations.

I disagree with Barth's dismissal of the "cultural stuff." In fact, I think that this stuff is the source of the rationale for defining boundaries in one way or another. Rather than posing this in an either-or manner, as Barth does, it is better to conceive the relationship between ethnic boundaries and cultures as interconnected and mutually reinforcing.

Similarly, Raymond Breton's (1964) concept of "institutional completeness" is valuable because it calls attention to the fact that an institutional presence is an essential ingredient for the creation and maintenance of *collective* ethnic identity (which, in turn, is a prerequisite for the preservation of individual ethnic identities). Ethnic institutions perform a number of valuable services for members of ethnic communities, including functions related to employment, the acquisition of political rewards, welfare, ethnic cultural expression, recreation, the adjudication of conflict both within and outside the ethnic enclave, and so on. Some groups have had the ability to create institutional networks that manage to perform a wide range of tasks on behalf of constituents, thereby binding them to the community. These are institutionally complete ethnic communities. Other groups have, for various reasons, been less successful in achieving institutional completeness.

Breton (1964, 204) speaks about "social entrepreneurs" who attempt to fulfill what they see as the needs of an ethnic "clientele." Another way of posing this is in terms of ethnic leaders and the mass of the ethnic community. Recently, attention has been paid to the role of ethnic leaders (Bodnar 1985; Greene 1987; Higham 1978). Their backgrounds, especially their social class backgrounds, their bases of support, the resources at their disposal for mobilizing ethnic-based action, the nature of the coalitions they form, and similar related matters are topics that, when addressed, help to answer, in part, questions relating to the particular character of an ethnic community.

Connected to analyses of leaders must be an examination of the ordinary members of the ethnic group. How internally unified or divided are they? To what extent do they act as either supporters or detractors

of potential candidates for leadership? What reasons underlie differing exhibitions of loyalty to leaders? What are the bases of loyalty, or in other words, what kinds of appeals to legitimation are made—on traditional, charismatic, or legal-rational grounds?

Research Agendas for the Future

Posing these and related questions serves to identify a number of potential research projects devoted to various aspects of the form and content of immigrant religion. Such topics abound. As indicated in my earlier review of recent research, for some groups the religious dimension is a virtually untapped topic. Even for those groups that have received scholarly attention, the current corpus is quite small.

For sociologists of religion with an interest in this general area, three principal avenues of inquiry should be considered:

First, we need case studies tracing and explicating facets of the internal dynamics of institutional religion and the salience of religious belief in the various immigrant communities. Ethnographic opportunities are limited only by problems related to entrée into a group, and in some instances by language barriers. One type of project would involve ethnographic studies of particular congregations; this research can interweave participant observation, interview, and archival data. Feagin, Orum, and Sjoberg (1991) have recently made "a case for the case study" that identified several virtues inherent in this kind of research: permitting the study of people in a natural setting, allowing for a holistic approach to social action and meaning construction, and enabling an appreciation of time and history. While such research should be encouraged across the board, there are two places where the opportunities at present are most visible: Korean Protestant congregations and Hispanic churches—including both Roman Catholic parishes and Protestant congregations, mainline and pentecostal. In addition, such work has yet to be initiated for Muslims, Hindus, or Buddhists. As Karen Brown's study (1991) suggests, ethnographic research should not be limited to congregational studies but should also encompass sects and new religions, as well as what might be perceived as religious entrepreneurs or charismatic figures operating within fluid or weak organizational structures.

Second, comparative research should be undertaken. This could entail at least three different kinds of comparisons. One would be concerned with comparisons between and among various new immigrant

groups. While a number of possibilities suggest themselves, useful work should include comparisons between Koreans and Filipinos, along with other newly arrived Asian groups, such as the Hong Kong Chinese and immigrants from Southeast Asia. Along similar lines, comparisons of Mexicans, Cubans, and Puerto Ricans should be encouraged, in terms of both the respective significance of Roman Catholicism for these groups and the differential impact that Protestantism, especially pentecostalism, has had on them.

Another type of comparison entails research on settlers from the same group who have located in different countries. Again, a number of possibilities for research projects exist, but I would like to single out the possibility of work on groups from the Indian subcontinent who have emigrated to various locales in Europe and North America, and West Indians in the United States and Britain, as providing strategic research sites that can help us understand the interplay between immigrant groups and host societies in the process of forging religious identities.

Third, comparisons can be usefully conducted that look at old versus new immigrant groups, such as Jews or Greek Orthodox on the one hand, and Hindus or Buddhists on the other. This kind of work would help us appreciate better the historical specificity of patterns of immigrant adjustment, and such an appreciation could be introduced into subsequent generalizations that might be formulated.

Finally, there is a need to look at the larger society vis-à-vis the immigrants, focusing on the former's relationship to and impact on the latter, while also attempting to assess the impact of the immigrants on the host society. This topic is without doubt the most underdeveloped of all—and the one that raises the most challenging methodological problems. Each of these avenues affords opportunities for fruitful dialogue between sociologists of religion and those specializing in ethnic studies.

References

Abraham, S. Y., and N. Abraham, eds. 1981. *The Arab world and Arab-Americans.* Detroit: Wayne State University, Center for Urban Studies.

————. 1983. *Arabs in the new world.* Detroit: Wayne State University, Center for Urban Studies.

Archdeacon, T. 1985. Problems and possibilities in the study of American immigration and ethnic history. *International Migration Reviews* 19: 112-34.

Aswad, B. C., ed. 1974. *Arabic speaking communities in American cities.* New York: Center for Migration Studies.

Barth, F., ed. 1969. *Ethnic groups and boundaries*. Boston: Little, Brown.

Blumer, H. 1954. What is wrong with social theory? *American Sociological Review* 19: 3-10.

Bodnar, J. 1985. *The transplanted*. Bloomington: Indiana University Press.

Breton, R. 1964. Institutional completeness of ethnic communities and the personal relations of immigrants. *American Journal of Sociology* 70: 193-205.

Brown, K. M. 1991. *Mama Lola*. Berkeley: University of California Press.

Choy, B. 1979. *Koreans in America*. Chicago: Nelson-Hall.

Conzen, K. N., D. A. Gerber, E. Morawska, G. E. Pozzetta, and R. J. Vecoli. 1990. The invention of ethnicity. *Altreitalie* 3: 37-62.

Cordova, F. 1983. *Filipinos*. Dubuque, IA: Kendall-Hunt.

Douglass, W., and S. Lyman. 1976. L'ethnie. *Cahiers Internationale de Sociologie* 61: 342-58.

Elkholy, A. A. 1966. *The Arab Moslems in the United States*. New Haven, CT: College and University Press.

Feagin, J. R., A. M. Orum, and G. Sjoberg, eds. 1991. *A case for the case study*. Chapel Hill: University of North Carolina Press.

Fenton, J. Y. 1988. *Transplanting religious traditions*. New York: Praeger.

Fisher, M. P. 1980. *The Indians of New York City*. Columbia, MO: South Asia Books.

Fitzpatrick, J. P. 1987. *Puerto Rican Americans*. Englewood Cliffs, NJ: Prentice-Hall.

Gans, H. 1985. Ethnicity, ideology and the insider problem. *Contemporary Sociology* 14: 303-4.

Gibson, M. A. 1988. *Accommodation without assimilation*. Ithaca, NY: Cornell University Press.

Glazer, N., and D. P. Moynihan. 1975. *Ethnicity*. Cambridge, MA: Harvard University Press.

Greene, V. R. 1987. *American immigrant leaders 1800-1910*. Baltimore, MD: Johns Hopkins University Press.

Haddad, Y. Y., ed. 1991. *The Muslims of America*. New York: Oxford University Press.

Haddad, Y. Y., and A. T. Lummis. 1987. *Islamic values in the United States*. New York: Oxford University Press.

Handlin, O. 1952. *The uprooted*. Boston: Little, Brown.

Herberg, W. 1955. *Protestant-Catholic-Jew*. Garden City, NY: Doubleday.

Higham, J., ed. 1978. *Ethnic leadership in America*. Baltimore, MD: Johns Hopkins University Press.

————. 1982. Current trends in the study of ethnicity in the United States. *Journal of American Ethnic History* 2: 5-15.

Hobsbawm, E. 1983. Introduction. In *The invention of tradition*, edited by E. Hobsbawm and T. Ranger, 1-14. Cambridge, UK: Cambridge University Press.

Hurh, W. M. 1977. *Comparative study of Korean immigrants in the United States*. San Francisco: R and E Research Associates.

Hurh, W. M., H. C. Kim, and K. C. Kim. 1979. *Assimilation patterns of immigrants in the United States*. Washington, DC: University Press of America.

Hurh, W. M., and K. C. Kim. 1984. *Korean immigrants in America*. Rutherford, NJ: Fairleigh Dickinson University Press.

Jasso, G., and M. R. Rosenzweig. 1990. *The new chosen people*. New York: Russell Sage Foundation.

Jenson, J. M. 1988. *Passage from India*. New Haven, CT: Yale University Press.

Kashima, T. 1977. *Buddhism in America*. Westport, CT: Greenwood Press.

Kayal, P. M., and J. M. Kayal. 1975. *The Syrian-Lebanese in America*. Boston: Twayne.

Kelly, M., ed. 1984. *Islam*. New York: Praeger.

Kim, H. 1977. The history and the role of the church in the Korean American community. In *The Korean diaspora*, edited by H. Kim, 47-63. Santa Barbara, CA: ABC-CLIO.

Kim, I. 1981. *New urban immigrants*. Princeton, NJ: Princeton University Press.

Kivisto, P. 1989. Overview. In *The ethnic enigma*, edited by P. Kivisto, 11-23. Philadelphia: Balch Institute Press.

———. 1990. The transplanted then and now. *Ethnic and Racial Studies* 13: 455-81.

Levin, J. S., and K. S. Markides. 1988. Religious attendance and psychological well-being in middle-aged and older Mexican Americans. *Sociological Analysis* 49: 66-72.

Mangiafico, L. 1988. *Contemporary American immigrants*. New York: Praeger.

Markides, K. S., and T. R. Cole. 1984. Change and continuity in Mexican American religious behavior. *Social Science Quarterly* 65: 618-25.

Marty, M. E. 1991. *Modern American religion*, vol. 2. Chicago: University of Chicago Press.

Melondy, H. B. 1977. *Asians in America*. Boston: Twayne.

Min, P. G. 1991. Cultural and economic boundaries of Korean ethnicity. *Ethnic and Racial Studies* 14: 225-41.

Morawska, E. 1990. The sociology and historiography of immigration. In *Immigration reconsidered*, edited by V. Yans-McLaughlin, 187-238. New York: Oxford University Press.

Naff, A. 1985. *Becoming American*. Carbondale: Southern Illinois University Press.

Palinkas, L. A. 1984. Social fission and cultural change in an ethnic Chinese church. *Ethnic Groups* 5: 255-77.

Pedraza-Bailey, S. 1990. Immigration research. *Social Science History* 14: 43-67.

Perez, L. 1986. Cubans in the United States. *Annals of the American Academy of Political and Social Science* 487 (September): 126-37.

Pido, A. 1986. *The Filipinos in America*. New York: Center for Migration Studies.

Portes, A., and R. Rumbaut. 1990. *Immigrant America*. Berkeley: University of California Press.

Reimers, D. M. 1985. *Still the golden door*. New York: Columbia University Press.

Rex, J. 1991. *The racial and ethnic structure of Europe*. Paper presented at the Social Science History Association annual meeting, New Orleans.

Rex, J., D. Joly, and C. Wilpert, eds. 1987. *Immigrant associations in Europe*. Aldershot, UK: Gower.

Richardson, E. A. 1981. *Islamic cultures in North America*. New York: Pilgrim Press.

Roosens, E. 1989. *Creating ethnicity*. Newbury Park, CA: Sage.

Rumbaut, R. G. 1991. Passages to America. In *America at century's end*, edited by A. Wolfe, 208-43. Berkeley: University of California Press.

Saran, P. 1985. *The Asian Indian experience in the United States*. Cambridge, MA: Schenkman.

Saran, P., and E. Eames, eds. 1980. *The new ethnics*. New York: Praeger.

Sarna, J. 1978. From immigrants to ethnics. *Ethnicity* 5: 370-78.

Schlesinger, A. 1921. The significance of immigration in American history. *American Journal of Sociology* 27: 71-81.

Shim, S. S. 1977. *Korean immigrant churches today in southern California*. San Francisco: R and E Research Associates.

Shin, E. H., and H. Park. 1988. An analysis of causes of schisms in ethnic churches. *Sociological Analysis* 49: 234-48.

Sollors, W., ed. 1989. *The invention of ethnicity*. New York: Oxford University Press.

Swatos, W. H., Jr. 1990. Renewing "religion" for sociology. *Sociological Focus* 23: 141-53.

Takaki, R. 1989. *Strangers from a different shore*. Boston: Little, Brown.

Thernstrom, S., ed. 1980. *Harvard encyclopedia of American ethnic groups*. Cambridge, MA: Harvard University Press.

Waugh, E. H., B. Abu-Laban, and R. B. Qureshi. 1983. *The Muslim community in North America*. Edmonton: University of Alberta Press.

Waugh, E. H., S. McIrvin, B. Abu-Laban, and R. Burckhardt. 1991. *Muslim families in North America*. Edmonton: University of Alberta Press.

Williams, R. B. 1988. *Religions of immigrants from India and Pakistan*. Cambridge, UK: Cambridge University Press.

Wong, B. 1982. *Chinatown*. New York: Holt, Rinehart & Winston.

Yancey, W. L., E. P. Ericksen, and R. N. Juliani. 1976. Emergent ethnicity. *American Sociological Review* 41: 391-403.

Yinger, J. M. 1986. Intersecting strands in the theorization of race and ethnic relations. In *Theories of race and ethnic relations*, edited by J. Rex and D. Mason, 20-41. Cambridge, UK: Cambridge University Press.

Zolberg, A. R. 1989. The next waves. *International Migration Review* 23: 403-30.

7

For a Sociology
of Religious Experience

JAMES V. SPICKARD

Sociologists have not comprehended religious experiences well. We know that more than 30% of Americans claim such experiences (Gallup 1978; McCready and Greeley 1976). Yet few in our discipline have investigated them in depth. Some 90 years after William James's pioneering 1902 treatise on the topic, *The Varieties of Religious Experience* (1961), little progress has been made. Why?

It seems to me that the problem is conceptual. Drawing upon a Protestant piety that can be traced back to Schleiermacher's late eighteenth-century defense of religion against its "cultured despisers" (Schleiermacher 1958; see Proudfoot 1985), James grounded religious experiences in feelings, which he treated as private. He drew a rigid distinction between these experiences and the "overbeliefs" by which they are labeled. Overbeliefs are clearly social. Treating experiences as private, however, removes them from the social sphere. Since James, the sociology of religion has focused on religious institutions and religious ideas. We have neglected religion's experiential side. A variety of observers—many of whom I mention below—have noted this failing. The time has come to cast a wider net.

Recent literature contains five different approaches to a sociology of religious experiences, none of which is fully developed. If we work on all five of these fronts at once, we may come to see religious experiences as fully social phenomena.

A Jamesian Approach

A major social-scientific approach to religious experience follows James's path. Though there are many worthy examples to choose from, I shall focus on Margaret Poloma's recent analysis of the role of "charisma" in the Assemblies of God (Poloma 1989; Poloma and Pendleton 1989; see also Jelen 1991; Kellstedt 1989). Poloma's research revolved around a "CHAREX index," an index of paranormal phenomena that she treats as "indicators of a personal relationship with God" (1989, 27). The index includes such elements as praying in tongues, receiving definite answers to prayer requests, giving prophecies at church services, and being "slain in the Spirit"—common but not universal experiences for members of the Assemblies. She assessed the frequency of these experiences by questionnaire and phone survey ("Have you ever . . . "), then statistically analyzed the connections between CHAREX and various sociodemographic variables, an index of religious participation, and an index of evangelism.

Poloma's analysis is thorough, and her work has the merit of taking members of the Assemblies seriously when they say that such experiences are central to their religious life. Though faked religious experiences are probably at least as common as faked orgasms, certainly some of these experiences are valid. The problem, however, is what people's reports of their own experiences really measure. Take Poloma's question about "receiving definite answers to prayer requests," for example. This is no pure experience, separable from its overbelief. As Mary Jo Neitz (1987) has ably shown in her ethnography of a charismatic Catholic prayer group, "having" such an experience involves knowing what a prayer request is, knowing when such a request is appropriate, having ideas about the kinds of ways in which God might answer such a request, and being able to recognize otherwise ordinary events as the answer one seeks. These are all matters of belief, on which the experience itself depends. One can "have" such experiences only after one has accepted the ideas that make these experiences possible.

Speaking in tongues is similarly inseparable from believing. A person does not first have the experience, then come to interpret it in religious ways. If this were so, people would first speak in tongues, then join the Assemblies to have their experiences explained and valued. Instead, prospective members learn that the experience exists, what it means, and how to pray to have it. Then they learn how to produce it. Neitz shows in some detail how her informants learn to speak in tongues by

learning to label, attend to, and even amplify certain occurrences that they might otherwise ignore. A person's report of such an experience cannot be accepted as pure experience, separable from religious beliefs.

Many social scientists besides Poloma use the overbelief model. I came close to this approach in an article on the role the *johrei* experience plays in the lives of members of Sekai Kyusei-kyo, one of the new Japanese religions (Spickard 1991a). Though the model takes religious experience seriously, it fails to acknowledge the role that religious ideas and institutions play in the construction of the experiences themselves. A full sociology of religious experience needs at least this much.

Labeling Experiences

A common and related approach also separates religious experiences from beliefs. It treats the former as anomalous brain-states and the latter as labels—both of which are open to empirical analysis. This approach is particularly common among psychologists investigating the altered states of consciousness that often appear in religious settings.

A fine example of this approach is Susan Blackmore's (1983, 1984) analysis of the psychophysiological origin of out-of-body experiences. During such experiences—which are quite well attested—people perceive themselves as having a double or astral body, which travels free of the physical body and sees close things as if they were far away. Blackmore argues that despite such perceptions, we cannot conclude that people's "spirits" actually leave their bodies and travel to distant places. Such experiences are matters of perception and provide only illusory support to the religious belief in life after death.

Blackmore points out that in normal consciousness, we do not directly experience the world. Rather, our brains mold our perceptions into a model of reality; we then "experience" this model. Normally, our brains combine our awareness of our bodies, our awareness of our thoughts, and our visual, auditory and other perceptions into a fairly stable self-model. We "experience" ourselves as located:

> [I]n our head, behind our eyes, or in some other convenient spot within the body. Wherever it is, that does not tell us that there is a soul or something at that spot, rather it tells us that we have chosen to organize our perception and self image that way, as a convenience in our construction of experience. (1983, 150)

If the normal place we locate the self is merely the result of a convenient model, what is to prevent our brains from occasionally putting the self elsewhere? Could we not experience ourselves above and behind the head, for example, where many out-of-body experiences appear to be set? Similarly, what is to prevent the brain from including only some of our sensations in its model building—leaving out, for example, the thoughts that normally fill most of our waking lives? This, says Blackmore (1986), is how we experience meditation: as a silencing of the internal chatter that is so much a part of our ordinary reality.

In both cases, says Blackmore, our vivid experiences are "real." Yet they are evidence for the truth of neither the immortality of the soul nor the possibility of nirvana. The theologies that these experiences "support" are overbeliefs: labels that we attach to our experiences to explain them. Clearly, overbeliefs need not be religious: An out-of-body experience can attract a secular interpretation as easily as it can a religious one. (Otherwise, parapsychology would appeal only to religious audiences.) Religiousness, for Blackmore, is a matter of labeling; the same experience may be religious or secular, depending on how it is named.

Other scholars have pursued such explanations with a fine appreciation of people's experiences, yet without taking native interpretations at face value. David Hufford, for example, has exhaustively examined reports of nocturnal assault, in which people feel themselves attacked and sat upon at night, burdened as if by a crushing weight. In Newfoundland, where Hufford first encountered such reports, the experience is called "The Old Hag." There it is believed to be a supernatural visitation. Inquiry in the United States found similar experiences to be widespread, possibly affecting "15 percent or more of the general population." The event is "probably best described as sleep paralysis with a particular kind of hypnagogic hallucination." Though it is not culturally produced, "cultural factors heavily determine the ways in which the experience is described (or withheld) and interpreted" (1982, 245-46). That is, people's interpretations of this event are overbeliefs: labels by which they name what has happened. Interestingly, not all societies have a name for this night terror; in those that do not, people keep quiet, lest they be thought insane. In Hufford's view, such an experience is empirically separable from any given interpretation of it. Both the experience and the beliefs are open to investigation.

In a similar vein, Mihaly Csikszentmihalyi (1975b, 43) has documented an experience he calls "flow":

[T]he holistic sensation present when we act with total involvement. . . . We experience it as a unified flowing from one moment to the next, in which we feel in control of our actions, and in which there is little distinction between self and environment; between stimulus and response; or between past, present and future.

Csikszentmihalyi and his associates interviewed rock climbers, dancers, chess masters, surgeons, and others who engage in activities requiring much concentration. When their skill and the requirements of the task match exactly, he says, they can attain an identifiable state of consciousness. They become one with the activity. The self dissolves, and the "flow" experience emerges.

Though he does not pursue the matter, Csikszentmihalyi suggests that many religious experiences are akin to "flow." Peak experiences, the meditation practices of Zen, yoga, and so on are valued in themselves, and cannot be reduced to "the external goals . . . [that are] mere tokens that justify the activity" (1975a, 37). Mary Jo Neitz and I have extended Csikszentmihalyi's hints because many of our informants' religious experiences exhibit a "flow"-like quality. "All sense of individual self vanishes. The person feels in a time out of time, connected to 'the way things really are' " (Neitz and Spickard 1990, 24). Here, again, the experience is seen as real, and its interpretation as an overbelief. Depending on the religious setting, this experience might be labeled the Kiss of Universal Peace or the Presence of Jesus Christ—or the Temptation of the Evil One. Outside religious settings, the experience will not be seen as religious at all.

There are two problems with this approach: First, it is open to the criticism leveled at Poloma above—that experiences are not completely separable from their labels, but are at least to some degree constituted by them. A "flow" experience, for example, is likely to be different for someone who believes it is a gift of God from what it is for someone who believes it is a gift of the Devil. Hufford suggests as much in his discussion of the cross-cultural differences in the ways people talk about their night terrors; Blackmore allows that one's intellectual acceptance or rejection of out-of-body experiences will influence those experiences. Second, the approach undercuts a full sociology of religious experiences because it limits social influence to ideas. According to the model, people have experiences, then they learn how to label those experiences. Though the first act is psychological and investigable, only the latter act is social; yet I think a sociology of religious experience

must be more than a sociology of *ideas about* religious experience—at least if it is to be worth furthering.

Constructivism

Both of the above approaches to religious experience separate experiences from beliefs. Another social-scientific approach to religious experience begins by questioning this split. In fact, it explores the ways that experiences and ideas condition one another. Mary Jo Neitz's (1987) description of the interpenetration of religious ideas and experiences among charismatic Catholics, related above, is a noteworthy example of this approach, which I have labeled "constructivism." It treats experiences as central to religion but does not see them as independent of the religious ideas by which they are explained.

The best theoretical presentation of constructivism is Wayne Proudfoot's (1985) critique of Schleiermacher and James. Proudfoot argues that religious experiences always presuppose religious ideas. Schleiermacher's experience of ultimate dependence, for example, cannot be identified as such without reference to the ideas of dependence and ultimacy. Which comes first, after all: a feeling of ultimate dependence or the notion that dependence might be ultimate—that is, beyond the natural sphere? A baby feels dependence on its caregivers, but this is not the feeling that Schleiermacher sees leading to religion. By the time a person has developed enough for such a feeling to emerge, she or he is thoroughly imbued with the concepts by which it will be articulated. One cannot separate these ideas from the experiences, says Proudfoot, and then build religion on the latter alone.

Proudfoot's approach to James is similar. James based religion on feeling, and Proudfoot calls on attribution theory to argue that emotions are not simply given but are matters of interpretation (Proudfoot 1985, chap. 5; Proudfoot and Shaver 1975). He leans heavily on Stanley Schachter's experiments, in which research subjects were given adrenaline, then placed in a social context that led them to interpret their arousal in one or another way (Schachter and Singer 1962; see also Maslach 1979). Subjects who were confronted with abrasive individuals came to see their arousal as anger; those exposed to euphoria thought themselves happy. In each case, a subject's felt experience was a product of both arousal and self-interpretation. Pure emotions, says Proudfoot, are impossible; thus James's attempt to base religion on pure feeling is absurd.

Clever readers will at once see the flaw in this argument. Instead of abolishing the distinction between experiences and labels, Proudfoot has merely pushed the labeling process back one step. With Schachter, he sees emotions themselves as labels applied to physiological states. In one circumstance, one label applies; in another circumstance, another. Emotions for him are like experiences for James: sensations plus overbeliefs. Note, however, that for James, emotions were *themselves* physiologically based. "My theory," James wrote, "is that the bodily changes follow directly the perception of the exciting fact, and that our feeling of the same changes as they occur is the emotion" (James 1890, vol. 2, p. 449). In being named, these perceptions are given conceptual content; the perceptions, though, are still analytically separable from their names. Proudfoot and James are thus in agreement: At some level, one's sensations are separable from the names they carry. Proudfoot may want to draw the line closer to the body than does James, but the structure of their division is the same. To enter human discourse, experiences must be named—and that naming is an overbelief.

What, then, are we to make of constructivism? Clearly, constructivists like Neitz and Proudfoot show that we cannot accept religious experiences simply as given; we must ask about their origins, to which religious beliefs may contribute. Not only does "speaking in tongues" involve learning religious ideas, out of which the experience is at least partly generated; the apprehension of a "flow" experience also has a conceptual component that cannot simply be declared "overbelief," much less ignored. Just as clearly, these experiences cannot be subsumed by beliefs, as Proudfoot sometimes tries to claim. Something beyond belief is involved; that something is worth investigating. The question for sociologists, then, is whether this something is social. Are ideas the only avenue by which religious experiences can be shared?

In the rest of this chapter, I want to elaborate two other ways in which religious experiences are social. Neither approach has received much attention in the sociology of religion; I suggest that it is time that each does.

Learning to Have Religious Experiences

The first of these approaches starts from the realization that no matter how much ideas may help constitute religious experiences, something nonconceptual always remains. Whereas the religious approach treats

that something as *sui generis,* and the labeling approach treats it as an odd brain-state, this approach sees it as something learned. People can, this approach argues, learn to have religious experiences—at least some of them. They can learn to produce certain brain-states, which then interact with labels to make experiences they call religious.

Let us take the example of Zen meditation. Meditation, of course, is at base an altered state of consciousness—one in which the usual chatter of thought is missing. To understand this state as an experience, we can contrast it with our experience of ordinary consciousness. As I sit at my desk in ordinary consciousness, for example:

> "I" consist of a stable body image with arms and legs, a model of myself as someone working. . . . "I" have plans for future actions (I must tidy up) and wishes that things were different (I wish I could concentrate harder) . . . The world around consists of the room, the sounds outside; the birds (Oh there are some birds singing. Don't they sound nice? I wonder what sort of birds they are.); children (I wish they'd be quiet), the radio (I hate the noise). (Blackmore 1986, 83)

Note the combination of elements that makes up this experience. "Self" and "world" are relatively distinct, though both are built of thought, memory, and sensation. "I" combines sensations, thoughts, plans, and self-images; "world" combines sensations, concepts (e.g., birds and their kinds), and judgments (hating the radio). "Self" and "world" intertwine in that "I" am always reacting to the "world"—both positively and negatively. "I" am distinct from the "world" in my experience, but I am not free of it; one involves the other in ordinary consciousness.

Now see me meditating:

> I am still. The birds are singing outside, there are sounds of children playing a long way away, and a distant radio. The muddle on my desk and the room full of things are filled with stillness. There is me sitting. The sounds are full of silence. I hear a woodlouse crawl across the floor. (Blackmore 1986, 73)

Here there is much less going on. My experience is less elaborate and contains no thoughts. I sense, rather than think, my stillness. I sense myself, I sense the world—but I somehow remain objective to both. Depending on the depth of my meditation, I may not separate them at all.

Given such an identifiable meditative experience—and there are many varieties—how is such a state attained? Clearly, ideas have little to do with it. Learning ideas about meditation is not the same as learning to

meditate. Like learning to play the piano, one studies with teachers and reads books, then one practices (see Sudnow 1978). As he or she masters the first exercises, the piano teacher monitors progress, gives new instructions or guidance, and sets the student to practicing again. Guidance consists not so much in labeling what is occurring as in suggesting technical changes: a different posture, a different mantra, and so on. Gradually one learns to focus one's attention in the right way and attains the proper state of consciousness.

David Preston (1988) analyzes in some depth the process by which "Zen reality" is transmitted from teacher to pupil. He argues that learning Zen results from meditative practice—for which conceptual rules (sit just so, don't look up, count breaths, and so on) are next to useless. These rules are socially learned, yet Zen teachers provide little guidance about how to follow them. Indeed, the beginner soon discovers that following them does not induce meditation. But Zen offers no other ideas, other than to say that ideas are meaningless. Preston argues that with extended practice—and an acceptance of the notion that ideas will not cause the Zen meditative state—the "bodymind" becomes more attentive. Preston borrows Bourdieu's (1977) notion of *habitus* to describe this training: The body itself becomes practiced, and its activities take on an "objective meaning" (Bourdieu's term) quite distinct from subjectively religious notions. All the while one meets with one's teacher, who guides one's activity. Ultimately, one may attain the "Zen state": a new sense of self that just sits without thinking or emotion.

The same nonconceptual training techniques that Preston describes for Zen exist in other religious settings. I have elsewhere sketched the ways in which Quakers and participants in the Gurdjieff Work learn to reproduce the meditative states that typify their religious practices. Similar analyses could no doubt be carried out for other religions and for nonmeditative religious experiences—though often the training is not as explicit as it is with Zen. The experiences need only be identifiable states of consciousness, and be learned. Clearly, this approach complements rather than contradicts the labeling and constructivist approaches to the social study of religious experiences. It locates a second way in which these experiences are socially formed, focusing on their nonconceptual aspects. In combination with the labeling and constructivist approaches, it promises to further our understanding of religious experiences as social products.

Living in Shared Time

A final approach to religious experience as a social phenomenon begins from the fact that religions—even in their mundane moments—are rarely private. People practice their religions together, side by side as it were, in shared time. To understand religions' sociality, we must understand how individuals can share time. To do so requires an excursion into theory: specifically, the phenomenological sociology of Alfred Schutz. Best known to sociologists for his analysis of typification (the process by which people call on their socially generated stock of knowledge to make their way in the world), Schutz's writings contain the germ of another approach to social life. I find this approach useful for the analysis of religious experiences.

Schutz fully recognized the importance of shared ideas as part of what ties people together. He argued, however, that such conceptual or semantic communication presupposes sociality rather than the other way around (1964, 162). Sociality is built on "the possibility of living together simultaneously in specific dimensions of time." Semantic understanding is one form of living together, but it is not the only one. Experiencing things together is another. In an essay on the phenomenology of music, Schutz illustrates how experiential sociality occurs.

Musical performances involve many people, among them composers, performers, and audiences. For Schutz, the heart of music is the experience shared by these people; music is, after all, the point of their interactions. In Schutz's (1964, 170-72) words,

> For our purposes a piece of music may be defined . . . as a meaningful arrangement of tones in inner time. . . . The flux of tones unrolling in inner time is an arrangement meaningful to both the composer and the beholder, because and in so far as it evokes in the stream of consciousness participating in it an interplay of recollections, retentions, protentions and anticipations which interrelate the successive elements.

These recollections, retentions, and so on are not the private memories people bring to their experiences. They are not associations of musical phrases with parts of the external world. The *Moonlight Sonata* does not have to remind us of moonlight to draw forth the recollections of which Schutz speaks. Instead, such recollections are internal to the music.

> The composer, by the specific means of his art, has arranged it in such a way that the consciousness of the beholder is led to refer what he actually hears

to what he anticipates will follow and also to what he has just been hearing and what he has heard ever since this piece of music began. The hearer, therefore, listens to the ongoing flux of music, so to speak, not only in the direction from the first to the last bar but simultaneously in a reverse direction back to the first one.

By structuring inner time, then, music allows composer and beholder to share experience.

Although separated by hundreds of years, the [beholder] participates with quasi simultaneity in the [composer's] stream of consciousness by performing with him step by step the ongoing articulation of his musical thought. The beholder, thus, is united with the composer by a time dimension common to both, which is nothing other than a derived form of the vivid present shared by the partners in a genuine face-to-face relation.

Music's peculiar sociality is not dependent on conceptual thought. Composers, performers, and audience all bring to music a socially generated stock of knowledge, which forms the ground of their experiences. *But musical experience is not reducible to that ground.* Music generates a shared experience of inner time, what Schutz calls a "mutual tuning-in relationship."

Mary Jo Neitz and I have argued that this relationship can be the basis for a sociology of religious experience (1990). Experiences are patterns of inner time; like all patterns in inner time, they can be shared. People experience time together in many religious settings, but especially in rituals. Instead of a focus on rituals' ideational contents—their theologies and symbols—a Schutzian approach could focus on the ebb and flow of their activity. Rituals, in this view, help people "tune-in" to one another, to share an inner state of consciousness. Seen in this light, the experiences that people have in religious settings are profoundly social —and in a quite basic way.

To illustrate what such an approach can do, I have elsewhere applied Schutz's insights to traditional Navajo religion (Spickard 1991b). I argue that Navajo rituals structure their participants' experiences of time; this structuring both generates and confirms the religion's conceptual principles. In essence, this is a more subtle version of James's thesis that religious belief grows out of experience. Unlike James, however, I see such experience as social, not private; unlike Proudfoot, I do not see ideas as the only way to connect the two. A brief overview of my presentation will show what I mean.

Navajo religion is highly ritualized. Firmly rooted in the Southwestern landscape, it concerns itself with maintaining individual and communal life and health. Its main event is the "chant"—a ceremony lasting several days and nights that is designed to reorder one's relationship with the powers of creation. Families choose to sponsor chants at times of crisis or potential disorder. A family member may be ill; someone may be leaving for or returning from a journey among foreigners. That person—the "patient"—is the focus of the ceremony. The family will engage a "singer," a priestly specialist in the particular chant deemed proper for the occasion. The singer will direct the entire ceremony, including sandpaintings, ritual emetics, and sweats, and the more than 100 prayers and songs that must be repeated exactly if the ritual is to have effect. These are highly repetitive and display a detailed imagery. On the surface, they contain a simple message. Each invokes a Holy Person, then seeks identification between the patient and that Holy Person's powers. In some chants this leads to a request that the Holy Person remove and disperse the malevolence that besets the patient. Often the language models this removal.

As Sam Gill has pointed out, such prayers must be seen as performances, not as texts. From the point of view of the ritual's participants, such prayers "evoke and structure the images . . . in such a way that they create the power that can expel malevolent influences and that can reorder, and hence restore to health and happiness, a person who suffers" (Gill 1987, 110). Their impact is experiential, not conceptual. Like music, prayer presents a stream of images that structure inner time. It guides the hearer from image to image: backward as the images repeat what has been, forward as they foretell what is to come. Where theology is meant to convince, ritual prayer is meant to be experienced.

Navajo religion is particularly oriented toward prayer, because in prayer is believed to be the origin of the world. On a conceptual level, we can see this in the Blessingway myth, which is retold at all major creative events. Literally translated, it means "the way to secure an environment of perfect beauty." The myth recounts the occasion of the first ceremony, by which the world was made.

At the beginning of this world, the story goes, all was chaos (Gill 1983, 503-04; Gill 1987, 19ff; Witherspoon 1983; see Wyman 1970). The lower worlds had fallen into disorder and had been destroyed. All that was left was the medicine bundle, a collection of objects and powers from which the world was made. Thought and speech emerged from the bundle; they took the form of a young man and woman, too beautiful to

behold. As Long-Life Boy and Happiness Girl, they thought and talked about how the world was to be. Then they built a ceremonial hogan held up by the cardinal directions: East, South, North, and West. They entered the hogan and spread the contents of the medicine bundle on the sand. They painted the life forms of all the living things that would be in the world, along with the months of the year, the stars, and the landscape. Then they sang through the night. At dawn the painting was transformed into the world the Navajo know.

I have summarized this story; the Navajo do not do so. The Blessingway myth is told only in the context of ritual, where it is self-referencing. The story says that thought and speech created the world at the beginning of time; in the ritual retelling they create it once again. But this time the creation is in inner time—in the experience of teller and hearer. Every retelling is an origin. As people experience the story again, the world is renewed.

Their experience is not vicarious. Though the ritual goes to great lengths to identify the patient with the supernaturals and to model his or her cure, its ultimate reference is not "there-then." It is "here-now." More particularly, the ritual experience is not a *copy* of the original world-creation. It *is* the world-creation. In Navajo eyes, the ritual literally recreates the world. In Austin's terms, Navajo ritual is performative. Navajo "ritual language does not describe how things are; it determines how they will be" (Witherspoon 1983, 575; see also Gill 1977). By telling the myths of the world's origin in ritual, it allows ritual participants to experience the world restored to its original perfection.

Like music, this world-creation cannot be done conceptually. I can summarize rituals, but doing so subverts their purpose. Rituals to restore perfection take time. They use the same tools that did the original deed: knowledge and language. And they are patterned on that deed. Long-life Boy and Happiness Girl sang songs and painted sand in the first hogan. Ritual singers do the same today. Order and harmony arise as they create their world in its minute detail. Ritual, like music, is a reordering of shared time.

Navajo chants are social experiences in three ways. They are social insofar as they require many people for their execution. This is the sociality of church life that our discipline studies well. They are social insofar as they make use of shared elements of the Navajo worldview. This is the sociality of beliefs our discipline also acknowledges. But Navajo chants are also social as they guide experience along well-worn channels, toward an inner reorientation to the world. Through ritual

acts, the patient is united in inner time with all patients who have gone before. The singer is united in inner time with all singers. The helpers are united with all helpers, and the families with all families. And all are united with the Holy Persons, the world-creators.

To the extent that we limit our understanding of the social nature of religion to churches and to beliefs, we miss much of Navajo religion's purpose. It is not, primarily, designed to heal social splits, though it may do that. It is not, primarily, designed to reinforce or change people's ideas, though it may do that as well. It is designed to "cure" people: to create an experience of the harmony between self, society, and world that in the Navajo scheme of things always is, and is always coming to be. This harmony lives in a shared present—in the midst of ritual.

Navajo rituals are thus directly analogous to musical performances, conceptualized in Schutzian terms. By structuring inner time, both rituals and music unite people, living and dead, in a common experience. First this happens, then this, then this—not just to me but to you and to our ancestors and our descendants. Ritual forms community and keeps it alive; the shared experience of ritual is at the center of religious life.

The Paths Ahead: A Research Agenda

We have, then, five approaches to the social study of religious experience. Three focus on the relationship between experiences and religious ideas. A fourth focuses on how various experiences—seen as altered states of consciousness—are learned. And the fifth focuses on rituals as experiences of shared time. Ideas, practical learning, and the "mutually tuned-in" moment are three different social aspects of religious experiencing. Hitherto only the first has been explored, and that only slightly. All deserve study.

Each of the five approaches can generate concrete research. Of these, the Schleiermacher-James overbelief model is probably the least useful. Though it finds religious experiences important, its portrayal of them as *sui generis* discourages detailed inquiry. A full sociology must at least explore the ways in which ideas and institutions interact with the experiences themselves. Rather than suggest ways to pursue the overbelief model, then, I shall focus my suggestions for future inquiry on the other four.

Despite its theoretical limitations, the labeling approach could well generate more research along the lines Blackmore, Hufford, and

Csikszentmihalyi have pioneered. Such research would isolate and identify a particular kind of experience, then explore the ways it is manifested and interpreted in different religious and nonreligious settings.

New religions and New Age groups are prime sites for such investigations. For example, the *johrei* experience that is central to Sekai Kyusei-kyo has many analogues. A form of spiritual healing, *johrei* involves the projection of "divine light" from the hand of a minister or church member. This light "raises the spiritual level" of the person or group on the receiving end. Though it is not seen, people often feel it as a heat passing over their bodies. The church teaches that *johrei* clears away the spiritual clouds that cause illness and misfortune. Members equate it with the Light of God that they believe is bringing about a new age (Spickard 1991a).

When I was studying Sekai Kyusei-kyo in the mid-1970s, the Berkeley Psychic Institute was teaching an almost identical kind of spiritual healing. Here, the experience was at most quasi-religious. It was presented as a skill that required no metaphysical allegiances, only a desire to become a psychic healer. Yet in its most developed form, it involved the use of visualized spirit guardians. As near as I could tell—as a nonpractitioner—it was the same as *johrei*. I later felt similar sensations from the hands of an American Indian healer. Though other scholars have noted the common occurrence of such healing practices, even among the white middle class (McGuire 1988), they have generally looked at beliefs about healing, rather than at the experience itself. It strikes me that there is a need for a good comparative study of such healing, undertaken from a phenomenal point of view. First, such a study would locate a set of similar healing practices. Then it would probe the ways in which different religions interpret them.

Of course, the topic need not be healing. It could be any of a number of sensations or states of consciousness found in religious settings. Csikszentmihalyi's "flow" experiences and Blackmore's out-of-body experiences are only two of many possibilities. Students of American Indian and Siberian shamanism, or Tibetan Buddhism (particularly in its wilder forms), or even Scientology should have no difficulty locating phenomena to investigate. In some cases—such as the diverse forms of meditation found among Buddhists—some comparative physiological work has been done (see Tart 1975). With a common mental state already identified, the sociologist has only to study the different ways in which the state is labeled.

A more complete project would move from studying the social labeling of such religious states of consciousness to examining the ways in which those states are learned. This moves from the second to the fourth approach outlined above. Preston's (1988) work on Zen is a perfect model; it shows how experiences and ideas interact in the process of transmitting nonconceptual reality. Besides this, and my rudimentary research on other forms of meditation, little work has been done in this area. Like the labeling approach, the learning approach depends on identifying discrete states of consciousness as central to religions. Transpersonal psychologists are more accustomed to this than are sociologists, who must master the psychological literature in this field and extend it in the direction of their own interests.

One current researcher in this area is worth mentioning, if only because her work cries out for sociological completion. Felicitas Goodman (1986, 1990) posits a single "religious altered state of consciousness (RASC)," which she says is cross-culturally universal. This RASC is physiological, she says: Trance induction techniques "activate certain neurophysiological processes," which bring about certain key experiences. "What produces the differences is the change in [body] posture" during trance induction (1986, 83). In a series of experiments, Goodman had her subjects crouch like a Nupe diviner or lie like a shaman figure from a cave painting at Lascaux. Each of these (and other) postures produces a distinct experience, she says. Nupe imitators, for example, see blue or white lights, feel themselves spun around, and think they are all-knowing. She claims that other body postures generate other experiences.

The problem with Goodman's work is twofold. First, though she claims that trance in a given body posture always produces the same experience, I find her subjects' trance descriptions not all that similar. They are certainly not identical enough to undercut the notion that people's ideas about what they are doing influence how they describe what happens to them. Second, she neglects almost completely the social context in which her trance states occur—the very thing that most interests sociologists. In my reading of her 1990 work, it seems to me that as her subjects learn to enter trance in given body postures, they also learn to have the "right" experiences. The final experience is no mere idea; neither is it a pure result of bodily position; it is something in between. This, of course, matches the constructivist paradigm—though with more emphasis on the body than a constructivist like Proudfoot is willing to allow. A research project could be designed to explore

the social conditioning of posture-induced trance states, building on Goodman's work.

As Neitz's (1987) work with charismatic Catholics shows, however, there is no need to limit the study of religious experiences to the marginal and the bizarre. Middle-class American religion is not without experiences. It would be fascinating, for example, to approach the experiences Poloma (1989) finds in the Assemblies of God with the sophistication of a constructivist. How, for example, do the young, educated, upwardly mobile members of the Assemblies come to welcome tongue-speaking rather than rejecting it? On the surface, this seems odd: Who would welcome words coming unbidden out of one's mouth, even if they are unintelligible and thus not potentially embarrassing? Even odder is being "slain in the Spirit," knocked down by an unseen force in the middle of prayer. Surely the constructivist could trace the complex interaction between sensation, belief, and social approbation that together constitutes this experience. Though the Assemblies of God are not a mainline denomination, similar charisms are found in most of the more "establishment" churches.

The constructivists, of course, do not have the only fruitful approach. How interesting it would be to reanalyze Neitz's data on charismatic Catholics to see if identifiable states of consciousness were being taught while these Catholics learned to see their experiences as religious. Is learning to speak in tongues just a matter of identifying and labeling certain sensations? Or does one also learn to produce a certain state of consciousness, which one also learns to interpret in a particular way? This can be researched empirically, rather than simply remaining a theoretical debate.

The last approach, based on Schutz's sociology of music, requires separate treatment. Essentially, it allows us to see rituals as experiences —as opposed to just collections of symbols, the focus of most recent ritual studies. In a sense this is not new: Emile Durkheim (1965) saw rituals as experiences. He, however, saw ritual only as "collective effervescence," not as the multitextured sharing of time of which Schutz speaks. Schutz substitutes a laser for Durkheim's spotlight—and allows a far better analysis of ritual experience as a result.

It is easy to imagine an empirical study of ritual following Schutz's lead. One would most likely choose a religion rich in liturgy—one whose members identify ritual as a key reason for belonging. Rather than focusing on what ritual "means" to them and postulating a mental "traditionalism" as the source of its appeal, this approach would look

at the ways sharing ritual forms people into a community. As with the Navajo, we should expect the experience of ritual to resonate with their theology: The former elaborates in time what the latter summarizes in ideas. Yet ritual is not reducible to these ideas. Theology may be a blueprint, but one cannot live in a blueprint. Ritual is the house wherein such religions dwell.

Traditionalist Catholics, Orthodox Jews, and Eastern Rite Christians all emphasize ritual enough to make such a study promising. One could look at different liturgical styles within these groups. How do different styles affect individuals? Do they solidify or fragment the community? Of particular interest might be converts—especially those for whom ritual was a chief attraction. How do they experience these rituals, as opposed to the rituals of their former churches? Are such converts different from "natives" in their approach? Another study might focus on differences between ritually oriented and dogmatically oriented denominations. Does the relative importance laid to the experience of ritual make a difference to church loyalty or to relations between clergy and laity?

Such questions are endless, and there is no point in specifying them further here. Given the conceptual tools with which to work, it is but a small step to explore the experience of ritual time as a separate social modality, alongside the sociality of ideas and of institutions. In a sense, the entire sociological study of religious experience has been waiting for such tools. For too long we have thought such experiences to be purely private. Now that we can see experiences as social in several ways—and as central to the religious life—progress is certain to occur.

References

Blackmore, S. J. 1983. Are out-of-body experiences evidence for survival? *Anabiosis* 3: 137-55.

———. 1984. A psychological theory of the out-of-body experience. *Journal of Parapsychology* 48: 201-18.

———. 1986. Who am I? In *Beyond Therapy,* edited by G. Claxon, 71-85. London: Wisdom Publications.

Bourdieu, P. 1977. *Outline of a theory of practice.* Cambridge, UK: Cambridge University Press.

Csikszentmihalyi, M. 1975a. *Beyond boredom and anxiety.* San Francisco: Jossey-Bass.

———. 1975b. Play and intrinsic rewards. *Journal of Humanistic Psychology* 15: 41-63.

Durkheim, E. 1965. The elementary forms of the religious life. New York: Free Press.

Gallup, G. 1978. *Religion in America: 1977-1978* (Gallup Opinion Index Report No. 145). Princeton, NJ: Princeton Religious Research Center.

Gill, S. D. 1977. Prayer as person. *History of Religions* 17: 143-57.

———. 1983. Navajo views of the origin. In *Handbook of North American Indians: Southwest*, edited by A. Ortiz, 502-05. Washington, DC: Smithsonian Institution.

———. 1987. *Native American religious action*. Columbia: University of South Carolina Press.

Goodman, F. D. 1986. Body posture and the religious altered state of consciousness. *Journal of Humanistic Psychology* 26: 81-118.

———. 1990. *Where the spirits ride the wind*. Bloomington: Indiana University Press.

Hufford, D. J. 1982. *The terror that comes in the night*. Philadelphia: University of Pennsylvania Press.

James, W. 1890. *The principles of psychology*. New York: Holt.

———. 1961. *The varieties of religious experience*. New York: Modern Library.

Jelen, T. G. 1991. *Political mobilization of religious beliefs*. New York: Praeger.

Kellstedt, L. A. 1989. The meaning and measurement of evangelicalism. In *Religion and political behavior in the United States*, edited by T. G. Jelen, 3-21. New York: Praeger.

Maslach, C. 1979. The emotional consequences of arousal without reason. In *Emotions in personality and psychopathology*, edited by C. E. Izard, 565-90. New York: Plenum.

McCready, W. C., and A. M. Greeley. 1976. *The ultimate values of the American population*. Beverly Hills, CA: Sage.

McGuire, M. B. 1988. *Ritual healing in suburban America*. New Brunswick, NJ: Rutgers University Press.

Neitz, M. J. 1987. *Charisma and community*. New Brunswick, NJ: Transaction.

Neitz, M. J., and J. V. Spickard. 1990. Steps toward a sociology of religious experience. *Sociological Analysis* 51: 15-33.

Poloma, M. M. 1989. *The Assemblies of God at the crossroads*. Knoxville: University of Tennessee Press.

Poloma, M. M., and B. F. Pendleton. 1989. Religious experiences, evangelism and institutional growth within the Assemblies of God. *Journal for the Scientific Study of Religion* 28: 415-31.

Preston, D. 1988. *The social organization of Zen practice*. Cambridge, UK: Cambridge University Press.

Proudfoot, W. 1985. *Religious experience*. Berkeley: University of California Press.

Proudfoot, W., and P. Shaver. 1975. Attribution theory and the psychology of religion. *Journal for the Scientific Study of Religion* 14: 317-30.

Schachter, S., and J. E. Singer. 1962. Cognitive, social and physiological determinants of emotional state. *Psychological Review* 69: 379-99.

Schleiermacher, F.D.E. 1958. *On religion*. New York: Harper & Row.

Schutz, A. 1964. Making music together. In *Collected papers II: Studies in social theory*, edited by A. Broderson, 159-78. The Hague: Nijhoff.

Spickard, J. V. 1991a. Spiritual healing among the American followers of a Japanese new religion. *Research in the Social Scientific Study of Religion* 3: 135-56.

———. 1991b. Experiencing religious rituals. *Sociological Analysis* 52: 191-204.

Sudnow, D. 1978. *Ways of the hand*. New York: Harper & Row.

Tart, C. T., ed. 1975. *States of consciousness*. New York: Dutton.

Witherspoon, G. 1983. Language and reality in Navajo world view. In *Handbook of North American Indians: Southwest,* edited by A. Ortiz, 570-78. Washington, DC: Smithsonian Institution.

Wyman, L. C. 1970. *Blessingway.* Tucson: University of Arizona Press.

8

Present-Day Emotional Renewals

The End of Secularization or the End of Religion?

DANIÈLE HERVIEU-LÉGER

The issue of the status and the future prospects of religion in modern society has dogged sociological research since the early days of the discipline. For many years, the main idea put forward was that the social and cultural repression of religion in modern society ran parallel with the rise of Man's affirmation of his creative autonomy and of his power over nature. This classic approach to the process of secularization was coextensive with a theory of modernity that assumed that the historical development of rationalization and the emergence of personal autonomy were two aspects of a single movement—a movement culminating in Man's being "robbed of gods" and the collapse of "the human endeavor to create a sacred cosmos" that Peter Berger (1967, 27-28) saw as Man's self-projecting attempt to impose his own meanings on reality, to endow the whole universe with human significance and to root the social world in that universe, which it reflected and from which it derived its fundamental structures. As a result, the modern world was deemed to have lost the unity and meaning that it formerly derived from being perceived as the reflection of the sacred cosmos. According to this view, modernity was experienced as exposure to a world of change, mobility, and difference—a world in the making.

AUTHOR'S NOTE: This text was translated on my behalf by Roger Greaves. I acknowledge his work and extend my appreciation.

This crisis in the religious vision of a unified world was linked dialectically (i.e., both as consequence and as cause) to the historical process that Weber, Parsons, and others described as the emergence of differentiated social institutions, and more particularly with the juridico-political process involving the emergence of central government. The rise of secularization and the varying degrees of separation between church and state were the legal and institutional symptoms of the declining hold that the religious institutions had over society.

For the correlative study of religion and modernity, this paradigm implied a genetic approach that placed religion upstream from modernity and had the latter breaking with the preexistent religious universe via a long, contradictory and convulsive, though inexorable, historical process. This linear approach to secularization, which drew a direct parallel between the decline of institutional religion and the elimination of religion as such, met with severe criticism for many years. However, the real turning point in theoretical thinking did not occur until relatively recently, in the late 1960s and early 1970s, when it became obvious to empirical researchers everywhere that unexpected religious renewals were occurring, both within the established churches and in the form of new religious movements (Hervieu-Léger 1986).

The fact that the return of religion, first observed in student and countercultural groups, now has broad ramifications in middle-class and upper middle-class social strata (which are fully integrated into modern culture and indeed often possess high or fairly high cultural capital) has made a decisive contribution to renewing the correlative study of religion and modernity—to such an extent, indeed, that the diagnosis of religious decline (equated in scientific circles with the modern triumph of rationality) at times seems to have been reversed: Much attention is paid to the need for meaning expressed by Western societies perturbed by economic crisis and international disequilibrium, of the quest for spirituality which may be observed in these societies, of the possibility of a massive return of the sacred on the verge of the twenty-first century, and so on.

Religious decline *and/or* return? That is the question, with its attendant load of polemic and passion, on which debate among intellectuals and in the media concerning the religious position of modern, reputedly secularized societies has concentrated in recent years. Some see the "return of religion" as a regression, an irrational reaction to uncertainty and unrest like many similar reactions in comparable periods in the past. Others hail it as proof of the invincible religious dimension of Man,

over and above the illusory triumphs of rationality and positivism. In the midst of this ideological turmoil, it is clear that a "rethink" (i.e., a step forward in theory) concerning the concept of secularization is indispensable for the construction of a sociology of religious modernity. An analysis of the specific traits of the "new religiosity" may serve as a possible introduction to such an undertaking.

A Religion of Emotional Communities

Particular attention will be paid here to the pattern of community emotionalism which is very widespread, not only in the new religious movements, but also within the various churches and faiths.

In Max Weber's description (1978, 452-57), the religion of emotional communities is characterized by communities of disciples gathered around a bearer of charisma. The view here will be broader, taking in forms of religious communalization in which the expression of affect by individuals and the group is paramount and fundamental (Champion and Hervieu-Léger 1989). The religion of emotional communities is first and foremost a religion of voluntary groups, implying personal commitment (or even conversion, in the revivalist sense) from each of its members. The testimony brought to the group by each convert and the recognition he or she receives in return create very close ties between the group and the individual. This bond of membership is particularly emotional when (as stressed by Weber) communities of disciples are grouped together around a charismatic figure. In all instances, however, repeated personal membership acts, involving every member of the group, tend to become the main aim of community gatherings in their own right.

This intensification of the expressive dimension of community life does not necessarily mean that the expressive element is particularly effervescent. Groups in which song, dance, and glossolalia are used to bring participants to a state of trancelike collective excitement are relatively rare, and this kind of "hot" religiosity is seldom long-lived. However, all emotional communities pay particular attention to bodily involvement in prayer, to the physical manifestation of community nearness and the emotional intensity of intermember relationships through kissing, embracing, holding hands or shoulders, and so on. The aesthetic and ecological need for an environment favorable to "emotional

convergence" among participants is also prominent, as is the very wide-spread attention paid to nonverbal forms of religious expression. The obverse of this recognition of the importance of the body and the senses in individual and collective religious life is the mistrust, whether explicit or not, displayed for any kind of doctrinal or theological formulation of the convictions shared within the group. This repulsion for "intellectual religion" is more than the mistrust shown by any self-regulating group for "specialist" power. It represents a conviction that the intellectualization of belief is unnecessary and even harmful to the community's purpose in that it destroys the singularity of the personal commitments expressed within the community. The primacy of individual experience over any kind of objectively controlled community conformity is the reason for the porous borders established by emotional communities. They are easy to enter, but they are also easy to leave once emotional commitment to the community, its ideals, or its leader ceases. These flexible gatherings often come into existence through the condensation of wider and looser "networks." They create possibilities for "making contact" or "keeping contact" and do not formally imply any permanent relationship among their members. Notions of obligation and permanence are, generally speaking, alien to the religion of emotional communities. Participation is normally a personal choice and lasts only insofar as it brings personal satisfaction to the individual concerned. The fluidity of the emotional network corresponds to the mobility of individual and collective feelings within the group. It reveals the instability proper to emotional states taken as the gauge of intensity and authenticity in spiritual experience.

This ideal-typical characterization of the religion of emotional communities does not constitute a description of a population of empirically identifiable groups. It is a thinking tool for identifying certain trends attested very strongly in the charismatic-type communities which are present, in more or less euphemized guises, within religious institutions —parishes, movements, theology faculties, monasteries, and so on— and which shape the religious behavior of individuals.

Emotion, Religion, and Modernity:
Two Interpretative Approaches

What is the meaning and significance of the religion of emotional communities in relation to the traditional patterns of secularization? Is

it, as some seem to think, a "return" phenomenon, exposing the limits of secularization in modern societies? Or is it a more complex process, involving a recomposition of religious activity in "rationally disenchanted" modern society?

My first hypothesis will be that the answer to this question depends on the general conceptual framework used to formalize the relations between emotional experience and religion. In this respect, two distinct theoretical traditions are present in sociological religious studies.

In the Beginning Was Emotion ...

The first of these theoretical traditions makes individual and collective emotional experience the source and foundation of all religious expression. William James systematized this approach by distinguishing between "personal religion" (the inner experience of people contacting the invisible order in which the puzzles of natural order meet with a solution) and "institutional religion" in its many different forms: "Worship and sacrifice, procedures for working on the dispositions of the deity, theology and ceremony, and ecclesiastical organization are the essentials of religion in the institutional branch" (James 1961, 41). This distinction, which is a familiar one in the tradition of religious phenomenology, is joined (though not wholly matched) by other distinctions of the same type made by other writers: Wach's distinction between religious "experience" and "expression" (1951, 21-22), Roger Bastide's distinction between "live religions" (*religions vécues*) and "canned religions" or *religions en conserve* (Bastide 1967, 133-34), Henri Bergson's "dynamic/open religion" and "static/closed religion" (1946), and so on.

The purpose of this battery of antitheses is to transpose into the field of sociology the psychological dynamics of religious experience. They imply more or less explicitly that institutionalized beliefs and practices are never more than what the Durkheimian Hubert (1904, xxi) calls the "administered" form of an initial fundamental experience that precedes any kind of philosophical or theological formalization and that brings into play, intensely and indeed effervescently, the feelings and emotions of those who have it. This initial fundamental experience, encountered on both the personal and the collective planes, is the source of all authentic religiosity and remains irreducible to the doctrines and liturgies that are its socially accepted expression.

This viewpoint has given rise to the idea that the phenomenon of religion is two-tiered, as described by Henri Desroche (1969) in his commentary on a little-known text by Emile Durkheim: a primary tier, the intense and extramundane experience of emotional contact with the divine, and a secondary tier involving the socialization and rationalization of this experience into beliefs on the one hand and forms of worship or rites on the other. In Durkheim, the elementary religious experience, which is extrasocial or at least presocial, is essentially a collective experience, and as such exerts on individual consciences the "dynamogenic influence" through which society creates itself. This "emotion of the depths," which gives rise to group representations, is described by Durkheim in terms belonging to the register of passion and ecstasy: warmth, uplift, revivification, abnormal surge of strength, effervescence, intense passion, frenzy, transfiguration, rapture, metamorphosis, extraordinary potency conducive to excitement and frenzy, overexcitement, spiritual exaltation not unconnected with delirium, and so on (1965, 226-27). The Durkheimian view, which continues to be widespread in sociology and anthropology, is that all social life is fed, albeit very remotely, by religion—that is, the prodigious reservoir of energy resulting from the unification of individual consciences in the single and unique experience of the presence of the sacred.

However, the elements that compose the creative power of the emotional religious experience also make it formidable and structurally unstable. The exceptional intensity of the affect that it mobilizes and the overabundant energy that it releases make any prolongation of the experience dangerous and unbearable, both for the individual and for society. Ecstasy is by definition a transient and occasional state. People projected out of the everyday world by an extraordinary experience are necessarily obliged to return to that world in order to ensure their survival. The function of institutional religion is to ensure that ordinary religious experience is acclimatized to the routine of everyday life while ensuring that it will be periodically reactivated within carefully defined limits. Religious tradition, or what Peter Berger calls "the memory of the nocturnal voices of the angels in the sobering daytime of ordinary life" (1979, 43-44), is both a permanent reminder of the elementary experience and an indispensable shield against its destructuring effects. The main medium of control is the incorporation of emotion into a language and the assimilation of the experience into a specific panoply of symbols with a specific history and social background.

From Berger's description of this process, it is clear that the incorporation of the experience into a language is inevitably felt to be a kind of imprisonment. The more theoretical the language, the greater is the distortive effect exerted on the original experience felt to be. The more the tradition is intellectualized, the further away it moves from the superabundant wealth of the experience, which it holds ensnared in its web of philosophical and theological concepts.

Peter Berger is by no means alone in stressing the distortion felt to exist between the elementary religious experience, entirely a matter of sensations and feelings, and the historically dated and socially situated language sorts in which it is described. The effect is one that has long been present in various guises in religious studies. The point is that there is a close link between the notion of distortion and the traditional view that the history of the human race is the same as the history of the shrinking importance of religion in social life. Many writers with Durkheimian views rank religious activity on a number of different levels of attainment, ranging from the immediate perception of the divine to the administration of the sacraments, and this view frequently coincides with a chronological account of the decline of religion, in which the secularization of modern societies supposedly comprises the ultimate stage of the decline.

The myth of "pristine" religion that subtends many theories of secularization may thus be seen to combine two basic propositions concerning the "pure state" of religion: The first posits that institutional worship is never more than an impoverished (or "domesticated") form of an original extrasocial experience; the second asserts that at the beginning of time religion occupied all of the social dimension (Durkheim 1933, 169-70). A combination of these two propositions takes for granted that institutionalization is one of the vectors—indeed, probably the main vector—of the increasing social insignificance of religion, an insignificance that is augmented by the fact that institutionalization is also an inevitable corollary of the movement that allows religion, at least up to a certain point, to become established in a function that vouchsafes the social order by which it aspires to be recognized.

Emotion, or Religion by Default . . .

The interpretation of current religious renewals as a "reenrichment" of the modern symbolic universe sapped by the advance of instrumental rationality rests, as we have just seen, on a set of hypotheses of

Durkheimian origin concerning the institutional stabilization of "pristine" religious emotion. However, a second approach to the links between emotion and religious institutions makes it possible to take quite a different view of at least some of the current manifestations of a "return" of emotion. This approach is linked in the first instance to Max Weber's conception of the religious trajectory of mankind and the position that Weber allocates to primitive emotional experiences on that trajectory (1978, 530-31).

From Weber's point of view, the primitive emotional experience is the fundamental form of religious behavior. It is of small consequence and has little or no effect on everyday life, as long as it remains restricted to an individual who episodically has ecstatic experiences (possibly under the influence of external stimulants such as alcohol, tobacco, narcotics, music, and so on). Orgy, the social form in which ecstasy occurs and the earliest form of religious communalization, has the same degree of precariousness and inconsistency, as long as it is not controlled and led by a "professional" (i.e., a magician) with permanent prestige enabling him to transform these sporadic ecstasies into systematic and regulated behavior. For Weber, the "institutionalization" inaugurated by rational magic does not by any means drain the primitive experience of its substance. On the contrary, it inaugurates a process of systematization and rationalization of religious representations and practices. Step by step, from the magical manipulation of natural forces to the ever-increasing symbolization of the relationships between Man and the supernatural, religion is plucked from the limited universe of everyday designs and steered toward the unlimited universe of extramundane objectives. This dynamic of creative institutionalization producing an increasingly rich and complex symbolic universe is not self-generated; it is a consequence of the transformations and complexifications occurring in the social and economic universe whose need for meaning it also expresses.

The Weberian approach to the symbolic enrichment of religious representations culminating in ethical religion rests mainly on an analysis of the link existing between the ever-increasing rationalization of the forms of divine worship and the very concepts of God and the historical process of social differentiation. This link manifests itself and attains fulfillment in the emergence of a body of religious specialists who, by producing and disseminating an increasingly elaborate corpus of religious knowledge, reinforce and stabilize their own power through the elimination of the uncontrollable means used for attaining ecstasy

(Weber 1952, 187-93). The planned approach to salvation, insofar as its aim is the procurement of a "permanent *habitus,* and moreover one that [i]s consciously possessed," is the opposite of the disorganized manifestations of orgiastic intoxication expressed merely as "acute ecstacies, [that] are transitory in their nature and apt to leave but few positive traces on everyday behavior" (Weber 1978, 535-36).

Nonetheless, the move toward abstraction and rationalization does not result in a complete disappearance of the orgiastic components of the primitive religious experience. These components continue to be present, particularly in worship, in the form of song, dance, drama, and fixed prayer formulae. In more general terms, an irreducible continuity exists between the orgiastic desire for immediate sensual possession of the deity and the ethical desire for permanent possession of the divine, insofar as their ultimate aim—autodivinization or the incarnation in Man of a suprasensual being—is the same. Orgy is never entirely dissolved in rituality, and although it tends, as the rationalization process advances, to give way to the symbolic constructs and operations that ensure its sublimation in the form of mysticism, it is never entirely absorbed by the symbolic elements, because mysticism incorporates the primitive desire for immediate, emotional, direct enjoyment inherent in orgy (Weber 1946, 278). It may even fan that desire (Weber 1978, 535), thereby maintaining the dimension of the extraordinary and the extramundane at the very heart of the rationalizing process, which, by repressing ecstasy, incorporates the quest for salvation into the ordinary practices of everyday life.

As a matter of fact, it must be borne in mind that the process described by Max Weber is an ideal-typical one. In his demonstration, "pure" orgy, "pure" magic, and "pure" ethical religion are conceptual flags, enabling thought concerning the fundamental mutation of the relationship between religion and the world occurring through the progressive elaboration of the human objective of "autodivinization." In reality, orgy, magic, and the ethical quest for salvation join and combine without the presence of so-called primitive forms being excluded at any stage in the rationalization process. Even the "disenchantment of the world" is merely a boundary concept. From this point of view, secondary modes of reasoning may be grafted onto the primary logic of the "disemotionalization" of religion and create contrary effects. Hence, the ethical denial of the magical ambition to "possess God" may be inverted into a desire to make oneself entirely available to the action of God within oneself, a desire that may go as far as a refusal of the

elementary natural needs of the human body, such as hunger, sleep, and so on. In turn, this refusal may lead to extraordinary experiences, such as visions and hallucinations, that are part of the primitive universe of orgy. From the viewpoint that sees institutional rationalization as a major factor in the decline of religion, manifestations of this kind are immediately identified in terms of a "return of the repressed" and ascribed to a waning of the dominant rationalizing modes of thought due to a variety of influences. The Weberian point of view makes it possible to escape from this linear approach and bring into play in every direction all available combinations of the typical modalities of religious experience.

It will be argued that, in the event of an out-and-out rationalization of the world, leading to the repression and disappearance of ethical religion itself, the available range of combinations will necessarily fail after a short while. However, although Weber strongly underlines the "tension" with the religious sphere that results from the increasing differentiation and rationalization of the spheres of values (1946, 323-59), he also stresses on several occasions the limits of the rationalization process affecting these different spheres (including that of science) and the irrational effects that are likely to result. "Rationalization" is therefore another boundary concept. In practice, the inability to confer meaning on the world, as the result of the differentiation of the spheres of values, constantly reveals the irrationality of rationalization (Séguy 1986). Rationalist intellectualism has taken an arid turn that favors the rise of a new type of polytheism that associates with values (instead of with deities) such things as belief phenomena, ascetic practices, devotions, enthusiasms, and even experiences of ecstasy. "Disenchantment of the world" thus produces, contrary to its own logic, the revivification of attempts to give legitimate definitions of the world's meanings. These attempts involve intense commitment from individuals whose utter lack of transcendent perspectives exposes them to complete uncertainty concerning the outcome of their struggle. This accounts for the fact that their attempts give rise to strongly emotional experiences in which the most irrational passions are reactivated at the center of a hyperrationalized world (Weber 1946, 148-49).

From this general viewpoint, Weber does not systematize a theory of religious emotion. The primary emotional experience of the orgiastic type does not occupy him for long—at least, he does not see it as the manifestation of the "pure" religious experience. However, he does place emphasis on the historical process of rationalization, itself insep-

arable from the institutionalization of the religious sphere. His complex approach—branching, rather than linear—refashions, transforms, and reassumes emotional experience in different forms. It does not disappear; it is redistributed. It can even emerge from the rationalization process itself, not merely as the reactivation of a repressed or inhibited experience, but as a new form of religious experience in a specific sociocultural context.

Desecularization or an Emotional Consummation of Secularization?
Prospects for Research

What are the prospects offered to a sociology of religious modernity by a fresh look at analyses of emotion in religion?

Emotion as Desecularizing Protest

In the past, Durkheimian analysis of the "emotion of the depths" was partly responsible for steering the historical sociology of effervescent religious movements—heresies, mysticisms, messianisms, millenarianisms, and similar revivalist phenomena—toward a sociology of socio-religious protest seen as a radical reassessment of the collective assumptions of a society (Desroche 1968). This approach is also useful for the study of present-day manifestations of the religion of emotional communities—the sociology of charismatic movements makes abundant use of it. All of these movements involve criticism of institutional religion conjointly with criticism of the dominant regime of social relations in modern society. At the same time as they attach high importance to the plural expression of believers regenerated by conversion and stress the intensely emotional dimension of this conversion that totally transforms the lives of those who undergo it, they reject the aridity of the authorized forms of expression offered to the faithful by the religious institutions. They also oppose the abstraction of the dogmatic utterances and ritual settings within which the institutions set out to contain and restrain the unpredictable dynamism of the individual and collective religious experience.

This criticism, whether explicit or implicit, of the "coldness" of the religious institutions and of the slight attention they pay to believers' emotional needs, represents a broader challenge to the dependence into

which the churches have gradually come with regard to the modern primacy of reason. Present-day emotional religious communities all see the decline of the emotional substance of community life as a consequence of the religious institutions' adjustment to the ground rule prescribing a separate, specialized field for religion. They protest, whether explicitly or implicitly, against this passive acclimatization to modernity, which, instead of providing the churches with their intended social audience, has (in the charismatic view) produced a massive repression of religious experience. The link thus established, between institutional acceptance of the modern ground rule and the decline of the emotional density held to be consubstantial with authentic religious experience, makes it possible to account for the elective affinity existing between present-day emotional religious movements and currents of opinion within the institutions that are in favor of outspoken opposition to the spirit of the modern world. The recent history of the Roman Catholic charismatic movement provides many instances of this (Hervieu-Léger 1987).

What is important here is the convergence that can be distinguished—from a viewpoint taking emotion to be the source of "pure religion"—between the current upsurge in emotional religiosity and the demodernizing tendencies activated by the current spate of economic, social, and political turbulence. One approach to the sociology of the new religious movements has adopted this line of thought by associating present-day emotional renewals with a broader process of "desecularization," the origin of which is considered to lie notably in the inability of modernity to fulfill its promises of unlimited progress. This viewpoint, which suggests that the very concept of secularization should either be dropped or at least completely overhauled, has given rise to a great deal of sociological debate (see, e.g., Douglas and Tipton 1982; Hammond 1985; Stark and Bainbridge 1985). It would be worthwhile and fruitful to study the different orientations of this debate according to the different cultural and religious contexts in which it has taken place.

An important historical inquiry in the sociology of religion in this regard that should be undertaken is one that would explore the differing senses of "religion" in different times and places, and among different social strata. While there are those, like Wilfred Cantwell Smith (1963), who have complained at length about the Western bias attached to "religion" in comparative religious studies, perhaps a more serious flaw is the lack of documentation among Western scholars of religion of what this term has meant within their own cultural history. For example, up

until quite recently in the Catholic Church, parish clergy under diocesan jurisdiction were termed "secular" priests, while those belonging to orders were "religious." To term a priest "secular" today would mean something quite different.

Emotion as a "Way Out" From Religion

On the other hand, it is possible, by extending and augmenting the Weberian framework, to ask whether the general move toward secularization, which subsumes and absorbs the move toward rationalization, might not, in its most advanced stage, favor the emergence of a new kind of emotional experience. Emerging from the ruins of the great religious traditions that have been deprived of social and cultural relevance by the advance of instrumental rationality, these "returns of ecstasy" might correspond to an impoverishment of the religious imagination in the form of a regressive desire for immediate contact with the supernatural, a reversion to the meager universe of orgy and magic. From this point of view, present-day emotional renewals would, paradoxically enough, be a response to the general process of desymbolization, which, on the cultural level, conveys (and subsumes) the move toward the eviction of religion from society. This hypothesis, which posits an emotional conclusion to the process of secularization, is somewhat provocative and merits examination.

Practical considerations of efficacy and interest accompany the rise of instrumental rationality and tend to erase the cultural relevance of the symbolic devices, including religion, that traditionally ensured the organized supply of group meanings and individual identifications with those meanings. This does not mean that the need for meaning and identification disappears; it is even reinforced by the experience of uncertainty and complexity that characterizes modern society. However, it would be mistaken to believe that these demands for meaning, which are expressed acutely during periods of crisis, give the symbolic apparatus inherited from the past (the "great religions" in particular) a chance of reconquering a central position in present-day culture. Instead, the religious traditions of the past are treated as symbolic "toolboxes" on which the men and women of today draw freely, without this necessarily meaning that they identify themselves with the comprehensive view of the world and Man's place in that world that historically was part of the language of the traditions concerned.

An example will make this clear. In the traditional Christian universe, the theme of healing is regularly associated with the theme of salvation, the latter being metaphorically referred to and practically preceded by the former. In the new religious movements belonging to the Christian domain (and more especially in some charismatic movements strongly marked by the impact of psychology and human relations theory), an inversion of this point of view may frequently be observed: The theme of "salvation" ceases to refer to the expectation of a life of plenty in another world, which has become culturally devalued, but functions instead as a symbolic landmark extending the demand for healing to every aspect of self-fulfillment. This desire for fulfillment, as entire as oneself in the world, is completely in tune with the modern culture of the individual. In this modern articulation of salvation and healing, the former becomes a metaphor for the latter, a manner of saying that complete health in the present world implies at once the physical, psychological, and moral integrity of the individual. Furthermore, the reference to "salvation" has merely become a manner of requiring modern medicine to embrace a holistic view of the human condition (Augé and Herzlich 1984).

This sort of transfer of meaning, for which examples abound, is part of a broader process of instrumentalization of Christian references and signs within modern culture. The reason why religious language no longer succeeds in its own right is that in modernity there has ceased to be a feasible and conceivable bond of unity among the objective order of the world, the collective universe of meanings, and the subjective experience of sense. Or rather, coherence can no longer be presented as the result of once-and-for-all revelation: It is a human objective, a constantly expanding horizon for collective endeavor. The extraordinary power of fascination, still exerted by the great religious traditions within modern societies prey to anxiety and uncertainty, is due to the fact that they are stamped with the human need for coherence, which has remained imperious in modernity—coherence of the history of mankind bent on its fulfillment, coherence of the destiny of the individual caught up in that history. However, these selfsame modern societies at the same time rule out all possibility of providing, in the religious mode, a culturally plausible response to this demand.

By rejecting "intellectual" expressions of faith and attaching importance to the perceptible manifestations of the divine presence in the world, present-day emotional religious movements attempt to overcome this structural conflict in the condition of the believer in moder-

nity. On the one hand, they display the power of attraction still exerted, in a world of anxiety, by the religious vision of a wholly "sensible" world. On the other hand, they illustrate the impossibility for men and women living in modernity to assume the language in which that sense was objectified in the religiously integrated universe of the tradition. The recourse to collective emotion makes it possible to save the call for coherence, in all its religious intensity, without encountering the problem of the symbolic language in which that coherence was historically articulated.

This hypothesis suggests that the present-day development of emotional religiosity could be coextensive with the rejection of symbolic content in the modern universe, and so constitute a form of adaptation of the religious groups to the cultural new deal. From this point of view, it remains possible to see the overflow of the emotional expression of religious experience as the expression of a form of protest against the impoverishing institutional control of personal and collective believing experience. This revolt of the subjective against petrified church religion is altogether in line, as we have seen, with the cultural trends of advanced modernity, with its insistence on the individual's right to subjectivity, even in religious matters. However, we also need to ask whether the quest for nonverbal forms of emotional communication in these communities does not express, alongside the protest against the stereotyped nature of the authorized religious language, something of the rarefaction of articulated religious language in modern culture.

The position occupied by the practice of "speaking with tongues" in these groups poses the question directly, as glossolalia does not aim to communicate a message but to "give expression" (Samarin 1972). Insofar as the practice involves members of social strata fully assimilated into cultural modernity, this use of a language beyond language cannot be regarded as the symptom of a social and cultural exclusion that makes them foreign to the world as it is. Instead of defining an instance of socioreligious protest against an effective deprivation of all forms of expression—as found in historical pentecostalism, particularly in black communities (Synan 1971)—this practice might be called *new generation glossolalia* (*glossolalie des héritiers*), in a sense similar to that in which Jean Séguy (1983; see 1975), with reference to Pierre Bourdieu (see Bourdieu and Passeron 1964), uses the term *new generation millenarianism* (*millénarisme des héritiers*). This reflects the social and cultural protest of those who master, because of their social origin, the

symbols and references of the dominant culture, thus reversing the "religion of the disinherited" hypothesis of H. Richard Niebuhr (1929). The purely emotional orientation of these people's religious quest for sense might thus be seen as the result of the very success of their assimilation into the universe of modern rationality—a success so total that it destroys the plausibility, even for themselves, of the traditional language used to express their religious experience. The only solution is to use an inarticulate language whose capacity for communication is essentially expressive and poetic—a metalanguage that, by definition, avoids direct confrontation with the language of modernity, from which traditional religious language emerged and proved unacceptable (see Poewe 1992). Outside a specifically charismatic setting, this dynamic of opposition to the language of modernity may be seen in the title of Marsha Sinetar's "guide for spiritually emerging adults," *A Way Without Words* (1992), wherein, among other things, the author seeks to distinguish "between spirituality and religion."

The religious use of a "non-ordinary language" (old language, foreign language, "language of angels," and so on) has multiple social implications inside and outside communities. The mastery of this special language is a stage in the regulation of power inside communities. By demonstrating the distance between the ordinary things of everyday life and the religious universe, it can be the vector of socioreligious protest. At the same time, it separates the believers from the ordinary, unconverted people, and it gives public evidence to the collective and exclusive possession of secret knowledge. From this point of view, it is interesting to study the different attempts (across time and space, both geographic and social) to preserve, to rediscover, or to invent a non-ordinary religious language as part of a process of shaping or reshaping collective socioreligious identities.

The Religion of Emotional Communities: Between Modernity and Antimodernity

As we have seen, a fresh look at the two theoretical traditions, on which sociology has based its study of religious manifestations of the emotional type, provides us with a double approach to present-day emotional renewals. On the one hand, the renewals may be seen as the overflow of the "emotion of the depths" that can no longer be contained within the bounds ascribed to religious expression within the narrow rational universe of modernity. This gives rise to the suggestion that

their development represents a challenge to the compromise relationship existing between the specialized religious institutions and a secularized society functioning without any reference to religion, and this view emphasizes their "desecularizing" role. On the other hand, there are grounds for observing that these phenomena represent, on the contrary, owing to the importance attached to emotional manifestations freed from the constraints of language, the irreversible decline of a religious language capable of being understood socially, and this makes it legitimate to advance the hypothesis of an "emotional consummation of secularization." Does this mean that the two approaches totally exclude one another? A more interesting proposition, from the viewpoint of the construction of a sociology of religious modernity, is to explore instead, through the tension between the "desecularizing tendencies" and the "secularizing tendencies" at work *conjointly* in the emotional renewals, something of the intrinsically *contradictory* nature of the secularization process itself (Hervieu-Léger 1990).

In the context of the 1970s and the rise of the "new religious awareness," the expansion of community emotionalism was often studied in the classic terms of the sociology of socioreligious protest. It was seen first and foremost as the manifestation, in the religious mode, of a rejection of the atomization and abstraction of the social relations that characterize techno-industrial society, and as the expression of a burst of demodernization amplified by the crisis. This community renewal of emotional expressivity signified, from this point of view, rejection of the emotional indifference of modernity deemed to be entirely under the sway of measurable efficiency and bureaucratic functionalization of human relations. It was supposed to challenge the manner in which the major religious organizations come to terms with the traditional norms. However, this antimodern religious emotionalism could at the same time be observed as constituting additionally—and paradoxically—a kind of adaptation by the religions to the modern world. The pragmatic approach to tradition (which chooses the solutions that "work" in that they favor the experience and expression of individuals), the insistence on the right to subjectivity in religious matters, the primacy given to the emotional fulfillment of individuals, the attention paid to the personal and interpersonal advantages of community activity—all of these features are indications of the affinity maintained by the religion of emotional communities with modern culture, of which it is a contradictory product (Champion 1989, 1991).

An understanding of the ambiguity of this form of expanding religiosity makes it possible to appreciate why it attracts so many members of the intellectual middle classes (teachers, social workers, cultural mediators, business people with training in human relations, and so on) who are full participants in cultural modernity but who experience a highly acute contradiction between the cultural capital that they possess as a result of their upbringing and schooling and the reality of their socioprofessional and economic status. In particular, awareness of this essential ambiguity throws light on the continuity that exists between the counterculture of the 1960s, the anti-institutional movements of the 1970s, and the development of the "new religious awareness."

The tension in the religion of emotional communities between modernity and antimodernity is significantly apparent in the ambivalent relationship that the new religious movements belonging to the Christian domain (especially the Protestant and Roman Catholic charismatic movements) have with the tradition of the churches and faiths from which they spring. On the one hand, they subscribe to a kind of "religious spontaneity" that is altogether in line with the trend for subjectivity nourished by the modern culture of the individual. This spontaneity introduces elements of discontinuity with the set of beliefs, doctrines, attainments, norms, and obligatory practices that the institution itself defines as the corpus of its tradition, of which it is the guardian and the mentor. From this point of view, these phenomena may be regarded as contributing to the *institutional deregulation* that is coextensive with the general secularization movement. However, empirical observation reveals at the same time that these emotional community socializations constitute, in the modern context of the dissemination of belief phenomena, a favorable locus for the aggregation of the "personal narratives" produced by individual believers, and for the ultimate merger of these narratives with the "Great Narrative"—the tradition that the religious institutions claim to preserve (Cohen 1986). Thus, these findings open the way for a study of *emotional socialization in accordance with dominant values and norms* along lines similar to those followed by certain writers on the role of utopia (see Séguy 1980; cf. Beckford 1975; Dearman 1974; Johnson 1961). This does not contradict the preceding analysis of the emotional dissolution of institutional religion, but articulates with it dialectically. This need for a dynamic correlative study of developments that appear contradictory is not merely the concern of the sociology of religio-emotional phenomena; it is, rather, the preeminent theoretical imperative for a sociology of religious modernity.

References

Augé, M., and C. Herzlich, eds. 1984. *Le sens du mal*. Paris: Editions des Archives Contemporaines.

Bastide, R. 1967. *Les Amériques noires*. Paris: Payot.

Beckford, J. 1975. *The trumpet of prophecy*. Oxford: Blackwell.

Berger, P. L. 1967. *The sacred canopy*. Garden City, NY: Doubleday.

——. 1979. *The heretical imperative*. Garden City, NY: Doubleday.

Bergson, H. 1946. *Les deux sources de la morale et de la religion*. Paris: PUF.

Bourdieu P., and J. C. Passeron. 1964. *Les héritiers*. Paris: Minuit.

Champion, F. 1989. Les sociologues de la post-modernité religieuse et la nébuleuse mystique-ésotérique. *Archives de Sciences Sociales des Religions* 67: 155-69.

——. 1991. Individualisme, protestation holiste et hétéronomie dans les mouvances mystiques et ésotériques contemporaines. *Social Compass* 38: 33-41.

Champion, F., and D. Hervieu-Léger, eds. 1989. *De l'émotion en religion*. Paris: Centurion.

Cohen, M. 1986. Vers de nouveaux rapports avec l'institution ecclésiastique. *Archives de Sciences Sociales des Religions* 62: 61-80.

Dearman, M. 1974. Christ and conformity. *Journal for the Scientific Study of Religion* 13: 437-53.

Desroche, H. 1968. *Sociologies religieuses*. Paris: PUF.

——. 1969. Retour à Durkheim? *Archives de Sociologie des Religions* 27: 79-88.

Douglas, M., and S. M. Tipton, eds. 1982. *Religion and America*. Boston: Beacon.

Durkheim, E. 1933. *The division of labor in society*. New York: Free Press.

——. 1965. *The elementary forms of the religious life*. New York: Free Press.

Hammond, P. E., ed. 1985. *The sacred in a secular age*. Berkeley: University of California Press.

Hervieu-Léger, D. 1986. *Vers un nouveau Christianisme?* Paris: Cerf.

——. 1987. Charismatisme catholique et institution. In *Le Retour des Certitudes,* edited by P. Ladrière and R. Luneau, 218-34. Paris: Centurion.

——. 1990. Religion and modernity in the French context. *Sociological Analysis* 51: S15-25.

Hubert, H. 1904. *Introduction à la traduction française du Manuel d'Histoire des religions de Chantepie de la Saussaye*. Paris: Armand Colin.

James, W. 1961. *The varieties of religious experience*. New York: Macmillan.

Johnson, B. 1961. Do holiness sects socialize in dominant values? *Social Forces* 39: 309-16.

——. 1978. *A general theory of secularization*. Oxford: Blackwell.

Niebuhr, H. R. 1929. *The social sources of denominationalism*. New York: Holt.

Poewe, K. 1992. Max Weber and charismatic Christianity. In *Twentieth-century world religious movements in neo-Weberian perspective,* edited by W. H. Swatos, Jr., 159-73. Lewiston, NY: Mellen.

Samarin, W. J. 1972. *Tongues of men and angels*. New York: Macmillan.

Séguy, J. 1975. Situation historique du pentecôtisme. *Lumière et Vie* 125 (Nov-Dec).

——. 1980. La socialisation utopique aux valeurs. *Archives de Sciences Sociales des Religions* 50: 7-21.

——. 1983. Sociologie de l'attente. In *Le Retour du Christ,* edited by C. Perrot and A. Abecassis, 71-102. Brussels: Presses des Facultés Universitaires Saint-Louis.

————. 1986. Rationalisation, modernité et avenir de la religion. *Archives de Sciences Sociales des Religions* 61: 127-38.

Sinetar, M. 1992. *A way without words*. Mahwah, NJ: Paulist Press.

Smith, W. C. 1963. *The meaning and end of religion*. New York: Mentor.

Stark, R., and W. S. Bainbridge. 1985. *The future of religion*. Berkeley: University of California Press.

Synan V. 1971. *The holiness-pentecostal movement in the United States*. Grand Rapids, MI: Eerdmans.

Wach, J. 1951. *Types of religious experience*. Chicago: University of Chicago Press.

Weber, M. 1946. *From Max Weber*. New York: Oxford University Press.

————. 1952. *Ancient Judaism*. Glencoe, IL: Free Press.

————. 1978. *Economy and society*. Berkeley: University of California Press.

Religion and the Body

Sociological Themes and Prospects

JOHN H. SIMPSON

One might conclude after reading the founders of sociology that human beings are either disembodied minds and free-walking spirits or clever animals driven by a need to feed, reproduce, and concoct stories about their activities. The thoughtways of sociology, in other words, incorporate the primary dualism of Western culture, the notion of a split and tension between body and mind, matter and spirit, nature and culture, desire and reason. What is fundamental for the constitution of societies? Is it ideas that become materialized as social processes and structures through human discourse and action? Or is it the organization of humans to appropriate nature through collective action where discourse only summarizes and supplements action? Both views find support in the classics of sociology, and both views disembody the human actor in society (see Frank 1991; McGuire 1990; Turner 1984, 1991). Why that is so, how religion is implicated, and why there are signs that things are changing are the topics of this chapter.

The Rise of Sociology and Disembodiment

Disembodiment means that the properties of human actors and actions that are used to describe, understand, or explain a social structure,

process, or sociohistorical direction are not defined as properties that are contingent on the bodies of humans. In disembodiment, the properties of actors that attract theoretical attention either do not reference the body (explicitly or implicitly) or are viewed as determining and overriding the body in such a way that the body cannot be an effective source of social action.

How does sociological thought disembody the human actor? The answer is found in the notions and assumptions put forward in the nineteenth century and early twentieth century in the effort to establish sociology as the interpretive science of society. Sociology emerged as a way of understanding the social changes and conflicts that occurred in the West with the rise of industrial capitalism, mass democracy, science, and technology. Those changes and conflicts moved the West into the modern period, and sociology can be viewed as a "story" about modernity. In telling the "story" of modernity—that is, in the development of sociological theory—sociologists drew upon certain intellectual resources and rejected others. Especially important in that regard was a move away from models of society that rested upon biological or economic assumptions and a concomitant move toward an understanding of society as an interplay of values and beliefs pertaining to the organization of humans for production and reproduction.

The founders of sociology rejected the notion that societies could be understood as the aggregated behaviors of individuals attributable to biological urges, drives, and needs. They knew from history and the exploration of the non-European parts of the world that there were many distinct and different types of societies. That being the case, it was difficult to argue that common universal biological urges alone were the foundation of society since, if that were true, distinctly different societies would not exist. Common urges would lead to similar outcomes, and it would be impossible to tell one society apart from another. The notion of society, then, is based on the idea of nonbiological differences among biologically similar humans.

The founders of sociology also rejected the notion that societies could be understood as simply the aggregate behaviors of individuals pursuing their own interests or urges in a rational manner. Societies are more than associations of individuals calculating profit or loss, pain or pleasure, happiness or wretchedness as a basis for action. Models of society incorporating the idea of rationality based on calculation can be classified as "economistic." Such models were rejected as ways of representing and understanding societies for two general reasons. First, it was shown

that economistic models depend on nonrational assumptions and, hence, are inconsistent with the premise that society is rationally constituted. Exchange, for example, depends ultimately on nonrational trust as a basis for the contractual relation between buyer and seller that leads to profit or loss. Economistic models also neglect the importance of seemingly irrational social interaction and exchange in collective life. For example, in some societies the distribution of goods is governed by principles that violate the economistic notion of accumulation. Thus, rather than accumulate goods for personal or economic advantage, certain native peoples of the Northwest Coast gave away precious goods in order to achieve social standing (Codere 1950).

In steering a theoretical course away from biological and economistic models, the founders of sociology pushed the body outside the domain of sociological discourse. Pleasure, desire, happiness, pain, and frustration were either abandoned as primary resources in the construction of sociology and left to the attention of other disciplines, or simply taken for granted as primitive givens that could be neglected in developing an understanding of more "important" matters, such as the nature and control of the means of economic production. Sociology, then, in the first instance disembodied the human actor by averting its gaze from the body as a source for constructing theory.

Although the founders of sociology rejected models based on biological or economistic assumptions, they did accept, as a starting point for inquiry, the question that such models addressed: What is the basis of society in the first place? Without undue violence to the rich, varied, and complex theoretical traditions of sociology, it can be argued that sociological answers to the question fall into two broad categories. Thus, society is viewed as either (1) a way of securing benefits by overcoming the endemic problems that humanity would face without society (Hobbes 1968), or (2) a necessary but imperfect imposition that constrains, skews, and degrades human nature (Rousseau 1950). In the first category society is a means of beneficial control. In the second category society is an impairment that needs to be changed in order to perfect humanity.

Where society is viewed as a means of control, the body tends to be viewed as a center of primal forces to be managed and overcome. There is, in fact, a remarkable convergence among such otherwise disparate theorists as Max Weber and Sigmund Freud (both ultimately "control" theorists) regarding the domination of the body by culture as a source of civilization and social change.

In *The Protestant Ethic and the Spirit of Capitalism,* for example, Weber (1958) argues that the discipline of the body achieved through conformity to the ethical precepts of Calvinism ("inner-worldly asceticism") and conjoined to the practices of mercantile capitalism significantly encouraged and enlarged the institution of capitalism as an emergent form of modern economic organization. In Weber's view, rationally ordered bodies—sites where the words of practical, religious ethics triumphed over the pulls of desire, and whose actions were expressed in the methodical accumulative practices of early capitalism—cranked a powerful engine that helped propel the West into modern times.

In his well-known essay, *Civilization and Its Discontents,* Freud (1962) concludes that human progress and civilization could be achieved only through the renunciation of desire. Without the forceful taming and repression of bodily urges, civilization would not exist. But civilization always exacts a price, according to Freud, as repressed bodily urges surface in distorted behavior, fantasies, and individual unhappiness. Caught between the comforts and glories of civilization and the repression of desire, humanity exists in a perpetual state of discontent. Freud, however, thought that individuals could alleviate the pangs of civilization through the discipline of psychoanalysis, a form of discourse that salved the wounds inflicted by civilization on the body-seething-with-desire.

Thus, both Weber and Freud gave primacy to the triumph of words over bodies—spoken texts and regulated contexts of talk—the strictures of religious ethics and the logocentric episodes of psychoanalysis—as the key to understanding the dynamics of societies and their effects on individuals. In the control version of sociological thought, opinions, attitudes, beliefs, values, and ideas efface the body. Human actors are, in television lingo, "talking heads."

While society can be viewed as the solution via control to the problematic condition of humans in a state of nature, it can also be viewed as the source of the problems that plague humanity. Underlying this view are the assumptions that humans by nature are intrinsically good and that the natural state of humanity is peace, underwritten by a harmonious balance between the needs of humanity and the physical environment. Where human needs and the environment are not in balance, a condition of scarcity obtains. Society is organized to overcome scarcity, but it leads to inequalities, war, and the civil state. Society, then, corrupts and degrades humanity even as it "solves" the problems of scarcity and order. Nevertheless, the perfection of humanity always remains a possibility contingent on the formation of a society where true humanity

can be developed and expressed in the acts of free, autonomous individuals. Present evils would disappear in a social environment where naturally good humans freely express their essential nature.

At first glance one might think that the view of society, as an impairment and obstacle standing in the way of the development and expression of true human nature, would privilege the body as a theoretical object. That, however, did not happen in the development of sociological theory. The most important heirs of the view of society as an impairment and obstacle were Karl Marx and his followers (see Zeitlin 1990, 82-137). Marx viewed the body as the key laboring element in various historical modes of production designed to overcome scarcity. All modes of production, however, with the exception of communism, according to Marx, dehumanize the body by exploiting it. Capitalism is especially exploitative since it reduces the body to the status of a laboring machine that is maintained at a level of subsistence great enough only to ensure its continuation in the present and its reproduction to provide the next generation of laboring machines.

In principle Marx was body-oriented, but both Marx and his followers obscured the body by locating the mainspring of societies in modes of production and by assuming that social institutions or formations are dependent, in some ultimate sense, upon economic forces. Marxism, then, diverted attention away from the body by siting social reality in abstract forces of production outside the body, forces that, according to Marx, ultimately deform and victimize both desire and thought.

Marx saw in communism and the absence of private property in an industrial social formation a means for ameliorating and overcoming the obstacles that society as he knew it put in the way of the development and expression of true humanity. In this respect one of the greatest ironies of Marxism as a materialist sociophilosophical system was the effective abandonment of the sensuous materiality of the body and the attribution of effective agency to inanimate material property. Thus, property and the forms in which it is held ultimately determine human nature; Marx thought that under communism the commonly held property of the "people" would humanize them by inscribing itself on their bodies through unexploitative social relations. In that circumstance, however, the body is still submerged in property and its control, and has no independent expressive capacity of its own.

Were Weber, Freud, and Marx right? Must we understand societies from a perspective of disembodiment that either submerges the body in the words and discourses of action and civilization or makes the body

a thrall of property? The answer is no, but that does not mean that Weber, Freud, Marx, and the others who developed sociological theory were wrong. What it does mean is that sociological theory as it developed told a true "story" of its time and place, but since then things have changed in a direction that encourages the embodiment of human actors in sociological theory. Religion, in particular, is implicated in those changes.

Weber and the other theorists who first told the sociological story of modernity were right in the sense that they presented an accurate picture of the body as an element in the system of entrepreneurial and industrial capitalism that was developing in their time. Entrepreneurial and industrial capitalism were driven by two intertwined forces: the factory production of goods and the direct accumulation of capital. The factory system, as it developed in the nineteenth century, was geared to the efficient production of goods, using power-driven machines interfaced with disciplined laboring bodies performing simple repetitive tasks. The direct accumulation of capital required the repression of the urge to consume and, as Marx (1954) noted, the suppression of consumption beyond a subsistence level so that the surpluses generated by production could be reinvested. Entrepreneurial-industrial capitalism, in other words, was a system that depended upon the rationalization and material discipline of the body-as-producer-and-consumer, a requirement that is consistent with the disembodied actors that appear in the works of Weber, Freud, and others.

While capitalism in the nineteenth and early twentieth centuries was consistent with the repression and oppression of the body, it is by no means the case that economic forces alone effaced the body in that period. The development of scientifically based medicine also tended to disembody the human actor by progressively isolating the physical body as an object of study and control. Thus, the body came to be viewed as a mechanism or system that could be regulated and repaired, if necessary, like any machine (see Turner 1982). Empirical successes in the control and treatment of infectious diseases, the discovery of anesthesia, advances in surgery, and generally, the institutionalization of experimental, scientific medicine as the basis for clinical practice reinforced the classic Western notion that the body and mind were separate systems, inasmuch as the body could be isolated and successfully treated as an object.

The notion that the body is a machine or machine-like appendage in a system was also reinforced and supplemented by religious forces in

various ways. In the history of the West, the most important direction in this regard was the diffusion of asceticism and the spirit of monastic regimens into everyday life, a trend that was encouraged by the Protestant Reformation. Under Protestantism, the regulation and discipline of the body and the mind in terms of ascetic religious norms and practices became the responsibility of all believers. The conduct of religious life was no longer the duty and calling of only religious elites, who were sequestered from the everyday world in order to perfect their lives in ascetic monastic practice. All individuals were called to practice the norms of religion in the everyday world, a direction that Weber labeled "inner-worldly asceticism," since the spiritual disciplines that were collectively enforced and celebrated in the monastic context were relocated to the consciousness or internal psychic economy of the individual.

Clearly, the roots of capitalism, science, and Protestantism stretch far back into Western history, and each can be viewed as an independent development. But there is a sense in which they congealed together, in the late nineteenth century and early twentieth century, to construct the body as an object controlled by and subordinated to the disciplinary logics of work, science, and religion. The rationalization of work to produce goods and capital formation to expand investment, the subjection of the body to empirically effective scientifically based medicine, and the triumph of ascetic Protestantism in the evangelical movements of the nineteenth century and the parallel "puritanization" of Roman Catholicism came together as a resultant force brought to bear on the body as an object of control, regulation, and direction on behalf of civilization and progress in the modern age. Perhaps the greatest irony in this respect is the convergence of the secular logics of capitalism and science and the religious logics of Protestantism and a "puritanized" Catholicism to produce the modern body. The modern body, then, represents a synthesis of disciplinary logics that are usually viewed as institutionally differentiated and antithetical. The modern body, in other words, is a site for making sense of modernity as a production of the complementary forces of capitalism, science, and religion.

The Postmodern Body

Since the 1960s it has become increasingly evident that Western European and North American societies are no longer forcefully driven by the constraints of industrial capitalism and the culture of modernity.

Thus, according to many observers, Western industrialized societies have moved into the period of "late capitalism," where the culture of postmodernity now inscribes itself on the body in ways that are much different from the impositions of modernity (see Bell 1976; Featherstone 1988; Hutcheon 1989; Jameson 1991).

Late capitalism can be viewed in terms of three changes or shifts that have implications for the construction of the postmodern body: First, there has been a shift away from an emphasis on production to an emphasis on consumption. Whereas industrial capitalism was fixated on the formation of capital to produce goods—a complex, as noted above, that repressed desire and oppressed bodies—late capitalism uses capital to stimulate desire and celebrate the body as a servant of consumption. The "hero" of late capitalism is not the diligent worker, but the unsatiated, willing consumer, seething with desire for new things and experiences. The mind, complementing the body in late capitalism, becomes a locus of information processing, a platform that must be properly engineered and programmed so that the body can launch its consumptive projects. Thus, in late capitalism the problem of social control is relocated from the body to the mind. The question no longer is: "How can the mind be used to control the body?" The question now is: "How can the body be used to control the mind?"

Second, in the post-World War II period, the scientific understanding of the body and its applications in medical practice have accelerated at a rate undreamed of in modern times, when the body was viewed as an imperfectly understood machine that could be regulated and sometimes repaired if necessary. As the horizons of medical knowledge and technology have expanded, however, the ability of medical science to locate causal "ballparks"—as, say, in the cases of cancer(s) and the AIDS pandemic—visibly outstrips the ability of medicine to effect cures. The body, consequently, becomes a site for adjunctive extra-scientific or quasi-scientific manipulation. Western medicine, based on science and the clinic, may be supplemented or replaced by alternative forms of body care. Some supplemental or alternative therapies are anchored in suspicion regarding the relationship between industrial technology, the environment, and health, a suspicion that is thematized in public discourse about the pollution of the environment and its effects on the body. Other supplemental or alternative therapies are anchored in non-Western ideologies and practices, where they escape the "circle of inscriptive determination" that defined the modern body according to

the complementary logics of industrial capitalism, scientific medicine, and nineteenth-century Evangelical religious sentiments.

Third, the "patric" body of industrial capitalism has come under siege in postmodernity. The patric body occurs where economic production is separated from the household (see Turner 1984, 136-56). The patric body is to be distinguished from the historically more common patriarchal body, which is constructed where economic production is embedded in the household. Thus, the patric body exists where the family is a specialized unit of consumption and socialization (but not production), and public and private arenas are constructed as separate domains of masculine and feminine action, all subject to dominant masculine influence and control. Under industrial capitalism those features of social organization underwrote the development of the normative nuclear family—the stereotypical unit of mom, dad, and two kids, with dad, as the breadwinner, ultimately in charge. The patric body, then, is a distinctively gendered heterosexual body—male or female—producing and reproducing instrumental male dominance and expressive female submission, where the household in both industrial and late capitalism is a unit of socialization and consumption but not production.

The patric body is under siege for essentially three reasons: First, the technological control of reproduction and associated medical advances (e.g., antibiotics that make abortion a relatively safe procedure) have effectively moved reproduction from the realm of fate to the realm of choice. Women can be self-willed instruments of choice rather than unwilled objects of the desire of the other. Second, the expansion of the service, information-knowledge production, and light industrial sectors and the "de-gendering" of many traditional male jobs under late capitalism have substantially enhanced the demand for female labor force participation. Late capitalism, then, undoes the sense of necessity associated with the sharply gendered division of labor of industrial capitalism. Third, the global institutionalization of human rights supports the allocation of social rights to the previously socially "unrighted" bodies of women, gays, and lesbians, thus effacing the differences between patric bodies and nonpatric bodies (Simpson forth.).

These conditions lead to several questions with respect to the role of religion in such a sociocultural milieu: Is religion implicated in the shift from industrial to late capitalism? Can we find signs that religion now produces desire, assists in defining and operating on the body as more than a medicalized object, and underwrites the demise of the patric body? I have argued here that the modern body was produced by the

complementary logics of industrial capitalism, scientific medicine, and certain religious forces. Does the form of the argument also hold for late capitalism? Do religious forces reflect or complement the economic logics now in place, the ambiguities of scientific medicine (at once hypersuccessful and unable to cure), and the forays against the patric body? In other words, does the complementarity of secular and religious forces hold in postmodernity as it did in modernity as far as the body is concerned?

Seeking Answers: A Research Agenda

Answers to the questions are easiest to find in what, from a modern perspective, are the oddities and surpluses at the edges of late capitalist societies. Looking in that direction then, we can find religion under-writing the production of desire in the more entertaining television evangelists, linked to healing and alternative medicine, and decon-structing the patric body in the gay church movement. Those are only a few examples, and each, like all other possible examples, contradicts or faces opposition from the moments of modern inertia that persist in the contemporary situation. Thus, the body-laden services and rituals of Jimmy Swaggart's pentecostal tradition stand in stark contrast to the restricting, mind-oriented, body-submerging Sunday morning worship productions of mainline expressions of religion in America. The argu-ment holds across faiths, as the contrast between the body-intense services led by the Lubavitcher Rebbe of Brooklyn and the subdued "protestantized" services of Reform Judaism's "cathedral" synagogue, New York's Temple Emmanuel in Manhattan, illustrates.

Generally speaking, in fact, the conflict and tension between modern inertia and (what in modern terms are) postmodern oddities and sur-pluses define the field of contemporary action known as the "New Social Movements," a field of action that puzzles some modern folk because many New Social Movements seem unconnected to any readily visible economic or psychosocial flaws (see Hannigan 1991). They do not, in other words, fit into modern diagnostic categories. Furthermore, they seem to be both vibrant and either old (not modern)—evangelism, but on television; healing, but traditional in some respects—or unimag-inably new—gays and lesbians confessing and practicing their sexual orientation as Christians. Can one be both Christian *and avant garde*?

The modern secular mind is befuddled by the possibility that the answer might be "Yes."

One, then, can flip the television dial on Sunday morning and enjoy the excesses of Jimmy Swaggart as he strides and sweats the gospel. As with any good entertainer, his body helps his words, but the camera angles and his moves (he does not stand at a pulpit like Billy Graham or Jerry Falwell) push the message that his body moves are his words. Handsome, forceful, and thrusting as he preaches, Jimmy Swaggart's body is imminent in his words. His gospel, as viewed, is the gospel of desire transposed into a surface performance of desire for the gospel. There are few better indicators than Jimmy Swaggart that late capitalism is centered on the production of desire as the force that drives the system. That religion itself tends to be a market-driven commodity in late capitalism is well established (Bibby 1987). Jimmy Swaggart thus epitomizes the general tendency and need of religion in late capitalism to stimulate demand through the creation of desire, and in that regard he is merely the tip of the iceberg.

A number of different kinds of potential projects lie behind these observations. On the one hand, we probably need to look more carefully at how the body did in fact figure in religion even when it was formally factored out. We might look at liturgical fashion over generations. Televangelists are not the only users of media; Catholic programming, Mother Angelica's Eternal Word network for example, may be equally sensitive to these considerations, perhaps only implicitly. The shift from the style of Billy Graham to that of Swaggart may be valuably connected to other cultural shifts, for example, in popular music from the insipid tunes of the Eisenhower years to Elvis and the Beatles. And, as Danièle Hervieu-Léger has already touched upon, there is the increasingly important aspect of "touching" or "hugging" in informal religious groups.

Turning now to medicine, religion, and the body, there has been in recent years a remarkable explosion of healing practices and alternative therapies that move away from the modern notion of the body as an object that can be cured only by science. Those practices and therapies tend either to be supplements for or to stand as alternatives to allopathic (science-based) medicine, and in each case there is an association with specific forms of ideology and belief. Thus, such healing rituals as prayer, laying on of hands, and anointing of the sick—once routinely performed within the church but shunted aside by the mainstream churches with the rise of scientific medicine—have appeared again (McGuire 1982,

1988). They are particularly noticeable, by virtue of their long absence, in the middle-class mainline denominations, where they may coexist with such body-focused practices as glossolalia.

Generally speaking, prayer for the sick and other healing rituals that are performed within church contexts are interpreted as supplementing scientific medicine by adding a spiritual dimension to the healing effort. The view that healing practices supplement scientific medicine has, in fact, become a visible feature of mainline religion in America and, as such, represents an accommodation of mainstream—largely Christian —religious ideologies and scientific practices.

On the other hand, many therapies—some very old, others quite recent inventions—tend to be practiced and viewed as distinct alternatives to allopathic or scientific medicine. A glance at the Yellow Page directories for large urban centers (see "Holistic Medicine"), or various New Age publications, reveals an extensive range of alternative therapies and techniques. Thus, for example, the section "Health, Healing, and Bodywork" of *Common Ground of Puget Sound* publicizes "holistic medicine, homeopathy, oriental medicine, Native American medicine, chiropractic, holistic dentistry, massage, and bodywork" (1991-1992, 36). The same publication also advertises the services of those in the "Intuitive Arts": "Dream Exploration, Channeling, Myth & Ritual, Past Lives, Alchemy, Astrology, Dowsing, Psychic Reading, Handwriting Analysis, I Ching, Tarot, Numerology, & Palmistry." Furthermore, it makes readers aware of "Spiritual Practices" that include varieties of yoga and other meditative disciplines.

What conclusions can be drawn? First, while good estimates of the number of Americans who avail themselves of the services of those providing alternative regimens and therapies, "intuitive arts," or "spiritual practices" are not available, what evidence there is suggests that the figure is not small in absolute terms. Extrapolating from a 1976 Gallup poll, McGuire (1985) concluded that at least 10 million Americans were involved at the time in the alternatives of yoga, transcendental meditation, or some Eastern religion. The regular and continuing advertisement of alternatives clearly suggests that there are enough clients or patients to sustain the economic viability of the alternative sector.

Second, alternative "bodywork" takes place in the context of many esoteric alternative ideologies that may bear the same relationship to alternative bodywork that mainline religious doctrines and ideologies now bear to scientific medicine. That is not to say that a specific form of alternative "bodywork" is linked to or justified by a particular non-

conventional "intuitive" or "spiritual" practice, although that, too, may be the case. Rather, the point is that a field of alternative practices and ideologies now exists, a field where the common, mutually supportive element is some form of opposition, denial, or contradiction of the "normal" mutually supportive worlds of scientific medicine and conventional religion. Attending a naturopathic clinic may not necessarily mean that one believes that crystals hold the secrets of life and the self. But if one had to hazard a guess about who in the population *does believe* in crystals, one could probably do worse than pick those individuals who seek the help of naturopathic physicians.

With respect to healing, then, a variety of kinds of projects could be undertaken. On the one hand, the putative interest in Eastern healing arts might be explored vis-à-vis immigrant allopathic physicians of Hindu, Confucian, or Buddhist background. This could be one way to heighten the importance of social networks in healing decision patterns. We also could benefit from exploring "underground" ethnic patterns that persisted during the generations immediately preceding our own. The Pennsylvania Dutch "pow-wowing" (*Braucherei*) tradition is one example of what I have in mind here (see Neff and Weiser 1979). African-American religion has had a similar tradition of folk healing that stretches farther back into that culture than the arrival of recent Haitian immigrants (see, e.g., Raboteau 1978; Stuckey 1987, 3-97). In this context, too, both funeral ceremonies and the apparently increasing popularity of reincarnation beliefs deserve far greater attention as venues of both religious expression and religious formation than the North American emphasis upon religious organizations has allowed.

Finally, a third area for research is how religion is involved in deconstructing or maintaining the patric body. The patric body is a gendered sexual orientation system of heterosexual male dominance, and homosexual and female marginality and submission. Analytically, the system is based on the construction of three differences: gender (male/female), sexual orientation (heterosexual/homosexual), and power (domination/submission). Gendered, sexually oriented individual bodies in a system of male heterosexual domination are the signs or indicators of the patric body.

The patric body is strained or questioned where differences are redefined or overridden by new constructions, definitions, or apprehensions of similarity that undermine difference. An interesting case in this regard is the Universal Fellowship of Metropolitan Community Churches (UFMCC), a denomination founded in 1970 to minister to gays and

lesbians. By 1990 UFMCC had a membership of more than 30,000 in 250 congregations, with more than 300 individuals on its clergy roster (Metropolitan Community Church of Toronto 1990).

UFMCC is based on the notion that one can be both a Christian and a sexually active non-heterosexual. Given the definition in traditional Christianity of homosexual acts as sins, how is that possible? A complex of three interpretive tactics is employed to render Christian identity and homosexual practice consistent (see Thumma 1991). First, scripture is framed within a historical-critical hermeneutic that relativizes specific biblical passages that appear to condemn homosexuality if they are interpreted literally. In that regard the Bible is characterized as a document that is a product of its times and can be interpreted in light of changing realities without destroying its authority. Second, exegetical studies question the translation of various Greek words as referring explicitly to the homosexual acts of consenting adults. Finally, great stress is placed on the goodness of creation and God's inclusive universal love for all humanity. Thus, gays and lesbians have a basis for affirming a Christian identity, even an Evangelical identity (Thumma 1991), as persons whose sexual acts are not specifically condemned in scripture and who fall within the circle of God's accepting love. The claim of the UFMCC is that "we are Christians, too," and reasons are given to substantiate that claim. Those reasons constitute a direct challenge to the patric body since they destroy the distinction between the heterosexual and the homosexual based on the non-admissibility of practicing homosexuals to the category of Christian.

Where the reasons are accepted outside the gay and lesbian circle of Christians, the patric body is undermined and the stigma of homosexuality is mitigated. In that regard the UFMCC has "a vision and dream that is nothing short of the total reformation of the Christian world" (Metropolitan Community Church of Toronto 1990, 2). Needless to say, where that "vision and dream" is in effect borne in various ways into the precincts of mainline Christianity, conflicts occur. Thus, given the incessant press in late capitalism to allocate social rights without distinction, conflicts around matters such as the ordination of practicing gays and lesbians in mainline denominations are likely to persist for a long time.

Whatever their resolution in specific cases may be, such conflicts in any event provide considerable resources for questioning the patric body system (O'Toole et al. 1991). More generally, not only gay ordination but also abortion controversies, debates about the use of

reproductive technologies, the sexual politics of the world of work, and sexual abuse of various kinds underscore the patric body in late capitalism as a site of contests and struggles that define some of the more visible social dynamics and problems of the postmodern world.

Some of the relevant research topics here will be dealt with most appropriately in the context of Mary Jo Neitz's chapter. The topic of sexual relations, however, presents an extensive array of research possibilities. Both homosexual activism and antihomosexual movements are making their presences widely felt and generating extensive debate. From a sociological point of view it is important to look at the stratification and power variables that enter into these encounters. We need better data on who the homosexual activists are in terms of race, class, and ethnicity, as well as why they see churches as important venues for activism. A standard secularization scenario, for example, would not predict that acceptance by institutional religion would be an important issue for persons whose life-styles were "post-traditional." Indeed, the interest in religious acceptance by the gay and lesbian community may be one of the best evidences against the secularization thesis in its usual construction. Exploring in detail, then, why church acceptance is important to gay and lesbian persons may be a valuable resource to sociologists of religion as they seek to explain the persistence of religion as well as its changes.

References

Bell, D. 1976. *Cultural contradictions of capitalism.* London: Heinemann.

Bibby, R. 1987. *Fragmented gods.* Toronto: Irwin.

Codere, H. 1950. *Fighting with property.* Seattle: University of Washington Press.

Common Ground. 1991-1992. *Common Ground of Puget Sound* (Seattle) 6(3).

Featherstone, M. 1988. In pursuit of the postmodern. *Theory, Culture & Society* 5: 195-215.

Frank, A. W. 1991. For a sociology of the body. In *The Body,* edited by M. Featherstone, M. Hepworth, and B. Turner, 36-102. London: Sage.

Freud, S. 1962. *Civilization and its discontents.* New York: Norton.

Hannigan, J. 1991. Social movement theory and the sociology of religion. *Sociological Analysis* 52: 311-31.

Hobbes, T. 1968. *Leviathan.* New York: Penguin.

Hutcheon, L. 1989. *The politics of postmodernism.* London: Routledge.

Jameson, F. 1991. *Postmodernism.* Durham, NC: Duke University Press.

Marx, K. 1954. *Capital.* Moscow: Foreign Language Publishing House.

McGuire, M. B. 1982. *Pentecostal Catholics.* Philadelphia: Temple University Press.

————. 1985. Religion and healing. In *The sacred in a secular age,* edited by P. E. Hammond, 268-84. Berkeley: University of California Press.

————. 1988. *Ritual healing in suburban America.* New Brunswick, NJ: Rutgers University Press.

————. 1990. Religion and the body. *Journal for the Scientific Study of Religion* 29: 283-96.

Metropolitan Community Church of Toronto. 1990. *A short history of UFMCC.* Toronto: photocopied ms.

Neff, L. M., and F. S. Weiser. 1979. Manuscript "pow-wow" formulas. *Quarterly of the Pennsylvania German Society* 13: 1-7.

O'Toole, R., D. F. Campbell, J. A. Hannigan, P. Beyer, and J. H. Simpson. 1991. The United Church in crisis. *Studies in Religion* 70: 1511-63.

Raboteau, A. J. 1978. *Slave religion.* New York: Oxford University Press.

Rousseau, J. J. 1950. *The social contract and discourses.* New York: Dutton.

Simpson, J. H. forth. Fundamentalism in America revisited. In *Religion and politics in comparative perspective,* edited by B. Misztal and A. Shupe. New York: Praeger.

Stuckey, S. 1987. *Slave culture.* New York: Oxford University Press.

Thumma, S. 1991. Negotiating a religious identity. *Sociological Analysis* 52: 333-47.

Turner, B. S. 1982. The government of the body. *British Journal of Sociology* 33: 254-69.

————. 1984. *The body and society.* Oxford: Blackwell.

————. 1991. Recent developments in the theory of the body. In *The body,* edited by M. Featherstone, M. Hepworth, and B. S. Turner, 1-35. London: Sage.

Weber, M. 1958. *The Protestant ethic and the spirit of capitalism.* New York: Scribner.

Zeitlin, I. 1990. *Ideology and the development of sociological theory,* 4th ed. Englewood Cliffs, NJ: Prentice-Hall.

10

Inequality and Difference

Feminist Research in the Sociology of Religion

MARY JO NEITZ

Religion has been a major institution for the social control of women. It has been the focus of feminist attacks in both first wave and second wave feminism. Elizabeth Cady Stanton's last work, *The Woman's Bible* in 1895 (1972), and Mary Daly's first work, *The Church and the Second Sex* in 1975 (1985), were attacks on institutionalized religion and its treatment of women. Yet women have also found ways of using religious ideologies to argue for egalitarian treatment or demand that men change their behavior. Women have sometimes found space in religious institutions to organize in their own behalf; other times they created female-based religious groups. At the Woman-Church convention in Cincinnati, Ohio, in 1987, a reporter asked Gloria Steinem what had happened to the women's movement. Her reply—"This is the women's movement"—would have drawn a chuckle from Anna Howard Shaw, the first woman ordained in the Methodist church (in 1880) and later president (1914-1915) of the National American Women's Suffrage Association. Feminism has thus had a long and ambivalent relationship to religion in America.

Women, Ministry, and Oppression

A number of sociologists have designed research projects that attempted to identify the extent to which organized religion and religious

165

ideologies fostered sexism (e.g., Barrish and Welch 1980; Berc 1978; Himmelstein 1986). Some of this research was tied to resistance to the ordination of women in particular. Other research looked at the role of religious groups in opposing certain aspects of the feminist political agenda, such as abortion (e.g., Ginsburg 1989; Luker 1984; Neitz 1981). A few pieces looked at possibilities for coalitions between feminists and religious activists for particular political purposes, such as ordinances banning pornography (e.g., Jelen 1986).

Changes in society regarding women in the professions, as well as the pressures inside the denominations from women in the seminaries, spurred research on the topic of women in the ministry. Second wave feminism was accompanied by a renewed surge of women into the professions. The portion of clergy that was female doubled from 2.1% in the 1950s to 4.2% by 1980. Additionally, by 1980 half the Master of Divinity students at mainline seminaries were female (Nason-Clark 1987b). Jackson Carroll, Barbara Hargrove, and Adair Lummis's *Women of the Cloth* (1983) offered the first broad look at the impact of growing numbers of women in the ministry. Their work was, however, preceded by (and continues to be augmented by) the voices of women clergy, seminarians, and seminary professors (Charlton 1987, gives references to this literature). Additional work looked at the actual placement of women in positions in the ministry (Lehman 1980b; Royle 1982; Schreckengost 1987). Others examined the experience of women in the seminaries (Charlton 1987; Kleinman 1984). Another major direction was the examination of resistance to women in ministry, both in denominations where ordination occurred and in denominations where it has not been sanctioned (Lehman 1980a, 1981, 1985, 1986, 1990; Nason-Clark 1987a, 1987b; Royle 1987).

While most of this research examines mainstream Protestant denominations, there is some material on the rather different situations of women leaders within pentecostal churches and Roman Catholicism. Ruth Wallace has observed that women in the churches are marginal in the sense of Simmel's strangers "who came today and stayed tomorrow" (1975, 297). She argues that it is these "marginal women" who will effect change in the churches, yet she acknowledges a continuum of marginality with different women within various denominations in different places. Wallace includes as marginal the women who are blocked from being ordained, the women who have been ordained but who are "not permitted full entry," as well as the women who have full entry but seek to change the nature of the ministry.

Pentecostal Women in the Ministry

Most of the research on women clergy has been conducted within mainline Protestant denominations. These denominations have been most affected by second wave feminism. It is here that we have seen a burgeoning of female seminary students and the demand for the full incorporation of women into the churches. The pentecostal, holiness, and independent fundamentalist churches offer a different context for looking at the issues surrounding women in the ministry. In the early part of the twentieth century a high proportion of all women ministers were in these churches. Women as well as men got the call to preach or evangelize, and the call was what mattered.

As the churches became more bureaucratized, ministerial credentials changed. Building on Max Weber, Barfoot and Sheppard (1980) distinguish between the early days of the "prophetic ministry," where women were instrumental in the founding of pentecostal churches, and the "priestly" era that followed.

For Poloma, the controversy over the status of women within the denomination is one aspect of the continuing tensions between the attractions of charisma and bureaucracy. Poloma points out that "priestly pentecostalism," including a graduated clergy, developed very early— within the first three years of the founding. Women were increasingly denied access to the higher levels and were more likely to be evangelists than pastors, except in the poorest churches. The proportion of women ministers of all types reached a high of 18.9% in 1941, declining to 14% in 1983. For pastors, the high was in 1915 with 13.5%, down to 6% in 1918, and 1.3% in 1983. Even these figures overestimate the current inclusion of women, since more than one-third of the ordained women are retired (Poloma 1989, 103-09).

Poloma suggests that in recent years, as the Assemblies of God gained acceptance by other conservative religious groups, "it has come under the influence of a Biblical literalism that serves to restrict women's ministry." Today, according to one of Poloma's informants, young women who feel that they have a call to the ministry are encouraged to "head down to Central Bridal College [a play on the denomination's Central Bible College] in search of a husband who is called to the ministry" (1989, 108-10). In addition, there is a lack of support for women to serve on church boards or as elders in the churches, with younger pastors more negative than older ones (1989, 120-21).

Women who are serving as pastors in this context face a conflictive role. Their (desires for) leadership positions must be legitimated with rhetoric that emphasizes their subordination —to God, if not to man. Elaine Lawless's case studies of four white pentecostal women preachers in small Missouri towns offer portraits of women preachers who are part of an oral pentecostal tradition that is probably declining, as are the small towns in which the women can still be found. Both in life stories and in sermons, the women—two pastors of their own churches, one itinerant evangelist, and one who sometimes preached in the church that her husband pastored—portray themselves as submissive: God wills them to preach, and they only reluctantly take up the call. Lawless argues that women's sermons are different from those of both black and white male pentecostal preachers, and women pastors preach differently from women itinerants. While women pastors ostensibly have the most power, they also face the most constraint, as their daily lives, their fulfillment of traditional women's roles, are continually evaluated. Lawless argues that sermons of women pastors show that they fear they will be found wanting (1988, 137-43).

In a study of 27 black and 26 white pentecostal clergywomen, mostly from Georgia and Florida, Susan Kwilecki supports the findings from the studies by Lawless and Poloma. All of the clergywomen voice "principled passiveness," speaking about their reliance on the will of God (1987, 62), but not without differences by age and race. Although most of the clergywomen were in established pentecostal denominations, 20 were in newer, small pentecostal bodies, including nine who had chartered organizations by themselves with one or two congregations. Most of the clergywomen lacked formal education and did not support themselves solely from their churches. In response to questions asking for their opinions on gender issues, 13 women consistently answered in terms of a kind of egalitarianism where both men and women are subject to God's plan, divinely revealed. Twenty-five of the women evinced a patriarchalism based on a fundamentalist interpretation of scriptures. A few of these women even felt that women should not be allowed to pastor alone. Eleven of the egalitarians were black; 21 of the patriarchal respondents were white. Kwilecki notes that "the fact that 71% of the clergywomen who had founded or pastored churches singlehandedly were black, while 85% of those who pastored with their husbands were white suggests greater self-reliance among black subjects." However, she goes on to note that "[s]till black pentecostal churches like white ones teach biblical patriarchalism. And, in varying degrees, despite

their relative egalitarianism and self-reliance, so did the twenty-seven black clergywomen" (1987, 65-68). Kwilecki did find that younger women, with greater exposure to mainstream culture, express more am-bivalence about the required submissiveness (1987, 74).

While women in the ministry in mainstream Protestant churches have liberal views on gender issues, that is not the case for the women in any of these studies. None of the women in Kwilecki's study, for example, favored inclusive language (1987, 59). All of these works show tension between pentecostal understandings of charismatic leadership and more fundamentalist readings of biblical texts. Feminist researchers writing about these clergywomen do not see them as a force for change. Rather they see them as caught in the contradictions between the pentecostal definitions of femininity and pastoral roles. The opening that is created by the belief in charismatic leadership is countered by the increasing tendency to ally with biblically based fundamentalism. Even if they wanted to, women who take on ministerial positions have very little room to use such a position to work for gender equality.

Catholic Feminists

The Roman Catholic Church presents a different picture: Unlike most of the Protestant churches discussed so far, Roman Catholic women are not ordained. Yet several feminist sociologists have argued that a number of Catholic women have used their marginality to advocate changes in the Catholic Church.

Ruth Wallace suggests that women as well as men benefited from the increased official enthusiasm for lay participation in governance of the Catholic Church following the Second Vatican Council. The documents of the Council used the metaphor of the "People of God" to define the Church, a departure from the hierarchical images of the past. Although, as Wallace points out, power remained in the hands of the male clergy, changes in canon law allowed women to participate in the public ministry in many ways, including acting as eucharistic ministers (dis-tributing communion wafers blessed by the priest), lectors, and even chancellors of dioceses (1988, 25-27).

Involvement in the women's movement mobilized Catholic women to seek changes in their church, including ordination (Trebbi 1990; Wallace 1988, 29-30). Groups of lay women, including prominent theolo-gians, and women religious began to organize in the mid-1970s, as women began to graduate from seminaries with degrees in ministry. In

1977 the Vatican issued a declaration reaffirming its position that the ordination of women was impossible. In the early 1980s the Woman-Church movement emerged from a coalition of Catholic feminist organizations hoping to keep the issue of ordination under discussion within the Catholic Church. As the critique of the church hierarchy broadened to emphasize changing the structures, instead of merely allowing women to participate in the established structure, Woman-Church has sought allies among women of other religious traditions as well as secular feminists. Yet broadening the focus carries risks: The issues of major concern for women religious differ from the ones that matter most to married Catholic women. For both, however, Women-Church represents the creation of "a special place for women to reconstruct a religious culture around feminine experience and to theorize on that experience" (Trebbi 1990, 351).

Although the Vatican has continued to refuse to ordain women, demographic and social changes resulting in a severe shortage of priests have forced a redefinition of role of parish administrator in the Roman Catholic Church. Female and male members of religious orders, deacons, and lay men and women are now administering "priestless parishes." Wallace (1991, 1992, 1993) has examined the constraints and opportunities, both institutional and interpersonal, that this new role presents to women pastors in the Catholic Church. A key institutional constraint is that only priests are allowed to celebrate the Mass or preside at other sacraments. Wallace finds that the women pastors behave in ways that are systematically different from most priests: The women identify with their parishioners rather than seeing themselves as an elite set apart, and they systematically set about reducing the distance between themselves and other lay members of the parish. Wallace argues that these lay pastors represent the initial phase of transformation of the hierarchical structure of the Catholic Church.

Gendered Experience Within
Abrahamic Religious Traditions

Fundamentalist, Evangelical, and Pentecostal Women

When fundamentalism began to attract scholarly attention in the 1970s, that attention focused on the male leadership, the impact of the movement on the American political process, and impact of the growth of

"conservative churches" on liberal Protestantism. Feminist writers became interested as participants in the new Christian right mobilized against the ERA and abortion rights. Analysis of the public writings, especially the writings of male conservatives, stressed official positions on traditional family values, "male headship," antifeminist positions on abortion and the ERA, as well as opposition to the welfare state (e.g., Eisenstein 1982). Yet this work left unanswered questions about why women would be attracted to fundamentalist religion, and the extent to which evangelical women endorsed the official views. Answers to these questions can be found in research that examines the life experiences of women who have come to participate in these religious groups.

In a study based on a poll of 123 evangelical church women conducted in 1982, Carol Pohli emphasizes the insularity of evangelical culture in the twentieth century. She claims that evangelical women live lives separated from the mainstream and are "uninformed and uninterested about what the secular world calls significant issues" (1983, 540). She describes these women as "emotionally and psychologically confined" (1983, 543); yet she also finds that the Moral Majority includes women whose opinions diverge from those of their pastors and other public spokesmen. Pohli is conscious of the various strands in evangelical thought and action in the public sphere and refers to the nineteenth-century reformers. As one who has herself "escaped," Pohli celebrates the voices of the "small but significant percentage of Evangelical women who are thinking for themselves about personal and political issues" (1983, 529), but her condescension toward those she sees as still hidden in their closets fails to foster an understanding of their worldviews.

Early research on fundamentalist women, based on women who had joined religious communal groups, argued that in a period of time when cultural values seemed to be in flux, part of the appeal for women was the certainty of traditional roles (Aidala 1985; Harder, Richardson, and Simmons 1976). Some young women, with experience in the counter-culture, chose to join religiously based groups because such groups had clearly defined gender roles and norms governing sexual behavior. In her study comparing those who joined religious communes with those who joined communes of other types, Angela Aidala found that those who joined the religious communes were less tolerant of ambiguity about gender roles.

Other studies of charismatics, evangelicals, and the new Christian right have suggested that women as well as men see themselves as

having something to gain from the pro-family stance articulated by these groups (Ammerman 1987; Ginsburg 1989; Luker 1984; McNamara 1985; Neitz 1981, 1987; Rose 1987; Stacey 1990). These religious groups sanction hierarchical familial relationships based on age and sex. Wives are to be submissive to their husbands; yet the model for families is more neotraditional than traditional. The pro-family ideology dictates that both males and females make family life top priority. In my analysis of family symbolism in the Catholic charismatic renewal, I described the transformation of the figure of God-the-Father from an authoritarian patriarch to the "Daddy-God" of the charismatics. He is still the Father, but what he offers is unconditional love to his children (1987, 128-33, also chap. 5).

Among Catholic charismatics this translates into a considerable revision of traditional male roles, and some observers have argued that women agree to the doctrine of submission in return for support for male roles defined in terms of emotionally caring commitments in family relationships. In Rose's study of an independent charismatic fellowship with a high proportion of members having experience in the counterculture, the women spoke explicitly about themselves stepping back in order to build strong men. Rose claims that in order to attract men into the fellowship, the women accepted the notion that males were the "right and natural (that is, God-willed) leaders of the church government and family." While "in the process, the men did come to feel more competent, capable and responsible," it was "at the expense of the women" (Rose 1987, 255).

In the Catholic charismatic prayer group that I studied, the older married women, who had been socialized in the pre-Vatican II Catholic Church, tended to take the rules about submission for granted—it was not different in principle from what they had grown up with. They also clearly found the notion of an unmediated relationship to God very freeing. Younger married women, some of whom had seen themselves as feminists prior to joining the movement, were more ambivalent about the idea of submission. They saw it as a way to solve problems in their marriages; they traded formal authority for their husbands' emotional expressiveness and involvement in family life. Furthermore, there appears often to be considerable discussion between husband and wife before he renders "his" decision. Yet, some women and men express considerable ambivalence about the divisions of responsibility (Neitz 1987, 144; see Rose 1987, 253).

Newly Orthodox Jewish Women

Feminist scholars studying women newly converted to Orthodox Judaism face a similar puzzle: Why would modern women embrace such an apparently restrictive religiosity? Recent research suggests that the answer to the question depends in part on the population one is studying (Davidman 1990a, 1990b, 1991; Kaufman 1985, 1989, 1991; see Davidman and Greil 1993). Lynn Davidman has looked largely at unmarried women in the process of turning to Orthodoxy. She studied women in two very different contexts: the first, a highly encapsulating residential Lubavitch training center where young women (mostly between 16 and 25) learned about strict Orthodox practice; the second, a Manhattan synagogue with a reputation for reaching out to assimilated Jews. There Davidman started with the beginner's class, dominated by single women between the ages of 25 and 40. These older women, established in their careers, rejected the encapsulation of the Lubavitch sect as too constraining. Yet both groups of women were similar in wanting to find validation for their desires to marry and have children. Both hoped to find appropriate partners through the process of returning to Orthodoxy. While Davidman describes the women entering the Lubavitch community as "religious seekers," the women at Lincoln Center sought community and meaning, but did not express these concerns in religious or spiritual terms (1991, 102-7).

The returning women Debra Kaufman studied were at a different point in their lives; they had been Orthodox longer and were all married (most to men who were also newly Orthodox Jews). Kaufman argues that these women believe that the differences between men and women are real and important. They have discovered in Orthodoxy an alternative to "western values" of materialism and a chance to celebrate female "spiritual" qualities. Not only does Orthodoxy give dignity to the roles of mothers and wives, but Kaufman claims that for some of the women she studied, "the highest levels of spirituality are reached, if not recognized, through the female body and its experience" (1985, 549). Kaufman suggests that this particularly female spirituality is similar to the separatist women's spirituality advocated by radical feminist writers, such as Mary Daly.

Kaufman found a spirituality at the core of the women's turn to Orthodoxy that Davidman did not find. The difference in their findings may be due to differences in marital status and the stage of their return.

However, it is also the case that Kaufman's study is dominated by women in the Hasidic tradition (similar to Davidman's Lubavitch sample). It is not clear that the less encapsulated women of the Lincoln Center Synagogue would ever embrace the radically separatist spirituality that Kaufman describes. Encapsulation may be useful to explore in other contexts.

Women in the Historically Black Churches

As is the case for most Christian churches, women in the black churches outnumber men (Taylor 1988, 124). Churches have historically provided a significant platform for African-American women organizing in both their local communities and the churches themselves. Given the fact that the official position of pastor was often denied to them, women worked through other positions in the churches (Dodson and Gilkes 1986).

Cheryl Gilkes's work documents the avenues of oppression and agency experienced by black church women. She emphasizes the links between church activities and church organizations, and women's contributions and leadership in their communities. In the context of a racist society, women often worked to meet community needs and to seek justice for their people. Yet the activities were organized in such a way as to encourage and demonstrate women's leadership in both relatively autonomous women's organizations and the black community. Gilkes argues that "Black women's church and community work represents more than mere support for male organizations aimed at social change." She suggests that the tradition of independent organizations has its source in the structures of authority in the dual-sex political systems of West African societies (1986, 43-48). Even in churches where only males can pastor (including the sanctified Church of God in Christ, which Gilkes has studied in depth), women demonstrate their leadership ability in fund-raising and organizing. Also, like white Protestant women, they are likely to be involved in educational and musical activities within the congregations. Gilkes's careful analysis acknowledges differences between the more European-influenced churches (such as the black Baptists and Methodists) and the sanctified churches, which are closer to the African heritage. She also discusses the ambivalence that some black men feel toward the power these female "elders" hold. She cautions that "[s]ince the legacy of militant black female leadership is not always visible to white society, or is *not perceived as important by*

white society, progressive 'race relations' may mean regression in the relative position of black women" (1985, 57-58).

The African influence is even more pronounced in Karen Brown's study of Moma Lola, a Haitian immigrant and voodoo priestess living in Brooklyn (1991). Brown presents the veneer of Catholicism as a part of voodoo's public face and traces roots of voodoo in Dahomean religion. She suggests that under slavery voodoo lost its institutional base; with the body as its main ritual tool, possession performances became more extemporaneous and expressive. Today in Haiti voodoo continues to reflect the agricultural, patriarchal past, commemorating and renewing the connections between land and family. In New York, however, Haitians practice voodoo adapted to an urban locale, removed from land and often from family. Voodoo symbolism reflects inequalities of class and color. Brown shows how these have appeared historically, as well as the ramifications of Haiti's repressive political system for voodoo practice. Gender differences are also reflected in the symbols. Brown argues that while voodoo is misogynous, it is also extremely flexible. With movement from rural to urban residence in Haiti and the migration to the United States, roles of men and women have changed. Women engage in market activities and piece together the means of survival for themselves and their children. The men in this study are loved but not depended upon. Brown sees voodoo reflecting these changes: In practice, priestesses are increasingly important, and the women of the spirit world are becoming stronger as well.

Experiences of Women in the New Religious Movements

Although there is an extensive literature on the New Religious Movements, little of it has been concerned with gendered relations within those movements. (For an excellent review and critique of the literature, see Davidman and Jacobs 1992.) Aidala's study (1985) of religiously and nonreligiously based communal groups is an exception in that she insists that life-stage and gender are essential to the understanding of the relationship between structural change, cultural fragmentation, and social movement participation.

Women-Centered Religious Groups and Practices

In addition to various sorts of accommodations and resistances by women within Abrahamic religions, women have also created

women-centered religions outside of the dominant cultural traditions. These are often relatively small and relatively unorganized—by their very nature hard to research. Yet they are important sites for investigating theories about gender and alternative structures of authority. Carol Haywood studied four spiritualist groups, finding that while these groups are not radical in themselves, they offer resources for a "feminine style of religious authority." Leaders see themselves as "mediums" who function as "catalysts in other's transformations . . . associated with the direct experience of the sacred" (Haywood 1983, 160; cf. Baer 1993). The leader is a guide, and authority is diffuse; the belief system suggests that anyone could have access to spiritual powers. Although the groups have no explicit ideology granting women authority, in fact their beliefs about the nature of authority support women taking positions of authority.

The women's spirituality movement embraces a number of women-centered ritual groups that do offer ideologies explicitly supportive of women's authority. Coming out of both the neopaganism of the counterculture and the feminist movement, these groups are oriented primarily to immanent female deities and the celebration of seasonal rituals (Neitz 1990). Several authors are exploring how these woman-affirming beliefs, symbols, and rituals may be empowering to women.

Claiming the identity of witch can itself be empowering for women. Participation in inverting a cultural stereotype and identifying with those midwives and healers of another time, who were persecuted by male authorities, is seen as affirming an alternative construction of gender, religion, and self (Neitz 1990, 358-59). Rituals offer settings in which women who have been marginalized and alienated can be healed. Jacobs (1989a, 1990) studied short-term healing circles established for "healing rituals," where women who had been sexually abused named the sources of their suffering and established communal bonds. The processes of healing and bonding are not limited to such physical attack. Lozano and Foltz (1990) studied an established group and provide an example of a life-cycle ritual, a service for a member who had died, where we see the assertion of an alternative world.

Both feminists and nonfeminists have questioned what such empowerment means. Finley (1991) asks whether it promotes or inhibits political activity. In her study of leaders of explicitly feminist, dianic wiccans, she found high rates of political activism, although she admits that it is possible that these women were politically active before they became witches. It may be, however, that our conceptualizations of both

power and political activity need to be reconfigured in order to under-
stand these groups. Rather than power being seen primarily in terms of
the ability to get someone else to do as one wants, empowerment for
these women may be an attempt to gain legitimacy for their desires to
act on their own behalf. For women who are brought up to be responsive
to others' needs, the ability to verbalize one's own needs and act in one's
own behalf can be liberating.

New Directions for Research

While the question of "Where are the women?" has been attributed
to the first stage of feminist research, it remains a necessary question
for sociologists who study religion. In part, this is because some reli-
gious organizations are making a transition between being male-domi-
nated and letting women in, and that change must be assessed (see
Hargrove 1987; Hiatt 1987; Shriver 1987). It is also because other re-
ligious organizations continue as highly sex-segregated institutions.

The feminist project of asking how any given experience is gendered
also continues to be important. Individuals participate in religious
organizations and movements as males and females. Organizations and
movements create and maintain structures that continue to reproduce
gendered relations. Asking what these are and how they work, and how
they intersect with race and class, is basic to feminist research. The
analysis of how religious experiences and structures are gendered offers
an opportunity to bring into the sociology of religion emerging theoret-
ical perspectives that are developing elsewhere in sociology. It also
prods us to ask new questions regarding the assumptions about gender
and power built into classical theoretical perspectives in the sociology
of religion. Feminist theories on relationality, as well as recent work on
the body, emotion, and culture, have many applications to be explored
in the sociology of religion.

The strand of contemporary feminist theory coming out of the work
of Nancy Chodorow (1978) and Carol Gilligan (1982) posits a model
of the self that is connected to others (as opposed to the model, coming
out of liberal thought, of a separate autonomous self). Chodorow argues
that this connected or relational self develops out of the early childhood
experiences. Males develop gender identity in households where women
"mother" and fathers are largely absent. Boys therefore establish their
gender identity by becoming "not female." Girls identify with their

mothers, who are present and with whom they remain in relation. They never separate in the extreme ways that boys must. Gilligan's work on moral development showed girls with "connected selves" working through moral choices in ways that are markedly different from the prevailing models developed with male subjects. Subsequent work (e.g., Tronto 1987) has emphasized that the observed differences in behavior are not due to some essential characteristic of women (even one that is based in nearly universal early childhood experiences) but rather come out of a particular context. This model of the self in relation to others has many ramifications for the sociology of religion.

Applications in work on conversion, although still few, suggest how fruitful this model could be. In his study of the Hare Krishna, Burke Rochford (1985) found that women were more likely to be recruited through social networks, whereas the highly publicized technique of recruiting in public places worked primarily for men. In her study of deconversion from New Religious Movements, Jacobs found that personal relationships with the male gurus and religious leaders were critical for the female converts. She found that "female religious commitment involves a love-centered economy in which conversion is experienced as an emotional exchange" (1984, 170). Lynn Davidman's work on newly Orthodox Jewish women (1990a, 1990b, 1991) showed how the desire for relationships (rather than a spiritual quest) spurred the women's conversions. These studies help map ways in which religious commitments are gendered.

Religious groups are also good places to examine more fully Gilligan's contention that whereas the separative self employs an "ethic of rights" in making moral judgments, the relational self employs an "ethic of care." In her examination of a Catholic social justice organization, Yeaman (1987) found she could explain some of the observed differences between the men and the women by Gilligan's theory, yet both men and women employed an ethic of care rather than an ethic of rights in some contexts. Churches and religious organizations offer an excellent place to investigate further the concept of an ethic of care.

Another area to be explored concerns sociological treatments of the body. Meredith McGuire (1990) has recently challenged the social sciences of religion to "rematerialize the human body"; yet her work has paid little attention either to how religious interpretations of the body and the experience of the body are gendered or to the particular life-cycle experiences of women. In Brown's study of Mama Lola, however, healing is frequently as much a matter of healing relationships as

it is a matter of healing the body. Male culture often defined women's bodies as profane, but menstruation, pregnancy, childbirth, and lactation have frequently been understood by women through religious interpretations. They have been the subject of women's religious rituals. Sered (1986) examines "women's religion" existing within the traditional cultures of Judaism and Roman Catholicism. The practices associated with two shrines visited by women seeking help with infertility and inadequate lactation demonstrate the continuing importance of these matters of the body to modern women, even within traditional religions contexts. Research I have done on menstruation rituals within the women's spirituality movement shows that one of the attractions of such alternative practices is the opportunity to reinterpret the female body as sacred. Pregnancy can also be interpreted by women as a profoundly spiritual event. We need to know about how women inside patric religions and alternative religions view this (see Sered 1993). Midwives often feel that midwifery is a "calling" from God or Goddess (Logan and Clark 1989). How does this inform their spirituality and their midwifery? This topic can help us understand how religious cultures constrain women and how women make opportunities for resistance within them.

A related topic is that of sexuality. In Judeo-Christian cultures sexual norms have often denied women their sexuality while permitting male sexual abuse of women. Also, to the extent that church communities are, like families, primary groups, sexual abuse is probably more likely to happen and less likely to be detected than in other social organizations. The continuing dynamics of this process are an appropriate topic for feminist analysis in the sociology of religion. Kathleen Young's study (1989) of the use of the symbolism of Maria Goretti in the Roman Catholic Church to socialize girls to believe that (in the eyes of the Church) virginity is more important than life is a beginning here. Janet Jacobs's work on victims of sexual abuse suggests the importance of religious interpretations. Children reared in religious environments may interpret experiences of sexual abuse in religious terms, including using religious language to justify somehow what has happened to them. Alternative religious movements also create norms of sexual conduct.

Perspectives in the sociology of emotion also suggest a number of as yet unexplored avenues for feminist analysis in the sociology of religion. Perhaps because religious behaviors were dismissed as being "merely emotional," sociologists favored organizational analysis, and even social psychological issues such as conversion have been explored

mostly in terms of a cognitive framework. Yet Hochschild's (1983) concept of "emotion work" suggests a new, sociological way to think about emotion. For the sociology of religion it raises many interesting questions: How are emotions managed in religious contexts? For example, one of the things that happens in conversion is learning the appropriate gloss for speaking about one's experiences. (Among Catholic charismatics or AA members one learns how to testify.) While this has been described, it tends to be presented as a cognitive process. In what ways is it also emotion work? Also, how is the division of labor in emotion work gendered? How often are religious contexts places where men do the emotion work (preaching, pastoring, praying), while women provide the refreshments and clean the altar linens? What kinds of emotion work do male leaders do with men, as opposed to women? How do class and race structure emotion work being done in churches? While some of these questions are not new, this new perspective provides new ways of thinking about gender and emotion in religious contexts.

It is also important that we look critically at our own tradition. Relatively little has been done to examine carefully the sexist assumptions of the seminal works of social science. In her work Victoria Erickson (1992) begins this process. Erickson gives a critical reading of the work of Durkheim and Weber on religion. A central aspect of her work is an investigation of the sacred-profane dualism, in which the sacred is gendered masculine and the profane is gendered feminine. Erickson argues that this dualism is at the heart of the sexist bias in the sociology of religion and its implicit support of male dominance. Erickson's work is rich and provocative; it raises many questions about the work of the founding fathers and contemporary use of the concepts we inherited from them. More exegesis of the basic theories and concepts will help us better understand what we are taking for granted about gender and male power.

Two other topics explore the relations between gender and cultural transformation in religious traditions: The first suggests a feminist analysis of women's religious orders in the Roman Catholic Church. Because women religious were in a marginal position—not clergy, yet close enough to it to see its privilege; not benefiting from it, therefore less invested in the hierarchy—they could be important catalysts in the changes that occurred after Vatican II (Wallace 1989). Their story is yet to be told. What is the difference between orders that produced activists and those that did not? To what extent did the women religious see themselves as constrained, and to what extent did they frame conflicts

with the institutional church in terms of sexism? For women who left and communities that disbanded, how do gender issues figure in the particular affiliation with the church that no longer seems worth maintaining? These women's communities could provide an interesting context for looking at many questions about gender and social and cultural change. One might want to see how the ordination of women in the Episcopal Church has affected its female religious communities, where some members have been ordained.

A second topic concerns immigrants in the United States and the changes in their traditions that come from their experiences here. In her survey of women leaders in American Buddhist communities, Sandy Boucher (1988) has suggested that many of the changes appearing in American Buddhist groups come out of the encounter with gender practices in the dominant culture. Many of the new immigrants from Asia, Latin America, and the Middle East bring with them their own religious traditions, with gender norms that are different from those found in the dominant American culture. Some respond by trying to enforce the norms they brought with them. But in other cases interesting transformations occur that bring to the fore themes available in the immigrant tradition but not the dominant. For example, Sufism, a form of Islam less restrictive for women, may be more adaptable to American culture than other forms. It is possible that Sufism will grow in the United States, fueled by women who see themselves as Muslim but who find other forms too constraining (El-Sayed 1988). In thinking about these immigrants we need to ask what Americanization means for the traditions, and for the individual women and men who carry them.

References

Aidala, A. 1985. Social change, gender roles, and new religious movements. *Sociological Analysis* 46: 287-14.

Ammerman, N. 1987. *Bible believers*. New Brunswick, NJ: Rutgers University Press.

Baer, H. A. 1993. The limited empowerment of women in black spiritual churches. *Sociology of Religion* 54.

Barfoot, C., and G. T. Sheppard. 1980. Prophetic vs. priestly religion. *Review of Religious Research* 22: 2-17.

Barrish, G., and M. Welch. 1980. Student religiosity and discriminatory attitudes towards women. *Sociological Analysis* 41: 66-73.

Berc, M. 1978. Pluralist theory and church policies on racial and sexual equality. *Sociological Analysis* 39: 338-50.

Boucher, S. 1988. *Turning the wheel*. San Francisco: Harper & Row.

Brown, K. M. 1991. *Mama Lola*. Berkeley: University of California Press.

Carroll, J., B. Hargrove, and A. Lummis. 1983. *Women of the cloth*. San Francisco: Harper & Row.

Charlton, J. 1987. Women in seminary. *Review of Religious Research* 28: 305-18.

Chodorow, N. 1978. *The reproduction of mothering*. Berkeley: University of California Press.

Daly, M. 1985. *The church and the second sex*. Boston: Beacon.

Davidman, L. 1990a. Accommodation and resistance. *Sociological Analysis* 51: 35-51.

————. 1990b. Women's search for family and roots. In *In gods we trust*, 2nd ed., edited by T. Robbins and D. Anthony, 385-407. New Brunswick, NJ: Transaction.

————. 1991. *Tradition in a rootless world*. Berkeley: University of California Press.

Davidman, L., and L. Greil. 1993. Gender and the experience of conversion. *Sociology of Religion* 54.

Davidman, L., and J. Jacobs. 1992. Feminist perspectives on new religious movements. In *A handbook of sects and cults in America*, edited by D. G. Bromley and J. K. Hadden. Greenwich, CT: JAI Press.

Dodson, J., and C. T. Gilkes. 1986. Something within. In *Women and religion in America*, vol. 3, edited by R. Reuther and R. Keller, 80-130. San Francisco: Harper & Row.

Eisenstein, Z. 1982. The sexual politics of the new right. *Signs* 7: 567-88.

El-Sayed, M. 1988. *Muslim women and conversion*. Unpublished paper.

Erickson, V. 1992. *Speaking in the dark and hearing the voices*. Philadelphia: Fortress Press.

Finley, N. 1991. Political activism and feminist spirituality. *Sociological Analysis* 52: 349-62.

Gilkes, C. 1985. Together and in harness. *Signs* 10:678-99.

————. 1986. The roles of church and community mothers. *Journal of Feminist Studies in Religion* 2: 41-60.

Gilligan, C. 1982. *In a different voice*. Cambridge, MA: Harvard University Press.

Ginsburg, F. 1989. *Contested lives*. Berkeley: University of California Press.

Harder, M. W., J. T. Richardson, and R. Simmons. 1976. Life style, courtship, marriage and family in a changing Jesus movement organization. *International Review of Modern Sociology* 6: 155-77.

Hargrove, B. 1987. On digging, dialogue, and decision-making. *Review of Religious Research* 28: 395-401.

Haywood, C. 1983. The authority and empowerment of women among spiritualist groups. *Journal for the Scientific Study of Religion* 22: 157-66.

Hiatt, S. 1987. Women in research. *Review of Religious Research* 28: 386-89.

Himmelstein, J. 1986. The social basis of antifeminism. *Journal for the Scientific Study of Religion* 25: 1-15.

Hochschild, A. 1983. *The managed heart*. Berkeley: University of California Press.

Jacobs, J. 1984. The economy of love in religious commitment. *Journal for the Scientific Study of Religion* 23: 155-71.

————. 1989a. The effects of ritual healing on female victims of abuse. *Sociological Analysis* 50: 265-79.

————. 1989b. *Divine disenchantment*. Bloomington: Indiana University Press.

————. 1990. Women-centered healing rites. In *In gods we trust*, 2nd ed., edited by T. Robbins and D. Anthony, 373-84. New Brunswick, NJ: Transaction.

Jelen, T. G. 1986. Fundamentalism, feminism, and attitudes toward pornography. *Review of Religious Research* 28: 97-103, 297.

Kaufman, D. 1985. Women who return to Orthodox Judaism. *Journal of Marriage and the Family* 47: 543-55.

————. 1989. Patriarchal women. *Symbolic Interaction* 12: 299-314.

————. 1991. *Rachel's daughters*. New Brunswick, NJ: Rutgers University Press.

Kleinman, S. 1984. Women in seminary. *Sociology of Education* 57: 210-19.

Kwilecki, S. 1987. Contemporary pentecostal clergywomen. *Journal of Feminist Studies in Religion* 3: 57-75.

Lawless, E. 1988. *Handmaidens of the Lord*. Philadelphia: University of Pennsylvania Press.

Lehman, E. 1980a. Patterns of lay resistance to women in the ministry. *Sociological Analysis* 41: 317-38.

————. 1980b. Placement of men and women in the ministry. *Review of Religious Research* 22: 18-40.

————. 1981. Organizational resistance to women in the ministry. *Sociological Analysis* 42: 101-18.

————. 1985. *Women clergy*. New Brunswick, NJ: Transaction.

————. 1986. The local/cosmopolitan dichotomy and acceptance of women clergy. *Journal for the Scientific Study of Religion* 25: 461-82.

————. 1990. Localism and sexism. *Social Science Quarterly* 71: 184-95.

Logan, O. L., and K. Clark. 1989. *Motherwit*. New York: Dutton.

Lozano, W. G., and T. Foltz. 1990. Into the darkness. *Qualitative Sociology* 13: 211-34.

Luker, K. 1984. *Abortion and the politics of motherhood*. Berkeley: University of California Press.

McGuire, M. 1990. Religion and the body. *Journal for the Scientific Study of Religion* 29: 283-96.

McNamara, P. 1985. The new Christian right's view of the family and its social science critics. *Journal of Marriage and the Family* 47: 449-58.

Nason-Clark, N. 1987a. Ordaining women as priests. *Sociological Analysis* 48: 259-73.

————. 1987b. Are women changing the image of the ministry? *Review of Religious Research* 28: 330-40.

Neal, M. A. 1979. Women in religious symbolism and organization. *Sociological Inquiry* 45: 33-39.

Neitz, M. J. 1981. Family, state and god. *Sociological Analysis* 42: 265-76.

————. 1987. *Charisma and community*. New Brunswick, NJ: Transaction.

————. 1990. In goddess we trust. In *In gods we trust*, 2nd ed., edited by T. Robbins and D. Anthony, 353-71. New Brunswick, NJ: Transaction.

Pohli, C. V. 1983. Church closets and back doors. *Feminist Studies* 9: 529-58.

Poloma, M. 1989. *Assemblies of God at the crossroads*. Knoxville: University of Tennessee Press.

Rochford, E. B. 1985. *Hare Krishna in America*. New Brunswick, NJ: Rutgers University Press.

Rose, S. 1987. Woman warriors. *Sociological Analysis* 48: 245-58.

Royle, M. 1982. Women pastors. *Review of Religious Research* 24: 116-26.

————. 1987. Using bifocals to overcome blindspots. *Review of Religious Research* 28: 341-50.

Schreckengost, G. 1987. The effect of latent racist, ethnic, and sexual biases on placement. *Review of Religious Research* 28: 351-66.

Sered, S. S. 1986. Rachel's tomb and the milk grotto of the Virgin Mary. *Journal of Feminist Studies in Religion* 2: 6-22.

———. 1993. Religious rituals and secular rituals. *Sociology of Religion* 54.

Shriver, P. 1987. Context, challenge and contribution. *Review of Religious Research* 28: 377-82.

Stacey, J. 1990. *Brave new families.* New York: Basic Books.

Stanton, E. C. 1972. *The women's bible.* Salem, NH: Ayer.

Taylor, R. 1988. Structural determinates of religious participation among black Americans. *Review of Religious Research* 30: 114-26.

Trebbi, D. 1990. Women-church. In *In gods we trust,* 2nd ed., edited by T. Robbins and D. Anthony, 347-51. New Brunswick, NJ: Transaction.

Tronto, J. 1987. Beyond gender difference to a theory of care. *Signs* 12: 644-63.

Wallace, R. 1975. Bringing women in. *Sociological Analysis* 36: 291-303.

———. 1988. Catholic women and the creation of a new reality. *Gender and Society* 2: 24-38.

———. 1989. Bringing women in: the ACSS/ASR story. *Sociological Analysis* 50: 409-14.

———. 1991. Women administrators of priestless parishes. *Review of Religious Research* 32: 289-304.

———. 1992. *They call her pastor.* Albany: State University of New York Press.

———. 1993. Women heading Catholic parishes. *Sociology of Religion* 54.

Yeaman, P. 1987. Prophetic voices. *Review of Religious Research* 28: 367-76.

Young, K. Z. 1989. The imperishable virginity of Maria Goretti. *Gender and Society* 3: 474-82.

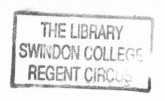
11

Back to the Future

Applying Sociology of Religion

WILLIAM H. SWATOS, JR.

Applied sociology of religion may well represent the oldest form of sociological practice. One major stream of early American sociology was the "alliance for progress" of this new human science with institutional religion (Reed 1981). Both the *American Journal of Sociology* and *Social Forces* in their early years carried a large number of religion articles of an applied nature. "Modernizing" church structures to deal with the social problems at the turn of the twentieth century was one of the major concerns of early American sociology (Swatos 1984). The work that was done in this period covered a wide range. Much was merely descriptive, reporting on specific projects undertaken by churches or interchurch bodies to alleviate local social problems or redirect administrative energies. Some, however, had lasting value. Walter Laidlaw, an urban Methodist minister-researcher, for example, is to be directly credited with the construction and ultimate federal government adoption of the concept and method of *census tracts* during a New York City Federation of Churches study of neighborhoods in 1902 under his direction (Green 1954). Laidlaw's work is particularly important to contemporary value-application debates in sociology because it demonstrates that applied sociology of religion can have an impact on general social science knowledge, independent of dogmatics or the initial imperatives of sponsoring institutions.

This was not the case only in the United States, however. The German sociologist Max Weber, now frequently invoked as the paragon of sociological disinterest, in fact throughout his life had a commitment to applied concerns, particularly with respect to religion (see Swatos and Kivisto 1990, 1991). These are most clearly manifest in his East Elbian and industrial workers studies, but they also inform much of his other work, as indicated by his widow in her biography (1988). At the time of the formation of the German Sociological Society, for example, Max Weber took an aggressive stance for the pursuit of practical questions and empirical research to answer them, and largely withdrew from involvement with the group when it became clear that this was not the direction that would be taken. Although Weber's French counterpart, Emile Durkheim, was less inclined toward direct work with the clergy, he too saw sociology as leading toward a sociology of morals by providing a base for a covenant that would bind men and women together in a meaningful social order apart from the harsh pragmatism of contractual existence (see Hall 1987).

The breakdown of the sociology-and-religion alliance was part of a much broader process in sociology that, as Janowitz (1978) puts it, separated the profession into "intellectuals" and "doers," with the former reaping the greater intradisciplinary status honor. One of the stigmatizing strategies of the movement from "practicalism" to "the pussyfooting sociologist . . . sneering at 'reformism' and condemning 'value judgments'" (Ross 1936, 180) was a lumping together of practically all applied researchers from its early years under such labels as "do-gooders" and "preachers' kids" (Reed 1982). As academic sociologists increasingly adopted William F. Ogburn's stance (in his presidential address to the American Sociological Society in 1929) that sociology "is not interested in making the world a better place to live," religionists were particularly singled out for criticism as relics of a bygone era (see Bannister 1987; Barnes 1929; Bernard 1934).

This did not end applied research in the sociology of religion—though it certainly did not enhance it—but rather sent it underground, primarily into seminaries and agency-sponsored research institutes. Foremost among these was the Institute for Social and Religious Research, whose urban department was headed by Harlan Paul Douglass, with a town and country department under the direction of Edmund deS. Brunner. In his early fifties, after an accomplished career of almost 30 years as a pastor and missionary, Douglass soon became the foremost religious researcher in American social science. "Combining field

research with survey data . . . Douglass never conducted a survey without spending at least some time on-site to gain firsthand knowledge" (Hadden 1980, 72).

During the 13 years of the Institute's existence, it published 78 volumes of applied religious research. An inventory of the Harlan Paul Douglass Collection of Religious Research Reports, housed in the Department of Research, Office of Planning and Program, National Council of Churches in New York, contains several thousand "fugitive" studies, primarily from the 1950s to the present, that rarely found their way into published format. A microfiche edition of 2,270 of those produced before 1970 is now available from Research Publications, Inc., under the title *Social Problems and the Churches* (Brewer and Johnson 1970). Although Douglass and Brunner's work is not without its institutional biases, as Rodney Stark (1992) has recently indicated, these materials provide both a measure of the continued demand for social science research on the part of religious audiences and a resource tool for those contemplating this venture.

During the 1950s the Religious Research Association (RRA) was founded, primarily to provide a professional association and communication link for workers in applied sociology of religion. Its membership consisted of two groups: an older cadre of trained social scientists who had found niches in seminary or occasional university settings, like Earl D. C. Brewer at Emory, and a newer group of "bootstrap methodologists" who often lacked professional training in sociology but were recruited to serve pressing denominational needs (Thorne 1974). The RRA addressed four interrelated themes: a concern about methodological sophistication, a desire to use academic expertise, a perception of a need for professional standards and symbols, and an ecumenical response to move beyond the Protestant mainstream (Hadden 1974, 30).

The second of these items largely addressed the first, as sociologists like Charles Y. Glock led a group of solidly trained methodologists into the association. The *Review of Religious Research* began publication in 1959 and continues as a quarterly journal addressing both basic and applied issues in religious research. Interfaith ties began with Roman Catholic members, such as Joseph Fichter, and soon included Jews, Mormons, and more recently, Islamic scholars. That this has redounded back to the religious traditions may be illustrated by the formation of research departments in some Roman Catholic archdioceses and studies commissioned by the United States Catholic Conference; whereas in an

earlier era, the Roman hierarchy had suppressed the continuation of Fichter's monumental research project on Catholic parish life (1951).

Organizing Foci

Applied projects in the sociology have run a wide gamut over the century. Early studies often focused on how the churches might serve "needy" groups in society. More recently there has been a shift toward intrainstitutional studies. Fichter (1980, 1982, 1984) has completed projects for the Roman Catholic Center for Applied Research in the Apostolate (CARA) and other Roman Catholic agencies on such topics as clergy alcoholism, clergy burnout, and Catholic hospitals. This does not mean that religious groups have necessarily become more introspective. Much of the work on the socially disenfranchised that religious groups once sponsored is now done under governmental or other secular auspices. The results of this work can be used by organized religion for a variety of ministries to target groups as effectively as those data supplied by the earlier studies.

For purposes of organizing our understanding of trends and prospects in applied sociology of religion, a helpful tool can be found in Roof's use of the cosmopolitan-local distinction (1976). To this, however, I will add a third dimension—namely, that supplied by Edward Bailey's construct of "implicit religion." This threefold division will enable us to survey a range of studies and, especially in the case of implicit religion, enable the introduction of some suggestions for future research.

Each of these dimensions has its own relatively distinct style, though of course there is also overlap; nothing is quite as pure in its concrete application as a secondary analysis such as this may suggest. With that caveat in mind, then, I would characterize as "cosmopolitan" research conducted by denominational and interdenominational bureaucracies to address questions of concern to administrators—how to educate pastors most effectively for stewardship development, for example—or to the membership at large. These would include large-scale statistical analyses, demographic profiles, and so forth. The "local" type is congregational research. This is sometimes a spin-off from larger projects, but local churches also identify needs—or can be assisted to identify needs —within their immediate fellowship or community in which sociological expertise can be of value. While all religious organizations in the United States are technically voluntary associations, most church

bureaucracies work like bureaucracies. Congregations, by contrast, have unique local circumstances that demand different analytical strategies. The implicit dimension, by contrast, is not necessarily tied to "religious" organizations at all; in some ways it involves seeking out the religious dimension in, with, and under other appearances.

The Cosmopolitan Dimension

Most denominations have developed an awareness of the value of the survey as a planning tool. Some have in-house research staffs. Some contract out to agencies, such as the Gallup organization or Hartford Seminary. Peter Berger's early work in the sociology of religion (1961a, 1961b) grew out of research for the Lutheran Church. Glock, Ringer, and Babbie's *To Comfort and to Challenge,* published in 1967, is actually a secondary analysis of data collected in 1952 by the Bureau of Applied Social Research of Columbia University for the Episcopal Church. The Office of Review and Evaluation of the Presbyterian Church in the United States was established largely as a result of constituent demands for accountability on the part of leadership in program implementation; members who were funding programs wanted to have some impact assessment data for subsequent budgeting. Since the northern and southern branches of that denomination have united, research has remained a commitment through such things as the Presbyterian Panel Survey, an ongoing research strategy. The United Methodists have alternated between in-house and contract research. CARA both commissions research associates and undertakes direct involvement. Groups once considered too fundamentalist to tolerate social science also are increasingly open to applied research, particularly in regard to such topics as new membership development and stewardship. In addition to denominational agencies, the Eli Lilly Foundation has taken particular interest in sponsoring such research in applied sociology of religion.

To some extent research and consulting for denominational and interdenominational organizations has been a reflection of the churches' own standing vis-à-vis society at large. The Glock study in 1952, for example, was concerned with church social policies and community action. The 1950s represented a period of church growth and a concern on the part of leadership for program development. More recently there has been considerable decline in membership among the so-called mainline denominations, and with that, research interests have focused more on membership issues, perhaps best exemplified by the essays in

Hoge and Roozen's *Understanding Church Growth and Decline* (1979), by Roof and McKinney's *American Mainline Churches* (1987), and by Roof's current work on religious attitudes and behaviors among the baby boomer generation (see Reinhart 1989; Woodward 1990). Churches and other agencies want to know why some denominations are growing while others are not, what motivates the church member to stay with or leave the church, how church members make decisions about financial support, and so forth.

One characteristic of the voluntary-associational character of American religious organization that does persist at the cosmopolitan level is an intimate relationship between member support and executive occupational survival. Regardless of formal organizational polity, American religious organizations actually operate on a congregational, bottom-up principle, so that the financial pinch often hits at the top. Whereas many secular formal organizations' administrative staffs remain relatively untouched by financial ebbs and flows (while labor is laid off), most local ministers remain in place, while a managerial staff member, usually at the middle level, is cut.

What church bureaucracies and funding agencies want from sociological research are: strong quantitative skills, expertise in questionnaire design, clear and relevant data analyses, and an absence of either theoretical or methodological mumbo jumbo. The greatest difficulty many sociologists face coming into church consulting is sufficient familiarity with church teaching and practices to execute good research. Regardless of their personal religiosity, sociologists often lack substantive training in religion as a set of organizational structures related to some more or less explicit goal statement. This can lead to naively constructed instruments that either are rejected by the contracting agency or are used and then found wanting. This is partially the reason that many organizations have begun to develop in-house staffs, and partially, too, why so many contracts go to the uniquely qualified Hartford Seminary, which, in reality, is principally a theologically mindful social research organization that provides no regular program of theological instruction for ministerial candidates. Ironically, sociologists who are taught to be value-free all too often focus on values rather than structure in approaching religious organizations.

How an understanding of structure can be used creatively can be illustrated by looking at several books attempting to deal with problems of growth and decline in mainline Protestant denominations: Jeffrey Hadden's *The Gathering Storm in the Churches* (1969), which focuses

on the increasing divergence of clergy and laity on theological, social, and political issues; Dean Kelley's *Why Conservative Churches Are Growing* (1972); and Robert Wuthnow's *The Restructuring of American Religion* (1987), which focuses upon the intradenominational differences between and interdenominational similarities among conservatives and liberals. Hadden and Wuthnow are university-based sociologists of some prominence, and at the time he wrote *Why Conservative Churches Are Growing,* Kelley, who is now retired, held an applied position with the National Council of Churches. The books can be tied together inasmuch as Hadden shows wide differences on core issues between clergy and laity in mainline denominations; Kelley claims that consistent meaning systems are what characterize conservative versus mainline groups; and Wuthnow attempts to demonstrate a shift along meaning-systems axes that might be seen as a critique of the two earlier works, but can also be interpreted as a reasonable outcome of the trends those books discuss.

All of these claims undoubtedly have some truth to them, but a sociologist of organizations would also note that none of these authors pays sufficient attention to the fact that the liberal churches by and large are much more bureaucratic and exercise far greater bureaucratic hegemony over the placement of clergy into local cures. Not only *how* the clergy are placed, but also *who* may be placed is increasingly removed from local hands, apparently, as denominations liberalize. The same is generally true for clergy removal. This structural difference between conservative and mainline churches is often overlooked in analyses that focus primarily on values.

Thus, to these analyses the following kind of model can be profitably added: Whereas church organizations in the United States are voluntary associations dependent upon a local base of support, denominations, in which clergy are assigned to local cures or called to cures with permanent tenure or called only after the completion of a hierarchically approved curriculum of study, are more likely to experience clergy-lay dysensus to a greater extent than those in which the choice of a pastor is primarily congregational, in which professional training is minimized, and in which the line between lay and clergy roles is diffuse. This model emphasizes primarily the social structure of the religious organization—at both its cosmopolitan and local levels—over abstract meaning systems imputed to participants. The fact that in recent times these happen to be conservative churches probably reflects more of a rejection of the bureaucratic style of administration and its attendant

life-style than an a priori value commitment. We should thus expect that those who reflect mainline denominational liberalism are more reflective of the "knowledge class," a promodern value orientation, whereas those who reject it—regardless of whether they leave its local instantiation in a particular congregation—will be discontented with the modern project, though not necessarily its technical products (see Swatos 1981).

An applied sociologist of religion, using a model such as this with denominational executives, might suggest some surprising alternatives to contemporary programming. Data from organizational mergers in the business world, for example, might be included to raise questions about the long-range prospects of interdenominational mergers at the formal organizational level. Corporations that merge do not necessarily show greater profitability, though they do show greater concentration of power at the top. How valuable this is to those organizations whose ultimate power lies at the bottom should be studied very carefully. Although the Roman Catholic bureaucracy has a remarkable history and, indeed, could well be studied under the rubric of the transition from empire to transnational corporation, there is no assurance that mainline American Protestantism can ape this model successfully.

Here values return again to the analysis, but from a structural perspective: To what extent can an organizational form, founded on localism (the American denomination), structure itself on cosmopolitan principles when those principles have no clearly operative control mechanism for their enforcement? What the Protestant denominations lack, in contradistinction to both historic Roman Catholicism and the modern corporation, is clout over their members, and this is becoming increasingly less true even for Roman Catholicism, in spite of its authoritarian tradition. This example is offered to illustrate how an applied sociology of religion that understands both the intraorganizational structure of religious groups and the relationships between forms of social organization and societies generally can develop analytical tools for assessing trends at the societal and even global level.

The Local Dimension

The discussion of structures for pastoral deployment can help us segue from the cosmopolitan focus to that of the local congregation. Many congregational projects develop from larger denominational concerns. Often the parent body will provide consultants from its own ranks, or provide training for consultants appointed by regional judicatories that

serve as mediating structures between denominational headquarters and the local congregation. A local congregation interested in evangelism (that is, recruitment of new members) or stewardship (fund-raising) may well make use of materials and personnel supplied by a denominational agency. Denominations may also attempt to require local congregations to engage in specific quasi-research activities. The Episcopal Church, for example, in the early 1980s promoted such a program under the title of The Next Step. Congregations were to engage in self-evaluations, according to prescribed formulae with respect to five different areas of ministry, designated SWEEP: service, worship, evangelism, education, and pastoral care. The Next Step in Mission program followed a fund-raising program known as Venture in Mission, promoted by the church's hierarchy largely to deflect attention from internal denominational divisions. Similar kinds of congregational self-evaluations are supposed to be done when new clergy are hired.

Some local congregations, however, also look for applied sociological expertise—again, perhaps, through their larger structure—to work with them in addressing concerns in their own congregation or the community within which they operate. These may be general topics, such as "planning for the future," or specific, such as where to relocate (if at all) the church building in light of neighborhood change (Bartholomew 1969). It is studies of these sorts that constitute the bulk of the Harlan Paul Douglass Collection of the National Council of Churches. Such studies can have continuing relevance and be applied across a variety of denominational lines, for example, Samuel Kincheloe's "The Behavioral Sequence of a Dying Church" (1929).

Here a first principle for applied research in the congregation can be articulated: Local congregations must be understood primarily in terms of local rather than cosmopolitan (that is, denominational) context (see Swatos 1981; Warner 1987). A major difference between working with a local congregation versus a denominational organization is that the researcher must know the locality within which the work is to be done. Survey instruments of wide generality can be used accurately only if they are interpreted in light of local circumstances. It may be far more important, for example, to know the religiopolitical networks within a given community than it is to know how a national sample of members of different denominations responded to political issue items on a questionnaire.

Neighborhood change is one of three areas that might be considered as important foci for applied sociology of religion. Church members

and leaders will often say, "Churches are people," and so they are. But church people rapidly, sometimes amazingly rapidly, build buildings, and from then on "the church" is more likely to refer to a piece of real estate than a group of people (see Hill 1992, 263-64, for a particularly apt illustration of this tendency). The real estate, in turn, is likely to be subject to demographic change. Local congregations form primarily around ethnic, status, or age lines. As demographic change impacts upon a neighborhood, the building remains, while the congregation moves. Congregations are increasingly sensitive to this possibility and seek to determine the best strategy to couple real estate and people. A sociologist who can bring expertise in demographics, cultural differences, and affiliational behaviors can contribute substantially to this decision-making process, especially as she or he is religiously sensitive so as to recognize that the church building is an affectively charged setting. Critical life events have been solemnized and symbolized within its walls. A business executive who would think little about relocating a company's headquarters, if it better served the goals of the corporation, may shed tears over the destruction of the altar at which a marriage was solemnized or from which a parent was buried.

A second area for sociological applications in religion is that of expansion of membership. Congregations are becoming increasingly aware that there may be reasons why people do or do not choose to affiliate with them that extend beyond theology. It is no accident that this problem has occurred for churches, nor is the desire to address it merely Machiavellian. Historically, local congregations—denominations, in the original, nonbureaucratic meaning of that term—functioned to fit people into local communities (Swatos 1981; see Warner 1987, 289-96). A person's religious profession said something about social status and ethnic background. Transportation restrictions limited the range within which church selection could be made. Vertical social mobility often brought denominational mobility, at least intergenerationally. Otherwise, however, denominational congregations were multigenerational collectivities of families.

Geographic mobility has radically changed this situation, and churches cannot appeal to the same stable familistic attachments that once undergirded their programs. Churches must now appeal to new people in a different sense from the past. A creative example of how sociological factors can be brought to bear on new member ministry, from the standpoint of the structure of the existing congregation, is the work of Arlin Rothauge, which operates from the simple, but effective basic hypoth-

esis that "the most effective means of carrying out a new member ministry varies with the size of the congregation" (1983, 5). Using four categories, based on the active membership categories of under 50, 50-150, 150-350, and 350-500+, Rothauge shows that the size of the church (as people) affects interaction patterns and that these, in turn, are of critical importance to the attraction and retention of new members (see Lee 1992). I have also described (Swatos 1990), from the situationalist viewpoint, how and why a new member program using extensive telephone contacts does and does not work in different settings.

A third locus for applied sociology in congregational studies is on the occasion of clergy turnover. Regardless of denomination, the church pastor exercises office charisma (except for the rare cases of genuine charisma). Regardless of the reason for turnover, something of a crisis atmosphere occurs with clergy turnover. This is minimized, but not by any means removed, in churches that operate on the assignment system (principally the Methodist and Roman Catholic churches). A pastor's leaving, or a church's difficulty in attracting a new pastor, or differences in the newly assigned pastor's style from a predecessor's can signal a need for self-study and evaluation. Some denominations require this activity prior to new pastor placement, although here the structure is usually provided by the denomination as well. A social scientist from outside the structure can work with a congregation to do as little as develop an effective survey instrument or other data collection technique. In other cases, a sociologist may actually do the research, analyze its results, and even take part in the subsequent hiring process. She or he may also design and implement a format for interviewing prospective candidates. At other times a church may wish to learn, prior to advertising its position, how it can most effectively minister to the community in which it is located, given both its human and technical resources. A sociologist can make an assessment of both factors and provide a profile for action.

In addressing a congregation's needs, it is important to make especially clear what unique talents sociological training and perspective bring to the assignment. The general population tends to think psychologistically. This can express itself, for example, in such taken-for-granted assertions in the hiring process that, since extended pastorates correlate with church growth, the church should seek a pastor who wants to "stay around a while." The psychologistic assumption here is that the individual pastor makes the difference in church growth. A sociologist, by contrast, can point out that there is an alternate explanation for the

pastorate/growth association; namely, that congregations who work well together as groups attract both pastors to extended ministries and members to their fellowship. This specification of the relationship emphasizing the group not only can show the significance of the theoretical perspective of sociology, but may also open the door for continued research and application as the congregation decides it wants to learn more about how to work well together as a group.

The Implicit Dimension

A final area for applied sociology of religion is the newest and perhaps the most challenging. It centers upon the notion of "implicit religion" introduced by Edward Bailey in the early 1980s (see, e.g., Bailey 1983, 1990a, 1990b). Although the work of Robert Bellah and his colleagues, *Habits of the Heart* (Bellah et al. 1985), does not use this phrase specifically, and indeed may be too closely tied to the Durkheimian project to be fully representative of Bailey's thought, it nevertheless constitutes what may well be the best published substantive investigation in this genre. In that book, the authors look at the role of individualism in modern American society and culture and how it interacts with historic political and religious communities (among others). From it we can extract something of a sense of at least one dimension of implicit religion in America.[1] More recently, Clark Roof, a scholar who has built a solid reputation on quantitative research, has, in a vein similar to the richness of *Habits of the Heart,* directed attention to the importance of narrative accounts in his baby boomer research (1993). This again suggests the importance of underlying structures of meaning in thought and action that may or may not be termed "religious" throughout a pluralistic sociocultural system.

An equally significant venue for implicit religion applications in sociology, however, occurs in quite a different realm—namely, the burgeoning organizational style known as total quality management (TQM). This newest adaptation of what is sometimes called Japanese management theory, though its origins lie with American scholars, is unabashed about the underlying dynamic of its implementation. In one of the principal texts, Huge (1990, 26) describes the process of developing leadership commitment to the quality management program as "helping managers get religion," and the metaphor is not used merely off-handedly. At the center of the strategy is conversion to a total culture that encompasses values and action. Consider, as well, these concluding

lines of the book: "To all of you who have started to 'walk the talk' we extend our sincerest compliments and wishes for continued success. The spirit behind the process of total quality will see you through with Godspeed" (p. 231). This particularly explicit reference to religion in a thoroughly secular context highlights the underlying implicit religiosity in Anglo-American social life to which Bailey refers when he writes that "[t]he widespread apprehension of religiosity as fundamental to that which is distinctively human, and climactic in it, is no doubt responsible for the ever growing, yet rarely remarked, overlap or borrowing of concepts between analyses of religions and those of society" (1990a, 209).

My point, additionally however, is that not only is this of sociological significance analytically or foundationally, but it also represents an opportunity of enormous importance for sociology of religion. Put simply, there is no discipline more theoretically qualified to school in the implementation of the processes of ideological conversion, maintenance, and organization than the sociology of religion. Total quality management, by the very nature of the commitment it demands, also demands a religions perspective on human action. In the explicit language used by Huge, we can see in a pristine way the value of the implicit religion construct within applied sociology of religion. If there is anything to TQM sociologically (i.e., other than as a fad), it is its anti-modernism, for TQM moves from a perception of the life world as disintegrated parts to that of an integrated whole. The hallmark of Taylorism was, of course, the reverse. Inasmuch as religion deals with wholes, it should not be at all surprising that the halcyon days of modernity were also days in which sociologists as the high priests of its worldview were conducting the funerals of religions. Implicit religion gives the sociology of religion a way to reintegrate formal religions with the irreducible religiousness of life that modernity could not ultimately displace and that we now see articulated in what otherwise appear to be thoroughly secular circles.

A Research Agenda

As I have worked through each of the prior sections, I have tried to suggest ways in which applied sociology of religion might be engaged in problem solving. Here I will introduce some more explicit topics that

seem to me to be worth sociological investigation and to have applied importance.

The first concerns the liberal-conservative divide in American religion. Wuthnow (1987) has contended that liberalism-conservatism interdenominationally has become a more potent force in American religion than denominationalism. I have disagreed with that position in a review (1989), and I still do. Ammerman (1991, 47-48), for example, claims that conservatives have gained clear control of both the Southern Baptist and Missouri Synod Lutheran structures. Inasmuch as the Southern Baptists are the United States's largest Protestant denomination and a growing denomination, this is no small victory; the Missouri Synod church is also experiencing growth. My own participant observation research convinces me that, with the 1991 General Convention of the Episcopal Church, the denomination's liberals have won the day. The Greek Orthodox, who 20 years ago were extremely warm to Episcopalians, have utterly cut them off, and dialogues with Lutherans and Roman Catholics are on hold. The United Church of Christ and the Unitarian Universalists are also firmly in the liberal camp. The positions of the Methodists, Presbyterians, and kindred groups remain somewhat ambiguous. In short, I see a redefining of the issues in, rather than a restructuring of, American religion, with denominational labels continuing to symbolize issue orientations. This needs to be investigated, using carefully controlled survey research in conjunction with congregational profiles.

Closely connected to the liberalism-conservatism divide is a series of gender-related issues that Hegy has termed the "libido factor" (1990). Robbins and Robertson have remarked that "the study of 'women and religion' has become part of the study of religion largely as a result of women demanding 'representation' and then proceeding to attempt a redefinition of the field" (1991, 328-29). The result, however, is some rather skewed perceptions of the history of both women and religion in general and the ordination of women in particular. The sociological character and contribution of "women's work" in denominational Christianity, for example, remains almost entirely unexplored, as does the relationship between that work and the ordination of women. Also unclear in the "membership crisis" of most of the mainline liberal denominations is the effect of women entering the labor force in record numbers. How much, in other words, is the decline of these churches connected to the economic role of women in the larger society and, for

that matter, to the state of the economy as a whole (see Schoenfeld and Mestrovic 1991)?

On the other hand, most studies of—and virtually all of the debate over—the ordination of women focus on the liberal denominations and feminist rationales. Yet, in fact, some of the greatest growth churches —often labeled "conservative"—have ordained women to the pastoral ministry for years and years prior to the mainline denominations, as Mary Jo Neitz has indicated; indeed, this action was once used by churches of the mainline to "prove" the "heretical" character of these groups. This applies to the Assemblies of God, the Church of God, and more recently, to a considerable number of nondenominational congregations, large and small, throughout the United States and Canada. What is alienating people from the mainline cannot be the same thing that is leading them into these other groups! What is different about the operation of these two groups of churches generally? Could it be, in fact, a cosmopolitan management strategy versus one of localism? The ideology of feminism lacks a local base among significant numbers of Christians of all denominations. The ordained women of the conservative churches have not demanded ordination because of secular theories of gender equality, nor have they markedly challenged the culturally accepted concept of God; rather they have used religious *experience* as the criterion for ordination. The gospel they have proclaimed has been culturally continuous with the experience of their adherents, and they have built congregations on themes that resonate with local concerns.

Much of the decline of religion is, in fact, a decline in precisely those kinds of religion that have stressed an intellectual or cognitive relationship to the divine. This has resulted in both the devaluing of the congregation as a social unit yielding potential rewards to individual participants (see Lee 1992) and the neglect of other dimensions of the personality: the affective sphere, to which particularly Jim Spickard and Danièle Hervieu-Léger in this volume have pointed, and also the conative sphere, which together may explain, for example, more fully ritual and moral life than the dogmatic approach emphasized in measures of belief. More thorough sociologies of emotion and conation may be needed to balance historic emphases on meaning and beliefs. In fact, we still have extremely weak understandings of "religion" from the subjective standpoint of actors, and these in turn need to be worked into larger social-systemic modes of articulation. Here a close-reading, emic sociology is needed to explicate the implicit senses of religion that lie in individuals' and groups' meaning-action-experience structures.

An outstanding example of the kind of merging of research and theory I have in mind may be found in Edward B. Reeves's work on the place of Sufi shrines in Northern Egyptian political life. Reeves provides an *empirically grounded* analysis that turns on its head the assumption that religious organization mirrors social relations. He demonstrates instead that "the role relations embedded in the cult of the saints" that surrounds these shrines are "an ideal model" for actual social relations (Reeves 1990, 172-73). As symbol creators, human actors are able to construct ideals within their social relations of how life ought to be. These *ideal interests*, regardless of whether they represent exactly what Max Weber meant by this phrase, have been too much neglected by the social sciences and need to be reclaimed. Within our sociocultural milieux humans are able to imagine a better world and work toward it. Sociology of religion could do worse than apply itself in a cooperative venture toward this end.

Note

1. Historically Bellah has been associated with the civil religion concept (1967), rather than implicit religion, and in his work Bailey (e.g., 1983) distinguishes implicit religion from civil religion, as have others using the implicit religion construct (e.g. Nesti, 1990). However, in a comment on the status of the civil religion concept subsequent to the publication of *Habits of the Heart*, Bellah (1989) indicates that he has "stopped using the term 'civil religion' " in his own work, noting that "*Habits of the Heart* is very much concerned with the same substantive issues" as his civil religion writings, and adds, "Mercifully, I have been spared the irrelevant arguments about civil religion in comments on *Habits*, which confirms to me that I was right to drop the term." In my view, the substantive issues in *Habits* that rightly bring it praise are those of implicit religion.

References

Ammerman, N. T. 1991. North American Protestant fundamentalism. In *Fundamentalisms observed*, edited by M. E. Marty and R. S. Appleby, 1-65. Chicago: University of Chicago Press.

Bailey, E. 1983. The implicit religion of contemporary society. *Religion* 13: 69-83.

———. 1990a. The "implicit religion" concept as a tool for ministry. *Sociological Focus* 23: 203-17.

———. 1990b. The implicit religion of contemporary society. *Social Compass* 37: 483-97.

Bannister, R. C. 1987. *Sociology and scientism*. Chapel Hill: University of North Carolina Press.

Barnes, H. E. 1929. *The twilight of Christianity.* New York: Vanguard.
Bartholomew, J. N. 1969. A study of planning techniques for local congregations. *Review of Religious Research* 11: 61-65.
Bellah, R. N. 1967. Civil religion in America. *Daedalus* 96: 1-21.
———. 1989. Comment. *Sociological Analysis* 50: 147.
Bellah, R. N., R. Madsen, W. M. Sullivan, A. Swidler, and S. M. Tipton. 1985. *Habits of the heart.* Berkeley: University of California Press.
Berger, P. L. 1961a. *The noise of solemn assemblies.* Garden City, NY: Doubleday.
———. 1961b. *The precarious vision.* Garden City, NY: Doubleday.
Bernard, L. L. 1934. *The fields and methods of sociology.* New York: Long & Smith.
Brewer, E.D.C., and D. W. Johnson. 1970. *An inventory of the Harlan Paul Douglass Collection of religious research reports.* New York: Department of Research, Office of Planning and Program, National Council of the Churches of Christ in the U.S.A.
Fichter, J. H. 1951. *Southern parish.* Chicago: University of Chicago Press.
———. 1980. *Religion and pain.* New York: Crossroads.
———. 1982. *The rehabilitation of clergy alcoholics.* New York: Human Sciences Press.
———. 1984. The myth of clergy burnout. *Sociological Analysis* 445: 373-82.
Glock, C. Y., B. B. Ringer, and E. R. Babbie. 1967. *To comfort and to challenge.* Berkeley: University of California Press.
Green, H. W. 1954. Serving the urban community. In *Methodism looks at the city,* edited by R. A. McKibben, 43-50. New York: Division of Missions, Board of Missions—The Methodist Church.
Hadden, J. K. 1969. *The gathering storm in the churches.* Garden City, NY: Doubleday.
———. 1974. A brief social history of the Religious Research Association. *Review of Religious Research* 15: 128-36.
———. 1980. H. Paul Douglass. *Review of Religious Research* 22: 66-88.
Hall, R. T. 1987. *Emile Durkheim.* New York: Greenwood Press.
Hegy, P. 1990. The libido factor. *Research in the Social Scientific Study of Religion* 2: 31-46.
Hill, C. 1992. The non-emergence of the civic church in English new towns. In *Twentieth-century world religious movements in neo-Weberian perspective,* edited by W. H. Swatos, Jr., 247-64. Lewiston, NY: Mellen.
Hoge, D. R., and D. A. Roozen, eds. 1979. *Understanding church growth and decline.* New York: Pilgrim.
Huge, E. C. 1990. *Total quality.* Homewood, IL: Dow Jones-Irwin.
Janowitz, M. 1978. *The last half century.* Chicago: University of Chicago Press.
Kelley, D. M. 1972. *Why conservative churches are growing.* New York: Harper & Row.
Kincheloe, S. C. 1929. The behavioral sequence of a dying church. *Religious Education* 24: 329-45.
Lee, R. R. 1992. Religious practice as social exchange. *Sociological Analysis* 53: 1-35.
Nesti, A. 1990. Implicit religion. *Social Compass* 37: 423-38.
Reed, M. 1981. An alliance for progress. *Sociological Analysis* 43: 27-46.
———. 1982. After the alliance. *Sociological Analysis* 43: 189-204.
Reeves, E. B. 1990. *The hidden government.* Salt Lake City: University of Utah Press.
Reinhart, P. 1989. The pivotal generation. *Christianity Today* (6 Oct.): 21-26.
Robbins, T., and R. Robertson. 1991. Studying religion today. *Religion* 21: 319-37.
Roof, W. C. 1976. Traditional religion in contemporary society. *American Sociological Review* 41: 195-208.

————. 1993. Presidential address. *Review of Religious Research* 33.

Roof, W. C., and W. McKinney. 1987. *American mainline churches*. New Brunswick, NJ: Rutgers University Press.

Ross, E. A. 1936. *Seventy years of it*. New York: Appleton Century.

Rothauge, A. J. 1983. *Sizing up a congregation for new member ministry*. New York: Education for Mission and Ministry Office, Episcopal Church Center.

Schoenfeld, E., and S. Mestrovic. 1991. With justice and mercy. *Journal for the Scientific Study of Religion* 30: 363-80.

Stark, R. 1992. The reliability of historical United States Census data on religion. *Sociological Analysis* 53: 91-96.

Swatos, W. H., Jr. 1981. Beyond denominationalism? *Journal for the Scientific Study of Religion* 20: 217-27.

————. 1984. *Faith of the fathers*. Bristol, IN: Wyndham Hall.

————. 1989. Review of R. Wuthnow (1987). *Journal of the American Academy of Religion* 50: 321-24.

————. 1990. Renewing "religion" for sociology. *Sociological Focus* 23: 141-53.

————, and P. Kivisto. 1990. Beyond *Wertfreiheit*. *Sociological Focus* 24: 117-28.

————. 1991. Max Weber as "Christian sociologist." *Journal for the Scientific Study of Religion* 30: 347-62.

Thorne, C. 1974. Reaction to Hadden. *Review of Religious Research* 15: 155-56.

Warner, R. S. 1987. *New wine in old wineskins*. Berkeley: University of California Press.

Weber, M. 1988. *Max Weber*. New Brunswick, NJ: Transaction.

Woodward, K. L. 1990. A time to seek. *Newsweek* (17 Dec.): 50-56.

Wuthnow, R. 1987. *The restructuring of American religion*. Princeton, NJ: Princeton University Press.

Index

About the Authors

John A. Hannigan is Associate Professor of Sociology at Scarborough College of the University of Toronto. His chapter in this book completes a trilogy of essays on the relationship between social movements and religion. (The other two articles appeared in *Sociological Analysis* [1991] and the *Review of Religious Research* [1990].) His present research interests include the ideological and spiritual foundations of the American conservation movement in the late nineteenth and early twentieth centuries, and the current conflict between farm groups and environmentalists over the economic and epistemological bases of agriculture.

Danièle Hervieu-Léger, a native Parisian, is director of research at the Centre National de la Recherche Scientifíque, Groupe de Sociologíe des Religions, and teaches at the Ecole des Hautes Etudes en Sciences Sociales. She is also editor of the *Archives de Sciences Sociales des Religions.* Her long-term theoretical interests are the relationships between religion and modernity, particularly the recompositions of religious beliefs and practices and the shaping of socioreligious identities in advanced societies. She has written extensively about these topics, and especially about the evolution of French Catholicism from this point of view, in articles and in her books, *Vers un Nouveau Christianisme? Introduction á la Sociologie du Christianisme Occidental* and *De l'Emotion en Religion* (with F. Champion). She is now preparing a book about the function of the religious reference to tradition in rapidly changing sociocultural contexts.

W. E. Hewitt is Assistant Professor of Sociology at the University of Western Ontario. He has written extensively on the relationship between religious ideology, social class, and social change in both North and South America. He is the author of *Base Christian Communities and Social Change in Brazil*, published in 1991. His articles have appeared in *Comparative Politics*, the *Journal of Latin American Studies*, the *Journal of Developing Areas*, *Sociological Analysis*, the *Canadian Journal of Sociology and Anthropology*, the *Journal for the Scientific Study of Religion*, and other periodicals.

Peter Kivisto is Associate Professor of Sociology at Augustana College, Rock Island, Illinois. His work on immigration and ethnicity includes *Immigrant Socialists in the United States*, *The Ethnic Enigma*, and *American Immigrants and Their Generations*. With Bill Swatos he has written *Max Weber: A Bio-Bibliography*. He is currently working on a synthetic sociological study of ethnicity in the United States, tentatively titled *The American Polyphony*.

Frank J. Lechner is Associate Professor of Sociology at Emory University in Atlanta. His work deals with problems in sociological theory, the sociology of religion, and world-system analysis. His publications include "The Case Against Secularization: A Rebuttal" in *Social Forces*, and chapters in several collections, including *Talcott Parsons: Theorist of Modernity*, *Religion and Global Order*, *Religious Politics in Global and Comparative Perspective*, and *Neofunctionalism*.

Mary Jo Neitz is a member of the sociology faculty and former director of the Women's Studies Program at the University of Missouri, Columbia. She has published a number of scholarly articles on women and religion, as well as *Charisma and Community: A Study of Religion and Commitment Among the Catholic Charismatic Renewal*. Her current research interests center on women in neo-pagan religions.

Eugen Schoenfeld fled his native Carpathia at the end of the Second World War, came to the United States on a scholarship from the Hillel Foundation, and ultimately completed his doctorate in sociology at Southern Illinois University. He has spent more than two decades at Georgia State University, as both Chairman and Professor of Sociology. In the past 10 years, his research interests have shifted from stratification to religion, and presently his research focuses on the relationship between

religion and morality, particularly the impact religion has on people's views of justice, freedom, and love. His most recent articles have appeared in the *Journal for the Scientific Study of Religion*, the *British Journal of Sociology*, and a special issue of *Sociological Focus* on the sociology of morals, assembled under his editorial direction.

John H. Simpson is Professor of Sociology and Chairman of the Sociology Department at the University of Toronto. He was educated at Seattle Pacific University, Princeton Theological Seminary, and Stanford University. He is the author of research publications on religion and politics, globalization, and fundamentalism and postmodernity, among other topics, and a collaborator with John Hagan and A. R. Gillis in the development of the power-control theory of common delinquency. He has held various offices in the Association for the Sociology of Religion and the Religious Research Association and is a Fellow of the Society for the Scientific Study of Religion.

James V. Spickard is Assistant Professor of Sociology at the University of Redlands. He was previously Research Director at the Cultural Development Institute, and has taught at the Institute for Transpersonal Psychology and at the College of Notre Dame. He has published articles in several journals, among them *Sociological Analysis*, the *Journal for the Scientific Study of Religion*, and *Religion*; his topics have included Mary Douglas's sociology of belief, liberation theology, Native American religion, and the new religions of Japan. His latest work is on the sociology of meditative experiences.

William H. Swatos, Jr., is editor of *Sociology of Religion* (formerly *Sociological Analysis*), an official publication of the Association for the Sociology of Religion, and has served as Secretary and a member of the Board of Directors of the Religious Research Association. He is the author of numerous scholarly articles and monographs. His most recent books include *Time, Place, and Circumstance: Neo-Weberian Studies in Comparative Religious History* and *Religious Politics in Global and Comparative Perspective*. He teaches a variety of undergraduate courses in sociology and philosophy. In 1989 the sociology department of the University of Kentucky, where he took his graduate training, honored him with its annual award and named him to its list of distinguished alumni.

Joseph B. Tamney is Professor of Sociology at Ball State University in Muncie, Indiana. His articles have appeared in the *Journal for the Scientific Study of Religion*, the *Review of Religious Research*, *Sociological Analysis*, the *Southeast Asian Journal of Social Sciences*, and *Asian Profile*. With Riaz Hassan, he co-authored *Religious Switching: A Study of Religious Mobility in Singapore*. His most recent books are *The Resilience of Christianity in the Modern World* and *American Society in the Buddhist Mirror*.